ANSEL ADAMS

ANSEL ADAMS

DIVINE PERFORMANCE

Anne Hammond

Yale University Press *New Haven & London*

Published with assistance from the foundation established in memory of
Philip Hamilton McMillan by the Class of 1894, Yale College.

Designed by Carol S. Cates
Set in Adobe Garamond type by B. Williams & Associates
Printed in Hong Kong by C & C Offset

Library of Congress Cataloging-in-Publication Data
Hammond, Anne.
Ansel Adams : divine performance / Anne Hammond.
 p. cm.
Includes bibliographical references and index.
ISBN 0-300-09241-5 (alk. paper)
1. Adams, Ansel, 1902–1984
2. Photographers—United States—Biography.
3. Photography of mountains.
I. Adams, Ansel, 1902–1984 II. Title
TR140.A3 H36 2002
770'.92—dc21
[B] 2001046909

A catalogue record for this book is available from the British Library.

The paper in this book meets the guidelines for permanence
and durability of the Committee on Production Guidelines for
Book Longevity of the Council on Library Resources.

10 9 8 7 6 5 4 3 2 1

For Mike

—rocks, trees, clouds,

lights and storms

comprising the vast Divine Performance

in which we live—

—ANSEL ADAMS, PORTFOLIO IV

CONTENTS

Attending a workshop offered by the Friends of Photography at the Robert Louis Stevenson School in Carmel, California, in the summer of 1982, I sat in the auditorium listening to the great photographer Ansel Adams tell his story of the Zone System. Soon afterward, I moved to Oxford, England, and began to study the history of photography, writing about the British photographer Frederick H. Evans and then coediting the journal *History of Photography* for ten years. In 1995 I pursued and earned my doctorate at Oxford University with a dissertation on Adams's landscape photographs. I could hardly have imagined that, twenty years after hearing him lecture, I would write this book about his work.

Adams's lifelong devotion to what he called the Natural Scene has motivated my interest in his work. His photographic art and his environmental activism were confluent streams flowing from a single idealistic source, springing from beneath the mystical and moral bedrock of his mountain life. Already aware of the work of the California philosopher and scientist Joseph LeConte, he photographed in the Sierra Nevada in the company of Joseph N. LeConte, son of the scientist, while observing the survey work in Yosemite of the geologist F. E. Matthes. Adams's devotion to science in no way precluded his commitment to natural religion; indeed, each confirmed his belief in the other. Equally, his emphasis on technical clarity in photography, so firmly grounded in Alfred North Whitehead's objectivist philosophy, was balanced by a subjectivist theory of art that was closely related to his love of music and shared with Alfred Stieglitz.

For Adams, photographs were subjective symbols of lived experience, extracted directly from the objective world of landscape. Through his close contact with nature as a mountaineer, he sought to sound the deeper reality of things and to sublimate this experience through his chosen medium of photography. This required an intense act of heightened consciousness in the presence of nature itself. For over sixty years, the Western landscape became the American place of his profound sense of the spiritual in art, the reconciliation of intellect with intuition.

I owe, first, a profound debt of gratitude to Mike Weaver, who gave me the confidence to embrace a life of the mind. I am also deeply grateful to Peter C. Bunnell for his generosity in sharing his archives and his boundless enthusiasm, as well as

to Mark Haworth-Booth for his continual support and quiet encouragement over many years. I am thankful to the British Academy for enabling me, an American citizen resident in Britain, to study Adams at Oxford, under Professor Martin Kemp, whose understanding of the relationships between science and art is incomparable.

Meeting Anne Adams Helms and Ken Helms was a great blessing; my profound appreciation of their help is exceeded only by my thanks for their friendship. It must be strange, indeed, for family members to witness an outsider's passion for the work of someone known to them so intimately. I remember with deep gratitude the gracious hospitality of the late Mrs. Virginia Adams, and I thank Leonard and the late Marjorie Vernon, for love shared in the pleasure of studying their collection. My researches were richly illuminated by three of Adams's students from the California School of Fine Arts days, Ira H. Latour, Bill Heick, and C. Cameron Macauley, whose contributions to the great Californian tradition of photography added new dimensions to my sense of Adams's world. My thanks, too, to John Szarkowski for his incisive critical suggestions.

My sincere thanks go to William Turnage, Carolyn Cooper, and Jessica Calzada of the Ansel Adams Publishing Rights Trust; the staff of the Center for Creative Photography, University of Arizona, Tucson, especially Amy Rule, Leslie Calmes, Tim Troy, Marcia Tiede, and Dianne Nilsen; Malcolm Daniel, The Metropolitan Museum of Art; David Wooters, Andrew Eskind, and Rachel Stuhlman, George Eastman House; Barbara Beroza, Yosemite Museum; Linda Eade and Jim Snyder, Yosemite Research Library; Steve Jones, Beinecke Library, Yale University; Janice Braun, F.W. Olin Library, Mills College; Virginia Heckert, Museum of Modern Art; and Drew Johnson, Oakland Museum. I have also received kind assistance from Melinda Parsons, Doug Nickel, Andrea Stillman, Rod Dresser, Mike Ware, Mary Alinder, Jim Harrod, Berndt Ostendorf, Paul Hickman, Kim Coventry, Jonathan Clark, Michele Penhall, David Gardner, Wilder Bentley II, and Janet C. Kelsey.

I would also like to thank the staff of the Bodleian Library, Oxford, for the acquisition of microfilms of the *Sierra Club Bulletin*; the Vaughn Cornish Bequest, Oxford, for funding a research trip to California; the Bancroft Library, University of California, Berkeley; Stanford University Library; Special Collections, University of California, Los Angeles; The Alpine Club Library, London; San Francisco Public Library; Houghton Library, Harvard University; The Huntington Library, San Marino, California; The Department of Photographs, J. Paul Getty Museum, Los Angeles; Special Collections, Getty Research Institute for the History of Art and the Humanities, Los Angeles; the John Simon Guggenheim Foundation; and The Art Institute of Chicago.

Versions of chapters 2, 3, and 5 appeared in *History of Photography* 23:1 (Spring 1999), 88–100; 23:4 (Winter 1999), 383–90; and 22:2 (Summer 1998), 169–78, respectively.

A New Consciousness

Ansel Easton Adams was born in San Francisco on February 20, 1902, to Charles Hitchcock Adams and Olive Bray Adams. As he was educated at home by his parents until he was nine, Ansel's early schooling was thoroughly unconventional. From his mother, who played the family piano during his childhood, he developed so strong a love for music that it almost became his career. From his father, who had hoped to study astronomy at the University of California at Berkeley, he acquired his love of science, particularly of chemistry and astronomy, fields that underlay his lifelong commitment to photography. In the company of both parents he made his first journey to the valley of the mountains he would photograph for decades.

In 1911, aged nine, Ansel Adams drew up a chart of the constellations, with careful notes on their positions in relation to other major stars, and he and his father studied the moon and the planets with a three-inch portable telescope.[1] Late in the summer of that very year, Charles may perhaps have taken his young son to hear the famous Harvard philosopher George Santayana deliver an address at Berkeley about the effects of Calvinism on American idealist thought. American culture, Santayana believed, now urgently required an infusion of self-confidence and spontaneity into the repressive and tradition-bound Calvinist tendency. He offered three resources for rejuvenating the culture: Ralph Waldo Emerson's transcendentalism, Walt Whitman's pantheism, and William James's pragmatic spirituality. Under these influences, he suggested, and inspired by our natural environment, the American attitude to life should turn away from the anthropocentric philosophical traditions of Europe and become centered on nature. A Californian he had recently met claimed that if European philosophers had lived among the mountains of western America, they would have developed quite different systems of belief.[2] A champion of James, Santayana took an empirical approach to artistic activity even while admiring scientific and mathematical thought. Great poets did not draw merely on their sensations; their imaginations, which were more profound than those of ordinary people, could be as orderly as those of astronomers.[3]

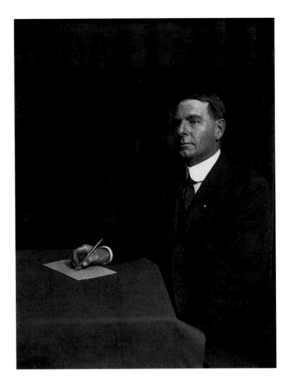

Fig. 1.1. Ansel Adams, *Charles Hitchcock Adams, San Francisco*, c. 1922, gelatin silver print

Perhaps Charles Adams was so avid for learning because he had been unable to complete his study of astronomy at Berkeley. After only two years, problems in the family lumber business had compelled him to leave the university. When the business collapsed in 1912, Charles became an insurance salesman, and then later was executive secretary for the Merchants' Exchange in San Francisco, all the while nurturing his interest in astronomy. He and Ansel visited the powerful Hooker 100-inch reflecting telescope, which came into use in 1919 at Lick Observatory at Mount Hamilton. New lens technology made the early 1920s a fruitful period for cosmologists and astronomers. Edwin Hubble discovered Cepheid variable stars while using the Hooker telescope at Lick Observatory between 1919 and 1924, thus providing evidence for the theory of the expanding universe.[4]

Charles Adams joined the Astronomical Society of the Pacific around 1920, and from 1925 to 1950 served as its secretary-treasurer, devoting the rest of his intellectual life to the encouragement of young astronomers (fig. 1.1). He wrote, "The study of astronomy, above all other sciences, tends to advance the ideals, the aspirations and the hopes of mankind. Its cultural value serves a mighty purpose, for it elevates the mind and thought of those who give heed to its teachings."[5] In 1923 he was appointed a director of the Astronomical Society of the Pacific, and wrote the secretary of the society in thanks: "Whatever I may be able to do I shall never feel that I have repaid the Society for the pleasure and instruction which the lectures and publications have given me and for the educational benefits which have accrued to my

son whose interest in the work of the Society has largely contributed to his taste for scientific thought and study."[6] In recognition of his contribution to the Astronomical Society of the Pacific, he was made a Fellow of the American Association for the Advancement of Science in 1931.

In the 1920s Ansel and Charles Adams shared a deep interest in the work of Arthur S. Eddington, president of the Royal Astronomical Society in Britain. They may at first have been attracted to Eddington's books on astronomy, *The Internal Constitution of Stars* (1926) and *Stars and Atoms* (1927), and then extended their interest to *The Nature of the Physical World* (1928), with its chapter on science and mysticism, and to *Science and the Unseen World* (1929). These later works considered the individual's direct apprehension of the spiritual ("intimate knowledge") to be just as valuable as the capacity to understand material reality with the help of scientific theories ("symbolic knowledge"). Eddington proposed that mystical experience could reveal, through our deepest emotional responses, indications of a reality that transcended the narrow limits of individual consciousness.[7] Such experience was possible because we interact with the environment, combining with the objective, measurable aspect of things a sense that we are subjectively apprehending something incommensurable: "God is conceived as an all-pervading force, which for rather academic reasons is not to be counted among forces belonging to physics. Nor does this pantheism awake in us feelings essentially different from those inspired by the physical world—the majesty of the infinitely great, the marvel of the infinitely little. The same feeling of wonder and humility which we feel in the contemplation of the stars and nebulae is offered as before; only a new name is written up over the altar. Religion does not depend on the substitution of the word 'God' for the word 'Nature.'"[8]

Reality consisted as much in feelings and moods excited by mystical contacts with nature as it did in our sense-impressions; in such moods we caught something of the true relation of the world to ourselves.[9] For Eddington, aspiring toward spiritual fulfillment and expressing oneself artistically were essentially the same. Both were based on a desire to touch, within the microcosm, a wellspring of intuitive insight into the macrocosm.

By the age of twelve, Ansel had attended a number of private schools, but a certain hyperactivity prevented his staying in any school for long. He was then showing some talent for playing the piano, having watched and listened to his mother at the instrument since he was very young. Henry Cowell, who later became a major avant-garde composer, gave him some lessons. The stepson of a neighbor, Cowell was already a prodigy at sixteen. The year after Ansel's piano lessons began, his father decided to buy him a season ticket to the Panama-Pacific International Exposition. At noon each day Ansel attended organ recitals performed at the Festival

Hall.[10] Over the next decade, three additional piano teachers encouraged him in his ambition to be a concert pianist.

During the early twenties Adams perfected his technique, tutored piano students, and was the "-an-" in the Milanvi Ensemble, the "Mil-" being Mildred Johnson, a violinist, and the "-vi" Vivienne Wall, an "impressionist dancer." With his father's help in 1923, he made the major purchase of a Mason and Hamlin grand piano. In early March that year, Adams attended a Paderewski concert in San Francisco, and almost certainly heard the pianist perform the "Moonlight" Sonata. Adams regarded Beethoven as the great poet of spiritual aspiration in music. In a letter to Virginia Best, his future wife, he applauded Beethoven's masterful ability to convey "a world of thought of the loftiest nature," bringing the hearer "so much closer to an understanding of the Great Mystery." Beethoven's music in particular offered Adams a profound and unified vision of the universe. In 1927, he gave Virginia a copy of Edward Carpenter's *Angel's Wings* (1898), a book of essays on artists including Wagner, Whitman, and Beethoven. According to Carpenter, the deeper the artist delved into his own psyche, the closer he came to identifying with the collective or universal soul, and the more significant his artistic contribution. For him, Beethoven had elevated the symphony and the sonata to unmatched heights of universality, reflected especially in the *Stimmung,* or profound mood, of the later sonatas. This was exemplified by the slight ambiguity, or lack of perfect resolution, in the last movement of the "Moonlight" Sonata, which Beethoven achieved by using a neutral chord of the diminished seventh, deliberately blurring the sense of key in the climax.[11]

In the months following Paderewski's concert, Adams began to relearn the piece. In November he expressed to Virginia a fresh appreciation of the sonata, writing that henceforth he would refer to it strictly as "Op. 27, No. 2, 'Sonate quasi une fantasia.' Moonlight? no—it is the infinite, thundering Sea. So clear and calm and pure is this great theme; so simple, yet so profound that it might reflect the voice of God."[12]

During this period, he regularly attended piano concerts in San Francisco performed by Benno Moiseiwitsch and Vladimir de Pachmann, who, along with Paderewski, were universally acclaimed for their interpretations of Beethoven, Bach, Mozart, Liszt, Schubert, and Chopin. Adams was now learning to perform these scores himself. Debussy, Ravel, and Palmgren interested him, and he greatly admired Scriabin and Mahler, but he was not particularly drawn to the modernist music of Ives, Hindemith, Stravinsky, and Schoenberg.[13] Unable to embrace the most avant-garde music now being composed in terms of pure musical sensation rather than of Romantic suggestion, he may have seen himself approaching an impasse in his musical career, condemned to a life of teaching piano and, at best, performing classical music.[14]

In 1916 the Adams family made their first summer trip to Yosemite Valley in the Sierra Nevada mountains of California. Ansel's serious mountain education began the next summer, 1917, when he returned to the valley alone. Francis Holman, a retired mining engineer and seasoned mountain traveler, took him on his first camping trip into the high country of the Sierra Nevada. During the next two summers he went alone to Yosemite, but during the rest of the year he also worked part-time as a darkroom assistant and delivery boy for Frank Dittman, who ran a photo-finishing service from his house on California Street near the Adams house in San Francisco. By 1918, he had learned basic photographic technique and was printing his own negatives at Dittman's in his spare time. Soon he was proficient and confident enough to produce photograph albums of his trips in the Sierra Nevada, an activity he continued for over twenty years. In the mountains of the Sierra Nevada, Adams experienced the kind of intimate knowledge of nature he and his father had already found in the stars. In 1923, he wrote to his future wife, "the most enlightened Astronomer will derive as much happiness and enjoyment on a forest path as Muir and Thoreau ever did;—perhaps more, for the harmony of law is more evident to him."[15]

In 1919, he joined the Sierra Club, and William E. Colby, the club's leader, soon gave him a summer job as custodian of the LeConte Memorial Lodge. This was the club's headquarters in Yosemite, named for Professor Joseph LeConte Sr., the scientist who was a friend of John Muir and a founding member of the club. For four years, the lodge provided Ansel with accommodation and gave club members a place where they could meet and study botanical specimens, books, maps, and Park Service and Sierra Club publications, as well as photograph albums of high-country trips made in previous years.

Adams made a lengthy trip with Frank Holman to Mount Clark and Merced Lake in June 1920. With another friend, he climbed Mount Clark, Red Peak, Gray Peak, Grizzly Peak, and Mount Conness to replace register scrolls left in metal tubes on the summits to record the ascents of club members. Adams compiled into an album twenty photographs that he made on this trip to the Merced peaks. He called the album "The Merced Group," and he presented it to the Sierra Club, signing it, "best wishes—Mr. Ansel Easton Adams—December 25th, 1920."[16]

In September 1921 Adams made a ten-day excursion to the Lyell Fork of the Merced River, and his report of the trip was published the following year in the *Sierra Club Bulletin,* together with a photograph, *View from Lyell Meadows, Lyell Fork of the Merced River, Yosemite National Park.* That summer he met Virginia Best, the young woman he would marry in 1928. Her father, Harry Cassie Best, a landscape painter, kept a studio home in Yosemite during the summer seasons, and sold his paintings and a few souvenir photographs locally. In the spring of 1923 Adams borrowed Frank Dittman's darkroom to make prints of some of his Yosemite subjects for sale at

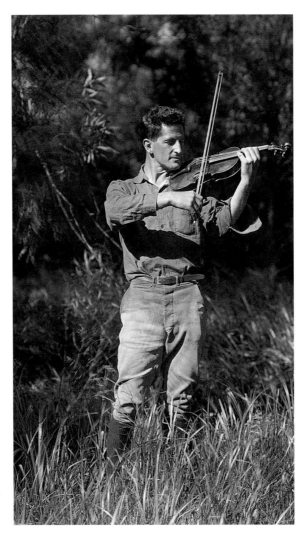

Fig. 1.2. Ansel Adams,
Cedric Wright, 1928,
gelatin silver print

Best's studio. In the summer, he traveled into the back country to Little Yosemite with Joseph Nisbet LeConte and his daughter Helen and son Joe.[17] LeConte Jr., explorer and topographer, and president of the Sierra Club from 1914 to 1916, was the childhood friend of Charles Adams.

In early July 1923 Adams and Frank Holman joined the annual high-country outing of the Sierra Club to Colby Mountain, Ten Lake Basin, Muir Gorge, and Pate Valley. On this trip Adams established what would be a lifelong friendship with Cedric Wright (fig. 1.2). Wright's father was Adams's father's attorney, and his uncle, William Wright, was head of Lick Observatory.[18] It was Wright who introduced Adams to the poetry of Walt Whitman and Edward Carpenter; in return, Adams taught Wright the basics of photography.[19] The two were like brothers, almost inseparable at home in San Francisco and Berkeley as well as on the trails of the Sierra Nevada.

Wright, thirteen years Adams's senior, had studied violin in Prague, Vienna, and Berlin. Both young men had been educated in the great composers of the nineteenth century. William James, whose work Adams and Wright were reading in the early 1920s, had affirmed that "not conceptual speech, but music rather, is the element through which we are best spoken to by mystical truth." The Canadian psychologist R. M. Bucke had written in 1879 that music provided direct access to the highest emotional states of human beings without any intellectual interference.[20] In *Cosmic Consciousness* (1901), he drew up a chart of the development of human faculties, the psychogenesis of humankind, in which he placed the musical sense above our moral nature and only one step removed from cosmic consciousness itself. In 1929, Cedric Wright was recommending J. W. N. Sullivan's masterful *Beethoven: His Spiritual Development* (1927). Sullivan began with the premise that art must be granted equal status with science and philosophy as a means of describing reality, and he proposed three categories of music: compositions that exist in aesthetic isolation as closed systems; program music with its recognizable associations; and "compositions which spring from a spiritual context and express spiritual experiences."[21] This last category, of which Beethoven was given as the model, served to stimulate emotional knowledge and enhance the development of the soul. Flashes of intuitive understanding that proceeded from one central overwhelming experience of the artist were typical of the mystic's unifying vision.

Adams had described himself in a letter to Virginia in 1922 as a liberalist, studying what he called the philosophic religions that were based on moral truths and a firm sense of personal quest.[22] In his teens he had been tutored by his aunt, Mary Bray, an admirer of the aggressive freethinker and agnostic Robert Green Ingersoll.[23] Ingersoll was a popular anticlerical orator and self-proclaimed American infidel. His message replaced blind faith in God with a pantheistic awe before the powers of nature: "A deity outside of nature exists in nothing, and is nothing. Nature embraces with infinite arms all matter and all force." Ingersoll's doctrine celebrated the laws of evolution and of the mental development of humankind, and of the unity in diversity of monism: "We do not say that we have discovered all...; we know of no end to the development of man. We cannot unravel the infinite complications of matter and force. The history of one monad is as unknown as that of the universe; one drop of water is as wonderful as all the seas; one leaf, as all the forests; and one grain of sand, as all the stars.[24]

William James wrote, "We all have some ear for this monistic music: it elevates and reassures. We all have at least the germ of mysticism in us." He saw the mystical event as a passive experience of nature, pantheistic and optimistic, in which the individual felt suddenly overwhelmed by a power greater than himself or herself and filled with sensations of "enlargement, union, and emancipation."[25] This was cosmic consciousness.

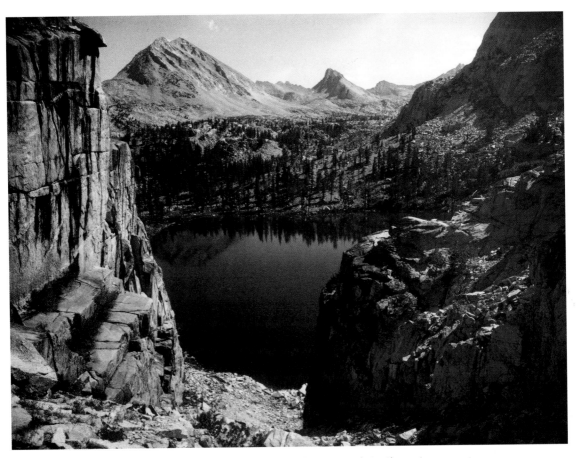

Fig. 1.3. Ansel Adams, *Marion Lake, Kings Canyon National Park*, c. 1925, gelatin silver print

The expression was first used by Edward Carpenter, an English ethical socialist, sex theorist, poet, and mystic of the turn of the century.[26] He developed the idea during his travels in 1890 to India and Ceylon and his investigations into Eastern religions. Cosmic, or universal, consciousness was Eastern; the concept of individual consciousness belonged to Western culture. Adams and Cedric Wright spent much time together in the 1920s reading not only Whitman's poetry but the poetry and prose of this English follower of Whitman.[27]

Carpenter believed the shattered cosmos of the post-Darwinian period could be reintegrated by music, art, and poetry as interpretations of experiences of the individual. They were active agents for epiphanic experience of the Universal One.[28] In contrast to the dualistic character of Western culture, Carpenter's philosophy was monist, implying a unity of all material and spiritual things in an Absolute One and the possibility of the self's ultimate union with that whole.[29] His *Towards Democracy* was a profound resource for Wright and Adams in its call for a return to the good relation of human being to human being, and of human beings to nature, which was, for Carpenter, a spiritual reunion. The "democracy" of his title meant a

sense of communality exemplifying the universal in humanity, the diversity in unity of souls.

Adams's personal conversion to Carpenter's monism occurred in August 1925 at Kings River Canyon while he was reading *Towards Democracy,* probably given to him by Cedric Wright. Ansel was accompanying Joseph N. LeConte Jr. who, following the death of his wife, decided to make a six-week trip into the Kings River Canyon region of the Sierra Nevada with his daughter and son in early June 1925, and invited Adams along again. The main reason for the trip was LeConte's desire to bury his wife's ashes and to erect a bronze plaque at Lake Marion, which he had named for her. That summer, the Sierra Club made a trip to the South and Middle Forks of the Kings River and the South Fork of the San Joaquin. Adams compiled an album of seventy-nine photographs for the participants of the Sierra Club outing, including seventeen taken of and around Lake Marion to memorialize Mrs. LeConte, one of which has survived in Adams's published work (fig. 1.3).[30]

In a letter filled with quotations from Carpenter's epic poem, Adams wrote to Virginia from the Kings River region, "The Carpenter book has established a real religion within me."[31] His mind had been shaken to its very foundation, but now he had a superhuman sense of new possibilities and new horizons. He felt suddenly in touch with a different aspect of his own personality, which he expressed in terms of a rebirth. His perception of unity was suddenly expanded and nature appeared as "the vast expression of ideas within the Cosmic mind." This echoes Carpenter's own conversion experience when, immediately after reading the *Bhagavad Gita,* he began writing *Towards Democracy,* filled with vitality and certainty that his life had at last taken root and begun to grow. R. M. Bucke had proposed four levels of human consciousness: perceptual; receptual; conceptual or self-conscious; and intuitional or cosmic.[32] Both Bucke and Carpenter took Whitman as the supreme example of this ultimate intuitional illumination. Now Adams aspired to join them.

Towards Democracy not only cemented the bond of friendship between Adams and Wright but also established the idealistic basis for the relationship between Adams and his fiancée. He quoted freely from Carpenter's poetry in his letters to her, entreating her to read specific poems that he felt held special significance for them at certain moments. In May 1926 he recommended that she read Whitman, Carpenter, P. D. Ouspensky, H. G. Wells, Havelock Ellis, and Santayana, but especially Carpenter's "O Joy Divine of Friends," a poem on the transcendent union that marriage is, the title of which they would later incise in the stone mantelpiece of their home.[33] The poem ends:

> *Not kisses only or embraces,*
> *Nor the sweet pain and passion of the flesh alone;*
> *But more, far more,*

To feel (ah joy!) the creature deep within
Touch on its mate, unite, and lie entranced
There, ages down, and ages long, in light,
Suffused, divine—where all these other pleasures
Fade but to symbols of that perfect union![34]

Such conjugality resolved individual personalities within the Absolute. A few months later Adams wrote to Virginia, quoting from another poem by Carpenter, "The rocks flow and the mountain shapes flow, and the forests swim over the lands like cloud-shadows." This idea of the continual transformation of all things, as Adams put it, "everything evolving into something beyond," became one of the cornerstones of Adams's philosophy of process.[35]

Cedric Wright also quoted Carpenter's *Towards Democracy* in an article about the Sierra Club summer outing of 1927. He expressed his admiration by dedicating the article to Carpenter on his eighty-third birthday.[36] In a style obviously modeled on Carpenter's, Wright claimed that the inspiration of the high mountains could elevate the condition of human beings through meditation and music performed in such a setting. This would assist in "the great process of change toward reality," the evolution toward absolute spirit that Carpenter wished for humankind. "Everything good is magnified and glorified through this mountain democracy." Direct experience of natural phenomena transported the individual from a merely scenic view into real intimacy with the subject, close up. Wright warned club members against falling in love with the "big mountain" and the "big tree," and recommended making intimate relationships with small subjects, taking "the pictures that have never been taken." These were the kinds of pictures Adams himself was just beginning to make.[37] An article by Adams, written to commemorate another Sierra Club outing, also combined quotations from Whitman with his own Carpenterian prose: "Space becomes intimate; the world of fixed dimensions fades into patterns of exquisite delicacy, and you mingle your being with the eternal quietude of stone."[38]

Charles Adams, a Master Freemason since the early 1890s, was also metaphysically inclined, believing the spiritual life to be just as real as that of the physical body: "Are not Mind, Consciousness, Character just as real as the physical parts of our being? We do not deny the reality of the hand, the foot, the working parts of our bodies which carry us through this world and do the bidding of that far vaster power emanating from the mental and spiritual sides of our nature.... The spiritual side of man, which controls and dictates his actions here, must live on after the call comes, subject perhaps to change, but preserving an individuality and a development through the experiences of this life."[39]

Ansel himself was drawn to the universal logic of P. D. Ouspensky, who presented a search for cosmic truth in terms of empirical science, appealing to the dawn-

ing sense of the astronomical sublime that father and son both felt so keenly.[40] In *Tertium Organum* (1923), Ouspensky wrote that the perception of certain natural phenomena could produce a revelatory experience in the beholder. "The change of seasons—the first snow, the awakening of spring, the summer days…, the aroma of autumn—awakes in us strange 'moods' which we ourselves do not understand. Sometimes these moods intensify, and become the sensation of a complete oneness with nature." Like Santayana, James, and Carpenter, he also insisted on the importance of intuitive, or emotional knowledge, the two paths to which were religion and art.[41] Of all the arts, music best expressed the "emotional tones of life," with poetry adding conceptual meaning to such expressions.

Adams first met A. R. Orage, the English literary critic and disciple of Ouspensky and G. I. Gurdjieff, at the home of the poet Witter Bynner in Santa Fe about 1928. Orage had been converted to the theosophical doctrine of the world-soul by reading Carpenter's *Towards Democracy* in the 1890s, and championed Carpenter and Whitman for having introduced Western readers to the "divine science of the East."[42] He lectured in America from 1923 to 1930, promoting Gurdjieff's teachings, and visited the American headquarters of the Theosophical Society at Point Loma near San Diego. Adams renewed contact with him when he made Orage's portrait in San Francisco, where he had come to conduct seminars at Berkeley and Stanford.[43] They discussed the potential of music to convey visual and emotional expression, and as an experiment Adams played a piano composition by one of his favorite composers, Alexander Scriabin's "Prelude, Op. 17, No. 3, in G-flat major," asking Orage to tell him what feelings and visual associations it suggested. Adams believed he was especially qualified to assess Orage's response because someone who had studied with the composer had showed him the correct way to interpret it.[44] Scriabin, whose synaesthetic symphony *Prometheus* (1910) attempted to unify the perceptions of the senses and the aspirations of the soul through music and colored light, was converted to theosophy by the painter Jean Delville in 1905.

Scriabin was known as an esoteric composer for his invention of the "mystical chord" (C, F-sharp, B-flat, E, A, D). According to him, this chord held the potential of every form of triad—major, minor, augmented, and diminished—its extreme range of dark and light sounds signifying the cosmic oneness of all nature, including the supernatural.[45] His compositions employed the immense tonal breadth of very large orchestras for intense emotional expression, but he also exploited the extended orchestral palette for its rendering of delicate detail. Scriabin's monistic belief in the ultimate cosmic reunion was manifested in his expressive range, from the most precise effects to the passionate crescendoes of symphonic works like *Le Poème divin* (1905) and *Le Poème de l'extase* (1909). In his notebooks of the period he wrote: "I want to create, create consciously. I want to ascend the summit.... I need the world. I am what my senses feel. And I create the world by these senses."[46]

Adams developed an interest in Scriabin's music as early as 1925, writing to Virginia that "tone in itself is spiritual and speaks spiritual messages," as exemplified in Beethoven and Scriabin. Paul Rosenfeld, whose *Musical Chronicle (1917–1923)* Adams received as a gift in 1925, had also written of Scriabin as radically simplifying the genre of the prelude for purposes of psychic transformation: "Through [the piano's] vibrations, life for an instant is made incandescent. It is as though much that has hitherto been shy and lonely experience has undergone a sudden change into something clarified and universal. It is as though performer and auditor have themselves been transformed into more sensitive instruments, and prepared to participate more graciously in the common experience."[47]

Awakened by the musician, the hearer became supersensitized to emotional intensities, through which he or she achieved a sense of spiritual union. In letters to Virginia in 1924–25, Adams's own language suggests the theosophical influence of Wright and Carpenter, as he refers to the color of the soul, commonplace things shining with the divine light, and art being nothing but the material expression of ideas. He goes so far as to claim spiritual reincarnation: "It is almost a rebirth; I sense another and much deeper personality within me.... New personalities, new outlooks, new possibilities, all crowding into my consciousness, and above all the nameless dread of having to continue under this life, and the dread also of separating myself from it. Can you understand what I mean?"[48]

In this period it is not an exaggeration to say that Adams was theosophically inclined.

In 1930 Cedric Wright forwarded a copy of one of Adams's poems to William E. Colby, secretary of the Sierra Club. To Colby, Adams appeared to be moving increasingly from music and art photography toward poetry and philosophy.[49] Adams had discovered poetry as one of the routes to intimate knowledge. He already felt himself an active participant in the music world of San Francisco, but it was Albert Bender (fig. 1.4), introduced to him by Wright in 1926, who opened to him the doors of dozens of writers in the San Francisco area, including Robinson Jeffers, Ina Coolbrith, Lincoln Steffens, Ella Young, Charles Erskine Scott Wood, and Sara Bard Field. When Adams traveled to Santa Fe in 1928, he took with him a copy of Jeffers's *Poems,* newly published by the Book Club of California, with a frontispiece portrait he had made of Jeffers. The writer Mary Austin was deeply impressed by it, and told him she considered Jeffers the greatest poet of his day, even greater perhaps than Milton. Jeffers's radically nature-centered lyrics set the insignificance of human beings against the magnificence of the nonhuman universe. He believed in a pantheism that he defined as "the certitude that the world, the universe, is one being,...one great life that includes all life and all things."[50] However, his religious pessimism, unlike that of William James and Carpenter, excluded human beings

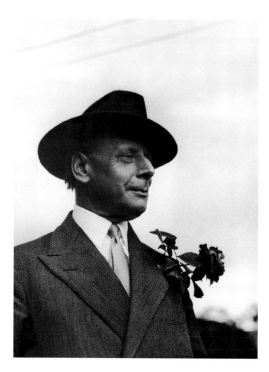

Fig. 1.4. Ansel Adams, *Albert Bender,*
c. 1930, gelatin silver print

from any hope of connection with God except through the external world. In an arts magazine in which some of Adams's own poems were published, Jeffers was described as the personification of California.[51] Adams quoted Jeffers's declaration, "this old world's end is the gate of a world fire-new," in a wall text at the opening exhibition of his San Francisco gallery in 1933.

Albert Bender introduced Adams to the poet Witter Bynner on a 1927 trip to New Mexico, although Adams and Wright had already been reading Bynner's poems. In April of the following year, Adams returned to Santa Fe to make photographs for the book *Taos Pueblo,* and he stayed in Bynner's house. A long friendship was established. Bynner found him a good companion and wrote a poem about him, "To a Guest Named Ansel."[52] Three of the very few poems Adams submitted for publication were published in the May 1929 issue of *Troubadour.*[53] He later referred to his poems generally as "spirit-writings."[54] One of them, "Tonquin Valley," was inspired by a Sierra Club trip he made to the Canadian Rockies the year before:

Immense summits of cold black stone
Pour streams of pallid ice to lonely valleys
Stern with the desolation of the North.

Frail winds stir stolid trees
Green-milky rivers trail the gorges
And clouds pile endlessly beyond the hills.

The old earth turns once more to bright Polaris
Awaiting the long, silent night
And the great white darkness.

In this special number devoted to the work of California poets, Adams's friend Ella Young was advisory editor, and Bender was applauded for his support of poets and artists in San Francisco. Among the contributors were Charles Erskine Scott Wood, Sara Bard Field, and John Varian. Varian's poem, "Body of God," was exuberantly theosophical in tone:

In the vastness of the Cosmic Night, and its eternities of resting
 Light is growing, and growing, and ever growing;
Yet, in the long end, the beautiful richness of that darkness will be
 as imponderable, and safe, and all-covering as ever.
Within the shoreless waters of space
Eternity is building its dream of Time and change,
Within the changeless universe cosmos ever moves and grows;
The atom is in its place, and the electron behind the atom.[55]

Two years later Adams's own poem commemorating Varian's passing, "To John Varian," was included in the July 1931 issue of *Troubadour*.

John Varian, born in Ireland, had been a friend of the Irish poet "AE" (George Russell), after whom he named his first son, Russell, and was a member, with "AE," of the Theosophical Society in Dublin until he and his wife Agnes emigrated to the United States in 1894. As members of the Irish Literary Revival in Dublin at the turn of the century, "AE," W. B. Yeats, James Cousins, and Ella Young embraced theosophy and comparative religion, partly in order to integrate Celtic mythology with other world beliefs. This provided a rich source of ritual for Irish Protestants outside the Catholic church, although Young seems to have been a Catholic. In 1914, the Varians moved to the town of Halcyon, near the dunes of Oceano in southern California, where they helped to lead a theosophical community. They reared three sons, two of whom, Russell and Sigurd, later became close to Adams through the Sierra Club. John Varian worked as a chiropractor and masseur in Arroyo Grande, at the office of Dr. William Dower. In 1903, together with Francia La Due, Dower founded the theosophical group at Halcyon that called itself the Temple of the People, which was quite separate from the American Theosophical Society at Point Loma led by Katherine Tingley.[56]

Established by Helena P. Blavatsky, the Ukrainian-born spiritual leader, Theosophy was a response to the conflict between science and religion in the late nineteenth century. She and her followers taught that the universe was composed not just of material properties but also of spirit and of the divine spark of consciousness, all

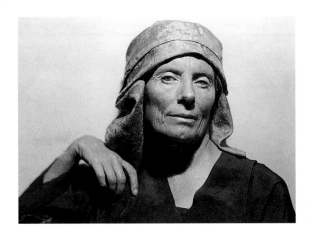

Fig. 1.5. Ansel Adams, *Ella Young*, 1929, gelatin silver print

three of which were in a continual process of evolution.[57] Transcendence of the human spirit in union with Carpenter's "All-One" was to be attained through a struggle to uncover one's true nature. This was, of course, the origin of the project of Ouspensky, Gurdjieff, and Orage. This kind of self-examination was undertaken by certain poets who associated themselves with the Halcyon Temple and lived as hermits on the dunes at Oceano in the 1920s, such as Hugo Seelig, whose poetry also appeared in the California Poets number of *Troubadour*. Seelig described some of his own poems written in the period 1925 to 1929 as "a progression from untenable separativeness toward what has been termed Cosmic Consciousness."[58]

Among composers attracted to this art colony and cooperative theosophical settlement at Halcyon was Adams's childhood tutor Henry Cowell. Cowell had been a friend of Russell Varian since 1911, when they were in their early teens. A piano sonata dedicated to Russell brought Cowell's creative ability to the attention of John Varian, who collaborated with him in setting to music John's creation-myth song cycle, "The Tides of Manannan," Manannan being the Irish Celtic sea-god symbolic of endless transformation. Music was perceived by theosophists as offering a special language for social communion and spiritual growth.

Three years after Varian's death, a collection of his poems was published with a brief note of remembrance, "To him, all nature, beneath its outer, static appearance, has fiery, pulsing beauty. The divinity of man, eternally incarnating and manifesting, is the overtone." One of the poems, "Sand Dunes," asked of the vast dunes of Oceano, "What majestic word are you speaking now, out of your ages and ages of growth . . . , talking to the light and reaching up to the sky?" Adams used "What Majestic Word" as the title of his *Portfolio Four* (1963), dedicated to Russell Varian.[59] His association with the Varian family during thirty years suggests that he was familiar with their beliefs and knew John's poetry well.

Another member of the Halcyon community was the Irish poet Ella Young (fig. 1.5). In the early 1920s she first came to the United States to visit with her

friends Molly and Padraic Colum in Connecticut. In the mid-1920s she lectured on Celtic mythology in Berkeley. By 1927 she and Adams had become friends, probably through Albert Bender, and she began to advise Adams on his poetry. Two unpublished poems he offered to her reveal his impulse to respond to her theosophical ideas. In one of them, he depicted his own consciousness as a distant faintly shining star in an immensely black universe.[60]

In 1928 Young took up residence in a cabin behind the Varians' house in Halcyon to devote herself to her poetry and to finishing her book *The Tangle-Coated Horse*. Adams and his wife, Virginia, drove to collect her for their trip together to Santa Fe in March 1929.[61] She inscribed a copy of *The Tangle-Coated Horse*, "To Ansel and Virginia who have adventured with me across the desert,...who know the American mountains to be magic-makers." On their return from Santa Fe, Ansel and Virginia received a letter from Ella welcoming them as new members of the Mountain Fellowship, and enclosing as a sacred token a handful of soil from the summit of Mount Shasta and the "Mantra of the Golden Fellowship of Mount Shasta":

I know that I am one with beauty,
And my comrades are one.
Let our souls be mountains.
Let our spirits be stars.
Let our hearts be worlds.[62]

In quoting her short poem Adams not only memorialized Ella Young but also summed up his own life's aspirations in the final words of his autobiography.

In 1933 an introductory number of a new monthly arts magazine, *Dune Forum,* was sent out to potential subscribers. A few issues were eventually published from the Oceano dunes near Halcyon. Its aim was to provide an opportunity for public discussions of philosophy, aesthetics, and economics, and to foster an understanding between scientists and artists, opening its pages "to scientist and mystic alike."[63] Many of the artists and writers who agreed to participate, including Mary Austin, Witter Bynner, Henry Cowell, Sara Bard Field, Robinson Jeffers, Mabel Dodge Luhan, Charles Erskine Scott Wood, and Ella Young, were well known by now to Adams. Hazel Dreis, a bookbinder who worked with Adams on his bound albums of photographs of Sierra Club outings in 1929 and 1930, and on *Taos Pueblo* (1930), his book with Mary Austin, had a house at Oceano, and was an original member of the editorial staff, as was Ella Young, referred to in an April 1934 editorial as the Godmother of *Dune Forum*.

Publishing mainly poetry, articles on philosophy, and critical appraisals of music, modern art, and architecture, *Dune Forum* also printed a number of Communist contributions, including one by Ella Winter, wife of the Carmel writer Lincoln Steffens, denouncing the failures of capitalism. But the magazine can be more generally

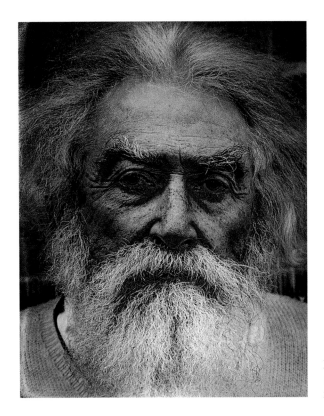

Fig. 1.6. Ansel Adams,
Charles Erskine Scott Wood,
1931, gelatin silver print

characterized as leaning toward technocracy, social credit, or new economics, as espoused by A. R. Orage, whose commitment to social credit was no less strong than his belief in Gurdjieff.[64] Unusually for a little magazine, the cover illustrations were mostly reproductions of photographs, by Chandler Weston, Brett Weston, Willard Van Dyke, Edward Weston, and Adams. Considering the radical tone of some of the articles, Adams's and Weston's association with *Dune Forum* may have been one reason they were labeled leftists by 1935.[65] John Varian, founder member of the Halcyon community, prophesied that a socialism that provided the basic human needs it promised would mark the beginning of a new religious evolution.

Dune Forum invited all political positions from anarchism to totalitarianism, a dialectic also established in Carpenter's writings. His *Civilisation: Its Cause and Cure* (1889) set out the supreme goals of human evolution toward the "cosmical man": the individual's return to a vitalist primitivism, and society's ultimate unification in "a complex human communism." Whitman, too, called for perfect personalities, as well as sociologies, to express the ideal of pure democracy.[66]

Many of Adams's friends in *Dune Forum* were indeed leftists, especially the poets Sara Bard Field and her companion Charles Erskine Scott Wood, hero of the left-wing magazine *New Masses* in the late 1920s (fig. 1.6), who were members of a committee seeking to obtain political asylum for Leon Trotsky.[67] Wood and Field

lived a bohemian life entertaining contemporary musicians, writers, and artists in Los Gatos, south of Cupertino, California. The famous Anglo-Welsh lecturer and novelist John Cowper Powys, photographed with Robinson Jeffers by Edward Weston around 1918, described Wood, his patron on the West Coast, as a Poseidon of the Pacific who physically resembled Walt Whitman.[68] Powys, whose most intensive period of lecturing on the West Coast occurred in 1922–23, had been closely connected with Wood and Field since 1917, when he was beginning to write *The Complex Vision* (1920). Adams would have recognized this book as one of philosophic religion; titles as different as "Philosophy of Communism" and "Souls and Bodies" had been considered for it.[69]

After a visit in 1930 to Wood and Field at their home, where Ella Young was then staying, Adams wrote to Sara Bard Field for counsel on what hope there might be for a life of the spirit in the face of a vast and seemingly meaningless universe. He was disturbed by the contradiction between that and the apparent underlying unity in the human construct of beauty.[70] To fight his sense of despair, he explained, he had turned to the poetry of Robinson Jeffers, whose philosophy of "inhumanism" interpreted the nonhuman world strictly on its own terms. But Field tried to dissuade Adams from reading too much Jeffers. She considered his mechanistic attitude, and his view that nature and society are opposed, to be destructive to the appreciation of a totally unifying life-force. Instead, she heartily recommended he read Matthew Arnold's poem "The Buried Life." It momentarily revealed the true course of human life in the underlying cosmic current flowing beneath the superficial eddying of a person's conceptual or self-conscious mind. Ignited in the poem by the voice of the loved one, this epiphany enables the protagonist to recognize the origin and destination of the stream of consciousness in himself, "The hills where his life rose, / And the sea where it goes."[71] As another example of our relation to the cosmic whole, Field offered an analogy used by the theosophical lecturer Manly Hall: humanity is to the cosmos as an electron is to the human body. Finally, she confided to Adams her own conviction that "all question about futility is stopped by the sheer wonder of this cosmos, . . . One is then neither proud or humble in relation to the universe, neither an optimist or a pessimist. He just *is.* He just goes with the tides he cannot measure, but which he senses and whose silver depths are at rare moments lighted for him by a moonlit beam of understanding." She urged him to preserve in his life "a most reverent examination of those things our finite minds can grasp," and to resolve to "let our lives increase those things, not destroy or weaken them." Adams expressed that same reverence more than fifty years later: "I believe in beauty. I believe in stones and water, air and soil, people and their future and their fate."[72]

Adams's desire for an expression of spirituality in his photographs was strong, but his agnostic upbringing predisposed him against the structures of conventional reli-

gion. In a film about his life, he later described his most profoundly felt work as "expressions without doctrine." This echoed a phrase used by A. R. Orage for the attainment of spiritual awareness, "metaphysics without theology."[73] Clearly, the theosophical approach to life appealed greatly to those who sought a spiritual interpretation of the universe, while being unwilling to commit themselves to any particular religion. True revelation would come ultimately through personal experience.

Adams's poem, "And Now the Vision," conveys mystical experience through immediate sensory contrasts, but with an unresolved poignancy:

> Now the wide vision, now the burst of light,
> Now the sweet recognition, now the song
> Shaking the depths of sky, rippling the sea,
>
> The trees stand in ecstasy, the evening clouds
> Move in stern phalanx before the lordly sun,
> Night comes as fires burn on the darkening hills.
>
> Praise God that I am here, Praise God for light
> And for the eloquent dark and all the myriad sounds
> Of earth and spirit and of the silent stars,
>
> And of the organ and the choir of strings,
> The symphony of souls and horns and harps.
> The prayer of lonely men, the meteor's flare,
>
> Dawn on the snow, noon on the clouds, night
> On the urgency of love. If truth be known
> No night would ever fall, no sun turn cold.[74]

"The clear realities of nature seen with the inner eye of the spirit," Adams wrote later, "reveal the ultimate echo of God." Perhaps he was remembering Santayana, who wrote that only "the eye of the spirit, in its virtual omniscience," perceived in nature the ultimate in the immediate.[75]

The year before Cedric Wright died, he asked his nurse to read to him from his copy of *Towards Democracy* and found that he had copied onto the back page of the book a poem Adams had written to Carpenter. The poems Adams had written, Wright told him in 1958, had been the keynotes of their lives.[76] In taking Adams back to those early years, Wright was reaffirming the ideals to which they had pledged themselves in their youth.

For ten years before Wright's death Adams tried to help him publish his lengthy manifesto on social reform and nature worship. In 1959, Adams begged the Sierra Club's executive director, David Brower, to publish *Words of the Earth*.[77] It was published posthumously in 1960 as the second in the series of Sierra Club exhibit-

format books. Adams's and Nancy Newhall's *This Is the American Earth* (1959) was the first, and the two are closely related. Adams remembered Wright as "an occupant of another world and a creator and messenger of beauty and mysteries," who gave him much-needed confidence and companionship in his formative period.[78] They shared their special Californian consciousness for more than thirty years.

From his earliest involvement with photography, Adams was interested in photographic publishing. He produced annual albums of photographs of the mountain expeditions of the Sierra Club beginning in 1923, and had sold several sets by the time he was introduced by Cedric Wright to Albert Bender in 1926. Bender, then treasurer to the Book Club of California, introduced Adams to the community of fine printers in San Francisco, greatly broadening Adams's knowledge of the printing world. In April 1927, Adams wrote to Virginia Best that he wanted to "try to combine the two processes of photography and the press." The following year, Adams joined Bender in becoming one of the thirty-one original members of the Roxburghe Club of San Francisco, a group of rare book collectors, printing enthusiasts, and professional printers, including Johnck and Seeger, Lawton Kennedy, and Edwin and Robert Grabhorn.[79] Each "printer-member" of the Roxburghe Club was exempt from dues but was expected to print annually at least one exemplar or keepsake for the membership. These ranged from small leaflets to whole books, such as T. J. Cobden-Sanderson's *The Book Beautiful*. In its first four years, four of the club meetings were held in Adams's San Francisco studio. Several of the keepsakes distributed in that period were produced by Adams in collaboration with various printers, either in the form of tipped-in photographs with hand-set text or as photoengravings from his negatives. The announcement for a meeting at Adams's studio in December 1930 read: "Mr. Adams will provide music during dinner. Afterwards Mr. Ernest Dawson...will address the club on that topic of perennially fresh interest to book men, *The Rare Book Market*."[80] In the spring of 1926 Bender offered Adams an opportunity to publish a portfolio of eighteen photographs, *Parmelian Prints of the High Sierras* (1927). Bender's friend Jean Chambers Moore, who published the portfolio, declined to describe the silver-gelatin prints as photographs, but coined the exotic term "parmelian," which she hoped would appeal more than "photographic" to collectors of fine books and prints.[81]

The trip Adams made later that year with Bender to Santa Fe to visit the writer Mary Austin stimulated his appetite for another such venture (fig. 1.7). Reviewers of her *Land of Little Rain* (1903), about the Southwest, ranked her work with that of John Muir and Henry David Thoreau. When Austin agreed to collaborate with Adams on a book of photographs and text about Taos Pueblo, Bender helped Adams to commission the San Francisco printer John Henry Nash to design the typography.[82] Nash was a fine printer in the William Morris tradition. He had established

Fig. 1.7. Ansel Adams, *Mary Austin*, c. 1929, gelatin silver print

himself in San Francisco in 1895, and had reached the apex of his career around 1920. He was much sought after for his Arts and Crafts style of printing. He also maintained the John Henry Nash Library of fine printing adjacent to his workshop at Sansome and Clay Streets, which Bender and Adams would have visited together as members of the Roxburghe Club.[83] In June 1928 Adams wrote to Austin that Nash had just returned from Europe with "unbounded enthusiasm" over the printing and design of their book.[84] But, by early 1930, conflicts developed over design and financing, and eventually the job of printing went to Edwin and Robert Grabhorn, also Roxburghers.[85]

Taos Pueblo was an unusual book for the period, because it was illustrated with actual photographic prints instead of photomechanical ink-reproductions. A prepublication notice by the Grabhorns printed in early 1930 announced that a unique feature of the book was that the same paper would be used for both prints and text.[86] With the average American income about thirteen hundred dollars a year, the price of *Taos Pueblo* (seventy-five dollars) made it as expensive as a new washing machine. Bender wrote to Adams in 1931, "I note the Stock Market reports only Ansel Adams photographs as the sole commodity that is on the rise." The financial

success of the book was a major factor in Adams's decision to abandon his aspiration to become a concert pianist, and to devote himself to a career as a serious photographer. A reviewer in a glossy magazine for art collectors called *Taos Pueblo* a splendid example of the modern art of fine bookmaking, its design "so wholly satisfactory to fastidious tastes as to stir the acquisitive instincts of many collectors."[87] Mary Austin was certainly delighted when she received her copy, agreeing with Adams that it was a superb piece of workmanship. However, she resisted the aestheticism of its Arts and Crafts production, insisting that she would like the book to receive as much credit for its content as for its quality as a piece of bookmaking.[88] Adams made the final selection of his photographs for *Taos Pueblo* only after having seen her text in October 1929; although passages can be found in Austin's text to which Adams's twelve images can be related, his photographs do not illustrate her text directly. She recommended that on future collaborations they should work more closely: "I think that we can do a little better next time by getting together on the subject before we begin."[89]

In 1925, the quest for authentic early cultures brought Carl Gustav Jung to Taos. By studying the religious rituals of Native American culture Jung hoped to gain a greater understanding of modern European-American society. He talked extensively with a chief of the pueblo, Antonio Mirabal. Sitting with him on the top story of one of the main house clusters of the pueblo, he learned how all life flowed from the mountain by way of the river, and how God, the sun, needed the assistance of his people in order for the stability of the cosmos to be maintained: "We are a people who live on the roof of the world; we are the sons of the Father Sun, and with our religion we daily help our father to go across the sky. We do this not only for ourselves, but for the whole world."[90] The multistoried structure of Taos Pueblo was founded on this need to witness the perpetuation of the natural order.

Mary Austin's *The American Rhythm* (1923) claimed that Southwest Native American chant was a basic component for the distinctive American poetic voice.[91] Tracing the development of American measure from the ax-stroke and pioneer's stride to the motions of horseback and locomotive, she saw the drum pulse of Native American ritual as contributing strongly to that evolution. Breaking her long journeys from California to the East Coast for lecture engagements, Austin occasionally stopped in New Mexico to visit her friend Mabel Dodge, whom she had known previously in New York. In 1918, Mary made a survey of the Native American pueblos in the company of Mabel, Tony Lujan, and the painter Gus Baumann, including the pueblo of Taos. Mabel and Tony lived nearby. In 1923 she traveled through southern Arizona and New Mexico collecting material for her book *Land of Journey's End* (1924), and decided to settle in Santa Fe.[92]

During the three-month visit by Ansel and Virginia Adams to Mary Austin in 1929, the three visited Mabel Dodge at her ranch, Los Gallos, in Taos. Mabel had

moved to New Mexico from New York in 1916 when an occultist, Lotus Dudley, told her that she had been chosen by the spirit world to be the bridge between Native American and white cultures. She had contributed in 1914 to Alfred Stieglitz's *Camera Work,* but had failed to persuade him to visit her in Taos. However, she did manage to bring members of his circle to her desert retreat.[93]

The painter Marsden Hartley had already been lured to New Mexico by Mabel Dodge in 1918. In 1921, in a collection of essays dedicated to Stieglitz, Hartley presented the Native American as "the one truly indigenous religionist and esthete of America." Mabel embraced this ideal by marrying Antonio Lujan, her former chauffeur, a Native American who cut a memorable figure in the Cadillac she bought for him, driving it at seventy miles an hour along the dusty New Mexico roads.[94] Nevertheless, it was Tony Lujan who went to the governor of Taos to plead the case for the book proposed by Adams and Austin. After an all-night meeting with the council, the governor finally decided to permit the pueblo to be photographed, but this may have been not so much a gesture of tolerance on his part as of thanks: Mary had wisely insisted that Mabel pay alimony to the estranged Taos wife whom Tony had abandoned for her.[95]

A Man of Taos (1930) portrays Tony Lujan acting the part described by Adams in a letter to Bender in 1929: "The Indians are really majestic, wearing as they do their blankets as Arabs" (fig. 1.8).[96] With chin raised slightly and half-closed eyes, he embodies Native American enigma. But *An Old Man of Taos* is its obverse in almost every way: If Tony Lujan wears a dark blanket, this tribal elder wears a white one; if the direction of Tony's gaze is indeterminate and mysterious, this old man looks directly at the camera, eagle-eyed, with a tight-lipped scowl, keeping the inviolate secrets of his culture to himself (fig. 1.9). This pride and defiance were noted by Austin: "Only Taos the proud, Taos the rebellious…holds its tribal integrity…. Their history is explicitly marked with revolt, rebellion and resistance to White aggression" (p. 4). But Robinson Jeffers saw the Native Americans slowly losing this pride in the face of an encroaching tide of tourism. In "New Mexico Mountain" (1932), he depicted the Corn Dance at Taos Pueblo as instigated solely by the old men of the tribe, and joined in by "a few shame-faced young men" who had to be cajoled into it by the elders.[97] Before his association with Mabel, Tony had been a member of both the Catholic church and the native Pueblo religion, but on embracing her lifestyle he seemed to have severed his ties with the religious culture of Taos. In spite of Mabel's avowed commitment to Native Americans, her marriage to Tony served only to fuel an already simmering power struggle within the pueblo.[98] If Adams felt his portrayal of Lujan as *A Man of Taos* was honest, reproducing it in subsequent books, Mabel Dodge Luhan chose not to reprint it in her memoir *Winter in Taos* (1935), perhaps because she recognized the depth of Tony's cultural conflict.

Fig. 1.8. Ansel Adams, *A Man of Taos* [*Tony Lujan, of Taos Pueblo, New Mexico*], 1930, gelatin silver print

Mabel was an emancipated woman whose sexually liberated behavior appeared outrageous to Mary's eyes; for her part, Mary was a formidable organizer of covert actions. In the 1970s Adams remembered Mary as commando, and Mabel as hunter.[99] His recognition of Mabel's ruthless approach to life was expressed in a letter he wrote to her when she published *The Edge of Taos Desert* (1937): "Not unlike you, when you first came to Taos, I am confronted with finding a real way of life and real vital simplicity. You found it, even though it required ruthless action and decision. …Your transition was effected in a mood of strength and inevitability, and it is going to help many another woman and man to 'take life by the talons' and carry it high."[100]

Fig. 1.9. Ansel Adams, *An Old Man of Taos*, c. 1929, gelatin silver print

Austin's ideal was epitomized by the Taos matriarch as a pillar of social stability. In the text of *Taos Pueblo*, she describes "the women going to and from the creek, dripping water jars poised on their heads" (p. 6). Adams was not unaware of such pictorial conventions, used by the painters of the region, as demonstrated in *A Girl of Taos* (plate 6).[101] The Southwest painters also depicted blanket-shrouded men of Taos, women baking bread, and other crafted details of the pueblo such as round adobe bread ovens, drying racks, and ladders. But *Winnowing Grain* also reflects the matriarchal aspect of Taos society that Austin describes in terms of "Mother-rule," alluding to J. J. Bachofen's concept of *Mutterrecht*, or "mother-right" as Edward Carpenter referred to it (fig. 1.10).[102] For Carpenter, as for Austin, matriarchy repre-

Fig. 1.10. Ansel Adams,
Winnowing Grain,
Taos Pueblo, New Mexico,
c. 1929, gelatin silver print

sented a primitive communism and a state of moral and social health long since undermined by modern capitalist society.

Drawing on classical myth, Bachofen and his followers knew Demeter, the earth mother, not only as the goddess of the harvest and the threshing-floor but as the founder of social order.[103] A woman with children was valued above all for her power of preserving the lifeline of a people. Matriarchy guaranteed the continuity of Pueblo civilization, and the clustered modular forms of Taos architecture themselves embodied the "Mother Hive."

In *North House, Taos Pueblo*, Adams presented the hive structure from one corner

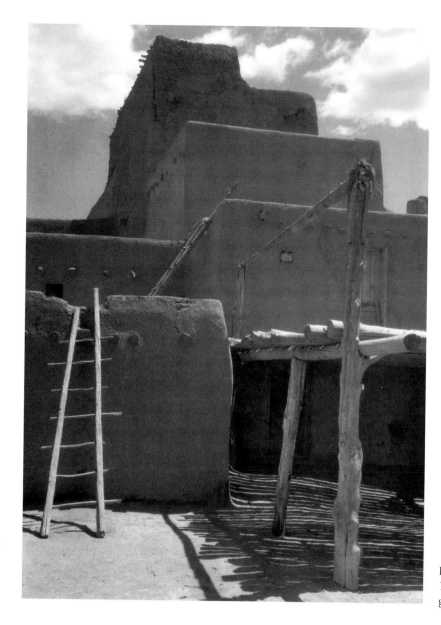

Fig. 1.11. Ansel Adams, *North House, Taos Pueblo, New Mexico*, c. 1929, gelatin silver print

to exploit five apparently regular stepped-back cubes with ladders, a drying frame casting the shadow of each rough-hewn pole (fig. 1.11). During the period of his work in Taos, Adams was exposed to the influence of post-Cubist abstraction in the work of Andrew Dasburg, whom Mabel Dodge had first invited to Taos in 1918, and John Marin, whom Adams met there in 1929. In both these artists' work, the geometric interpretation of form is applied to the landscape itself as well as to the modular blocks of the pueblos.[104]

On his visit in the spring of 1929, Adams may have read an article on modernism in New Mexico, suggesting a formal affinity between skyscrapers and the stacked

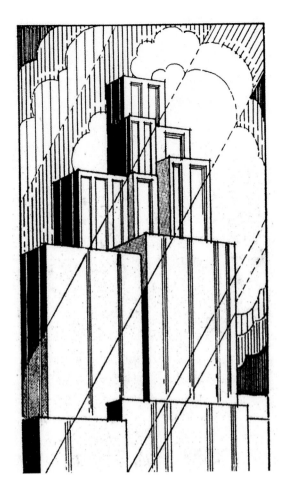

Fig. 1.12. Irving Parsons, "Original drawing showing kinship of skyscraper to pueblo," photoengraving from Withers Woolford, "Modernism in New Mexico," *New Mexico Highway Journal* 7:4, April 1929, 21

house-blocks of the Taos Native Americans: "In the arrangement of their houses, in decoration and in their other arts the people of the Pueblo Country express a modernity quite as startling as anything to be found in New York, Chicago or Paris. ... The pueblo of Taos is but one architectural example of the antiquity of the modern spirit." The article had two illustrations: an anonymous photograph of the North House in Taos, its geometric forms emphasized by the raking afternoon sun; and a line-drawing of a skyscraper, the stacked uppermost stories of which bring to mind the prismatic effect of forms and planes in the Taos structures (fig. 1.12). But Austin saw the geometric stack of adobe cubes as being more traditional than modernist: "The pyramidal house-heap was shaped out of tribal necessities" (p. 8). In 1920 the architect Rudolf Schindler wrote to his colleague Richard Neutra, later a friend of Edward Weston, that only the Pueblo adobes in America expressed a true organic feeling for the soil on which they stood.[105]

After intensive persuasion, Mabel Dodge Luhan (as she now called herself) succeeded in drawing D. H. Lawrence and his wife, Frieda, to Taos in 1922. She felt sure

he was the man to express the potential of Taos as the vital spark of a new world culture. Lawrence described Taos as "rather like one of the old monasteries. When you go there you feel something final. There is an arrival. The nodality still holds good." It was a growing point, a focus of life energy. Lawrence was in pursuit of the life force, represented in his essay "Pan in America" by a great tree: "Its raw earth-power and its raw sky-power, its resinous erectness and resistance, its sharpness of hissing needles and relentlessness of roots, all that goes to the primitive savageness of a pine tree, goes also to the strength of man."[106] He expressed the total integration of the tree with the Indian by describing how he warms himself at the fire in which the limbs of the tree are consumed, absorbing in this way the life of the tree into his own body. In *North House, Kiva Poles and Thunder Clouds*, the towering tree representing the aura of life is the one with which Mary Austin identifies Taos itself: "There it stands like . . . the fabled tree of its Creation legend, . . . a tree watered by hidden springs of whose waters our own sap is long unattainted" (plate 11, p. 5). By "unattainted" she meant, perhaps, that Western culture was too long untinted as well as unreached by this tradition of the "Red Man."

Despite Mary Austin's stated role on the title page of *Taos Pueblo* as "describer," her style is often poetic: Pueblo Mountain is a sleeping animal; aspens turn into tapestries and cottonwoods into nimbuses; Taos is the cosmic tree; the rounded hills are blanketed figures; and even the church is deep-rooted. Adams placed his version of the Ranchos de Taos church last in the book (fig. 1.13).[107] Concealed beneath the Cubist-realist composition crouches an animal form, grounded or earthed as the Sphinx. At least three versions of this subject were painted by Georgia O'Keeffe between 1929 and 1930, John Marin also painted it in 1930, and Paul Strand photographed it in 1931. These artists represented the church from the rear: by choosing not to show the ecclesiastical front entrance, they took the church out of its Christian context and de-Hispanicized it. The portrayal of Ranchos de Taos church in Adams's photographs and Austin's text also demonstrates this emphasis on the earthen nativeness of the adobe sanctuary. Adams wrote: "The building is not really large, but it appears immense. The forms are fully functional; the massive rear buttress and the secondary buttress to the left are organically related to the basic masses of adobe, and all together seem an outcropping of the earth rather than merely an object constructed upon it."[108] This one remaining Native American structure was in fact a Catholic church. Cultural survival was achieved through religious adaptation. The book's very title expresses this conflation of Indian and Hispanic cultures—one word being in the Native American language, the other being Spanish.[109]

By the time the book appeared, Adams had met Edward Weston through their mutual friend Bender. Weston had been aware of the quest for authentic culture in New Mexico since meeting D. H. Lawrence in the company of Dorothy Brett in Mexico in 1924. In 1930, when Adams made his portrait of Tony Lujan in San Fran-

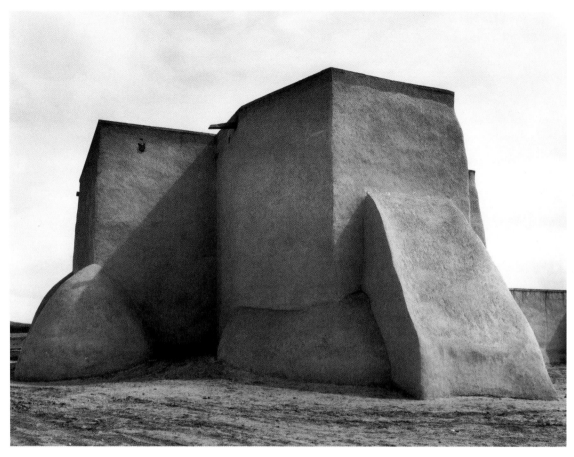

Fig. 1.13. Ansel Adams, *St. Francis Church, Ranchos de Taos, New Mexico*, c. 1929, gelatin silver print

cisco, Weston also photographed him on a spring visit to Carmel. Weston met Mabel and Tony in the company of Ella Young, whom he admired greatly for her intuitive sensitivity to his unconscious self.[110] In the spring of 1933 the Lujans visited Carmel again, this time with Dorothy Brett. At their invitation, Weston now made his pilgrimage to Taos, together with the photographers Sonya Noskowiak and Willard Van Dyke.

In the years 1929–33 Weston was deeply attracted to the writings of Hermann Keyserling, the Estonian count he described as his most congenial philosopher. Reading Keyserling had vitalized Weston's spirit: "The fallow soil in my depths, emotionally stirred, receptive, has been fertilized."[111] A friend of Jung and of Leo Frobenius, Keyserling was the founder of a school in Darmstadt that taught esoteric wisdom. His writings, translated into English in the 1920s, were all carefully read by Weston.[112] Although Keyserling knew members of the Luhan circle, he did not actually meet Lawrence, although we know he was keen to review *The Plumed Serpent* in 1930.[113] Lawrence thoroughly disapproved of Mabel Dodge Luhan's enthusiasm

for spiritual leaders like Gurdjieff and Orage, and was ambivalent about Dorothy Brett's similar interest in Keyserling. But, like Lawrence, Keyserling spent his life seeking to characterize the indigenous nature of regional cultures. For Keyserling, Puritan America's problem was that its psychic roots did not yet reach the rejuvenating depths of the pagan subconscious, as Catholic Europe's and Native America's did.[114] In 1941, referring to Weston's semimystical concept of the world and of himself in relation to it, Adams accurately associated him with the landscape mysticism of Keyserling.

Like Weston, Adams believed that the unique characteristics of a landscape, its weather, soil, wildflowers, and mountain peaks, were expressed in the psyche as well as in the physical appearance of a people.[115] Now Adams turned back to the peaks of the high Sierra. There in the mountains of California he would pursue his own goal of psychic integration with the landscape.

The High Mountain Experience

When Adams began accompanying the LeConte family on their summer trips in the high country above Yosemite in the early 1920s, Joseph Nisbet LeConte was already a High Sierra mountaineer of some forty years' experience, and a mountain photographer himself.[1] In 1925 and 1926, Adams accompanied the family to the Kings River Canyon, and his constant side trips for photographs made a lasting impression on them. He and LeConte climbed mountains and photographed together, and LeConte's daughter, Helen, recalled that Adams and her father had a close, friendly relationship, at least partly based on a shared passion for photography.[2] Adams's commemoration in 1925 of LeConte's late wife in his series of photographs of Marion Lake suggests that the mountain peaks of the Sierra Nevada, which were simply geological facts to many mountain explorers, were for Adams also tinged with mortality and mutability.

In a preface to J. N. LeConte's memoir, *A Summer of Travel in the High Sierra,* Adams described the spirit of turn-of-the-century Berkeley, where LeConte's circle lived and worked, as "Athenian" and a "vital center of the arts and sciences."[3] As Adams recalled in 1944, the scientific nature of LeConte's geographical explorations, measurements, and mapmaking in the High Sierra from the late 1880s through the 1920s was combined with his artistic sensitivity to the mountain experience. This made his photographic work a "creative, sympathetic statement" rather than a mere record of topography.[4]

In 1944 the Sierra Club published in four albums 143 photographs that LeConte made between 1896 and 1908. Titled "Photographs of the Sierra Nevada," the images were chosen from more than two thousand negatives made by LeConte and printed from the original glass plates by Adams, who kept them at his studio as a resource for the Sierra Club.[5] The subjects of LeConte's photographs covered the territory that he and Adams had followed on high-country trips in the mid-1920s: Nevada Fall in Yosemite, Mount Ritter and Banner Peak, Mount Abbott, the East Vidette, and the Grand Sentinel. Many of these mountain photographs showed a dramatic sense

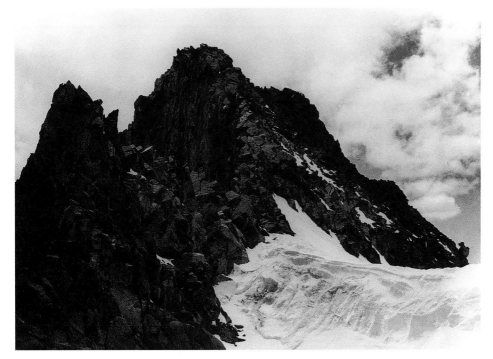

Fig. 2.1. J. N. LeConte, *Summit of Mount Lyell from the East Knife Edge* (6 June 1898), *Photographs of the Sierra Nevada by Joseph LeConte*, gelatin silver print, [San Francisco]: Sierra Club 1944, Album 2, no.2. Yosemite Museum, Yosemite National Park, California

of composition. *Summit of Mount Lyell from the East Knife Edge,* 6 June 1898 (fig. 2.1) presents the black massiveness of Mount Lyell asymmetrically half-draped with the whiteness of its glacier in a way similar to Adams's photographs in the late 1920s of Mount Ritter from Banner Peak (see fig. 2.5).

In the course of his extensive survey work to establish a north-south route along the crest of the High Sierra, LeConte was the first to survey Kings River Canyon in the southern Sierra Nevada in the 1880s. His work produced what Adams described as "the first functioning maps" of the region, which were still in use when the U. S. Geological Survey sent its official topographer, François Emile Matthes, to Yosemite in 1905–6.[6] In 1913, by which time dozens of theories as to the exact geological origin of Yosemite had been proposed, the Sierra Club and Secretary of the Interior Ray Lyman Wilbur (who was also president of Stanford University) asked the Survey to carry out a thorough study of the geological history of the Yosemite region and adjacent parts of the Sierra Nevada in order to determine to what extent Yosemite was a product of glacial action. Matthes was appointed as associate geologist and returned to conduct the survey of the region over a period of years.

Matthes's interpretation was shaped by the emerging discipline of geomorphology, the study of the origin and development of surface features of the earth, which he had studied at Harvard in 1904–5. His investigations took him into the

Merced and Tuolumne Basins, the San Joaquin Basin, and to Kings River Canyon and Sequoia National Park between 1916 and 1927. The later expeditions were undertaken when Adams was traveling in the same part of the Sierra with LeConte. In fact, Adams actually met Matthes in the mountains at least once on the trip he made with the LeContes in 1925. In addition, when Matthes returned to the high Sierra in 1935–36 to complete the geological survey of Sequoia National Park, Adams was deeply involved with the Sierra Club's high-country summer outings. When Matthes's writings on Yosemite and the High Sierra were published posthumously as *The Incomparable Valley* (1950), twenty-three photographs were contributed by Adams.[7]

In Adams's first summer at LeConte Lodge, the University of California Extension Division inaugurated a lecture series in honor of Joseph LeConte Sr., who had been first president of the University of California. In July 1919, Matthes delivered three lectures in the series, two of which, "The Origin of the Yosemite Valley as Indicated in the History of Its Waterfalls" and "The Origin of the Granite Domes of the Yosemite," were presented in the government pavilion. The other, "The Highest Ice Flood in the Yosemite Valley," was given outdoors on the 3,200-foot crest of Glacier Point overlooking the valley.[8] It is inconceivable that the young Ansel Adams, recently given the job of custodian of the LeConte Lodge in Yosemite, would not have been present.

For thirty years, Matthes's *Geologic History of the Yosemite Valley* was the standard work on the origins of the geological features of Yosemite and the Sierra.[9] It included photographs by J. N. LeConte, the local Yosemite photographers J. T. Boysen and A. C. Pillsbury, the expeditionary photographer J. K. Hillers, and the geologists Matthes, G. K. Gilbert, and F. C. Calkins. Matthes began by explaining the two main theories of the origin of the valley: the catastrophe theory, proposed by J. D. Whitney, that the floor of the valley had dropped out in a violent earthquake, and the uniformitarian glacial theory, adopted by John Muir, that the valley had been created by glaciers flowing from the crest of the Sierra range. In Matthes's opinion Muir had been correct.

The hypotheses on which Muir and Matthes based their investigations into the creation of Yosemite originated in the nineteenth century with Sir Charles Lyell. Lyell's uniformitarian geological theory proposed a slow, self-sustaining continuity of change over aeons against the prevailing theory of catastrophism, which held that geologic time had been initiated by the hand of the Creator and remained subject to divine intervention. Lyell's idea was based on the cycle of events in nature.[10] His notion of the unlimited age of the earth, with its distant and unreachable moment of creation, aroused a sense of the geological infinite that was comparable to that of the astronomical infinite that Edwin Hubble would excite a century later. The shock of realization of the immensity of geological time fueled the sublime

view of mountains, especially in relation to peaks where the evidence of mountain transformation by glacier action was also being discovered by Louis Agassiz, James Forbes, and John Tyndall. Stimulated by Lyell's cyclical change theory and accepting Darwin's evolutionism, the poet Alfred Tennyson attempted to escape the mechanical implications of random variation with a concept of spiritual evolution. In one of the poems from his long work *In Memoriam* (1850), he expressed a sense of cosmic process:[11]

> *There rolls the deep where grew the tree.*
> *O earth, what changes thou hast seen!*
> *There where the long street roars, hath been*
> *The stillness of the central sea.*
>
> *The hills are shadows, and they flow*
> *From form to form, and nothing stands;*
> *They melt like mist, the solid lands,*
> *Like clouds they shape themselves and go.*[12]

Adams often quoted Edward Carpenter's similar lines: "The rocks flow and the mountain shapes flow, and the forests flow over the land like cloud-shadows."[13]

In California, Lyell's uniformitarianism stimulated the thinking of Joseph LeConte Sr., then professor of geology and natural history at the newly founded University of California at Berkeley. LeConte's notion of the transmutation of species, derived from Lamarck and Darwin, led him to believe, however, that new forms resulted from the residue left by each cycle of geological and organic life. This was LeConte's Law of Circulation, first published in 1871, which combined uniformitarian with evolutionary thinking. The formation, action, gradual disintegration, and reconstitution of glaciers exemplified this theory. In his *Elements of Geology* (1877), which criticized Lyell for his lack of attention to North American phenomena, LeConte focused on Yosemite as a demonstration of his own thesis of evolutionary geology. In 1875, taking a group of colleagues and students on a trip through the High Sierra and Yosemite Valley, he had been particularly intrigued by the fact that the granite of the region fractured either perpendicularly or concentrically. The rock forms of the Sierra Nevada were based either on the curve or on the straight line. Half Dome, he pointed out, perfectly demonstrated both tendencies.[14]

John Muir, who had first met LeConte in 1870, wrote to him in 1871 with his account of the deformation of the Sierras by glaciers, with sketches to illustrate his points. LeConte had already seen the evidence for himself, but with Muir's help he developed his ideas in an article "On Some of the Ancient Glaciers of the Sierras" (1873).[15] Muir's acceptance of LeConte's Law of Circulation is evident from his own writings on "glacial denudation" (1874), which describe the cyclical processes of

water: evaporation from the sea, transport through cloud, crystallization into snow, compaction through thaw and frost into ice, and slow descent back towards the sea.

Muir's periodical essays, "Studies in the Sierra," presented the first detailed exposition of these forces, and served as the foundation for Matthes's geological history.[16] In studying the glacial nature of the Sierra range, Muir also discovered that the granite of which it was composed was "all one piece," that the range itself was a single piece of rock. He came to this realization after comparing the shapes of the great canyons of Yosemite, Tuolumne, Kings River, and Merced and the character of their granites.[17] "Studies in the Sierra" were reprinted in the Sierra Club Bulletin from 1915 to 1921, and would have been obvious reading matter for Adams in 1919, then starting his summer job in Yosemite.

Matthes decided that it was the structure of joints in Yosemite rocks that determined their form; for example, the oblique master joints of Yosemite's bedrock produced the successive diagonal peaks of the Three Brothers.[18] Particularly in Yosemite, where the opposing valley walls are clearly visible, the overwhelming presence of this phenomenon made the appearance of the rock forms diagonal, triangular, and pyramidal, a formal characteristic that deeply impressed Adams from his youth. When Matthes finished his survey of the area of Sequoia National Park in 1936 and was faced with the task of writing his report, he decided that visitors and park staff would be better served by albums of annotated photographs.[19]

The following year, Adams was asked by Walter A. Starr, a director of the Sierra Club, to consider producing a portfolio of photographs that would eventually result in the book *Sierra Nevada: The John Muir Trail* (1938). Adams's understanding of the geomorphology of the region is reflected in his description of the Sierra Nevada in the foreword as "a tilted block of the earth's crust...dominantly granitic," eroded over millennia first by rivers and then by glaciers of the ice age to reveal "a landscape of extraordinary purity and simplicity, vigor and grandeur." The role of the glaciers had been to sweep away aeons of inessential rubble and to bring to light the original landforms of a geological Eden, which he described in 1938 as the heart of the glaciated granite country.[20] Perhaps one reason why Adams was later so outraged by the blasting that was preliminary to building a road near Tenaya Lake in 1958 was that the glacially polished rock there showed the resistance of granite to glacial degradation. It was an integral mass of stone, without natural lines of weakness or fracturing, and it symbolized the wholeness of the Sierra Nevada.

Glaciers are the prime force responsible for the shape of the Sierra Nevada, and the study of them was very important to the members of the Sierra Club and other mountaineering organizations. Qualifying for membership in the American Alpine Club in 1907 required the applicant to have previously studied glaciology. In the Sierra Club Matthes continued as head of a committee on glaciology through the 1930s, giving public talks on the glacial origins of various geological formations.

Park educators, prizing the glaciers in the High Sierra, directed hikers to the Lyell Base Camp, from which they could "peer over the divide [at Donohue Pass] toward the spectacular Mount Ritter group." From this view of the Lyell Glacier they would obtain "the best conception of the living ice mass."[21]

Since 1787, when Horace Bénédict de Saussure ascended Mont Blanc, the Alps had been climbed primarily for scientific exploration. John Tyndall was among many nineteenth-century British scientists who saw the high Alps as a perfect demonstration of general physical laws, from glacier formation to the structure of a snowflake.[22] During this period, those who climbed for scientific research were joined by those who climbed for moral improvement. The aesthetic and moral appreciation of mountains affirmed by John Ruskin in his *Modern Painters* IV (1856) may have indirectly stimulated the mountaineering movement in Britain, but Leslie Stephen, whose approach to mountains was one of sheer muscular contact, directly opposed such attitudes. Stephen believed that only those who had personal experience of climbing the peaks were qualified to describe the qualities of mountains. Stephen's fellow climbers in the Alpine Club in London rejected as sentimental Ruskin's claim that a profound understanding of a mountain could be had by contemplation of the sacred mountain landscape from a distance.[23]

As custodian of the LeConte Lodge, where the Sierra Club kept a library, Adams received an informal education not only in mountaineering but also in the tradition of mountain writing. Between 1928 and 1936 he contributed nine reviews to the *Sierra Club Bulletin*. The first, a review of *The Englishman in the Alps* (1927) by Arnold Lunn, demonstrated wide knowledge of mountaineering literature. He noted appreciatively selections from Tyndall, Mummery, Conway, Whymper, Stephen, and Ruskin, which were a mixture of scientific description, adventure narrative, and aesthetic evangelism. He suggested that the term "Alps" might be applied also to the Himalaya, the Caucasus, and the High Sierra, all possessing "the same essential beauty and grandeur obvious to all who love the everlasting hills." Love of the mountains was a relatively recent development in the history of humankind, but "a deeper and deeper esthetic appreciation is revealed as time goes on."[24]

A close relationship between members of the Alpine Club in London and the Sierra Club had developed in 1906 after the San Francisco earthquake, when Edward Whymper, famed author of *Scrambles among the Alps in the Years 1860–1869* (1871) and president of the Alpine Club, wrote to the Sierra Club secretary, William E. Colby, offering to replace copies of his own books and issues of the *Alpine Club Journal* that had been destroyed. Adams's photographs appeared in the *Journal* in 1934, illustrating an article about the Sierra by Francis P. Farquhar, and also in R. L. G. Irving's *The Romance of Mountaineering* in 1935, in which a passage from Muir's *The Mountains of California* (1874) describing the peaks of the Merced Group was illustrated with Adams's *Snow Banners of the Sierra Nevada*.[25] In 1938, Adams sent the

Alpine Club a presentation copy of his *Sierra Nevada: The John Muir Trail,* with a letter indicating that the book was intended as an interpretation of the Sierra through photography, and "to further the work of Conservation of our finest American scenery." [26]

The Sierra Nevada range had already been perceived in a mountaineering context as early as 1861. Thomas Starr King had written that neither the Alps nor the Andes was a match for the majestic rocks of the Sierra Nevada; only "the awful gorges of the Himalaya" exceeded the tremendous height of the Sierra. In David Starr-Jordan's *California and Californians, and the Alps of the King-Kern Divide* (1903), illustrated with photographs by J. N. LeConte and owned by Adams, the Sierran peaks were compared favorably with those of the Swiss Alps: "The high Sierras, the huge crests at the head of the Kings, Kern, Kaweah, and San Joaquin rivers, are Alps indeed, not lower than the grandest of those in Europe, and scarcely inferior in magnificence." [27] Many Californian alpinists went so far as to wear Tyrolean-style hats on early Sierra Club high-country outings. [28]

In the 1850s and 1860s, photographers such as Edouard Baldus, Friedrich Martens, and the Bisson Frères brought back impressive panoramic photographs of the French Alps, but it was not until the late 1880s that the highest ambitions of alpine photography were achieved by Vittorio Sella. In the early 1920s, thirty-one photographs by Sella, made between 1884 and 1909, were given to the Sierra Club in memory of one of its early members, Frederick H. Morley. [29] Sella was an Italian mountaineer who became famous for the photographs he brought back from an ascent of the Himalayan peak K2 with the Duke of Abruzzi and D. W. Freshfield in 1909. Adams's friend and Sierra Club associate, David Brower, later recalled that most of these photographs were kept in a trunk at the Sierra Club headquarters in San Francisco, and that Adams, who mounted frequent exhibitions of photographs in these rooms, was familiar with them, and that he had probably seen them several years before he produced his own portfolio of mountain pictures, *Parmelian Prints of the High Sierras,* in 1927. [30] The photographs held at the Sierra Club offices included a four-part panorama of Everest, and subjects in the Alps, the Himalaya, Alaska, Africa, and the Caucasus, mostly 16 × 20 inches in size. Primarily studies of individual peaks, the aesthetic is generally one of high contrast, with snow-covered mountain forms set against dark gray or black skies. Sella also often used a telephoto lens to enhance the impact of a single peak centered in the frame (fig. 2.2).

Adams's appreciation of Sella's photographs, written in 1946, conveyed the depth of feeling that he believed mountain subjects were capable of expressing. Although most expedition photographs did not rise above the factual record, Sella's artistic sensitivity, insight, and response transfigured his mountain subjects by a concentrated interpretation. The immensity of Sella's alpine subjects, together with the photogra-

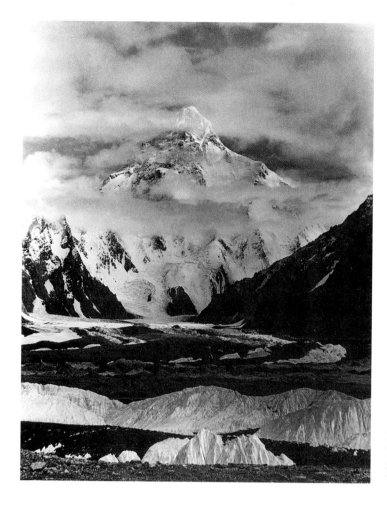

Fig. 2.2. Vittorio Sella, "K2 from Baltoro Glacier," no. 248, 1909, gelatin silver print. Bancroft Library, University of California, Berkeley

pher's subjective expression, moved the spectator to "a definitely religious awe."[31] The qualities of depth and atmospheric effect in Sella's pictures gave the viewer a strong sense of spatial triangulation with regard to the mountain peak. The real impression of the magnitude, distance, and shape of the object created "the essence of experience which finds a spiritual response" in the viewer.

In the summer of 1920, Adams took the sculptor William Zorach "scrambling" on Grizzly Peak in Yosemite, the near-disastrous result of which left Adams chastened but undaunted.[32] That summer, Adams also made his first long trip into the High Sierra (Merced Lake, Mount Clark, and the wilderness east of the Merced Range) in the company of Frank Holman, the Yosemite guide who initiated him into the rigors of serious mountaineering. By this time he was already taking his large-format Graflex camera on the shorter trips into the high country, and developing and printing his negatives in Yosemite. In September 1921, on another trip with Frank Holman, he climbed Rodgers Peak and planned to ascend Florence, Electra, and Lyell peaks. By the late 1940s, standing on a summit overlooking a view of a

thousand square miles of Sierran peaks, he could honestly assert that there was not a single mountain in sight that he had not climbed.[33]

On July 11, 1934, members of the Sierra Club outing in the High Sierra made the first ascent from their Lyell Base Camp of "the most spectacular and beautiful peak in sight," standing between Electra Peak and Foerster Peak and overlooking the Lyell Fork of the Merced River.[34] They unofficially named it "Mount Ansel Adams," in appreciation of his leadership and his photography. Adams had first attempted to climb it himself in 1921, and the photograph he made then was reproduced in the *Sierra Club Bulletin* the following year.

Adams contributed a few short articles to the *Sierra Club Bulletin* about his various climbs in the High Sierra in the early 1920s, and regular reports of the activities at LeConte Lodge.[35] In 1926 William F. Badé, Muir's literary executor, relinquished the editorship of the *Bulletin*. His successor, Francis P. Farquhar, a serious mountain climber, made the *Bulletin* into the most highly regarded mountaineering journal in the country during the next twenty years. In Farquhar's first year, six Adams photographs were reproduced, and in the subsequent decade Adams averaged ten photographs in each spring's issue of the *Bulletin,* usually images made on the previous summer's Sierra Club high-country outing. Farquhar also began the practice of printing frontispieces in photogravure for the annual volumes, including Adams's photographs *The Black Kaweah* (1928), *Mount Robson* (1929), and *Half Dome, Yosemite,* now known as *Monolith, The Face of Half Dome* (1931). Each of these mountains is formidable. Just a few years before Adams photographed the Black Kaweah, James Hutchinson referred to it as "sheer, treacherous, and unclimbed"; Mount Robson, to which the Sierra Club had traveled for its 1928 summer outing with Adams as official photographer, was (at 12,972 feet) the highest peak in the Canadian Rockies; and Half Dome, although it had been surmounted from the back as early as 1875 by the use of cables, was from the valley floor still an unscalable wall.[36]

In the spring of 1926, shortly after Cedric Wright introduced them, Albert Bender suggested to Adams that he offer for sale a portfolio of his mountain pictures, produced to the high standards of presentation expected by collectors of fine prints. The portfolio of eighteen images was titled *Parmelian Prints of the High Sierras* (1927). Thirteen of these images, including the two made at Marion Lake commemorating Mrs. LeConte, were made on trips into the eastern Sierra and to the southern Kings River region between 1923 and 1926, the years of Adams's mountain trips with the LeConte family. Reviewing it in 1928 in the *Sierra Club Bulletin,* LeConte praised the technical virtuosity of the photographs, "the fact that they are the handiwork of Ansel Adams is sufficient to guarantee their artistic perfection."[37] Adams's gift for composition and his skill with the telephoto lens, giving distant subjects "the appearance of a 'close-up,'" presented the Sierra Nevada "in a more

pictorial sense than by literal representation." LeConte appreciated that Adams was making pictures rather than topographic records, and that he was employing all the artistic skills at his disposal: framing with tree boughs, dividing the frame with the antirecessive device of a pine trunk or a screen of trees in silhouette, the occasional use of the soft-focus lens and fine parchment-style photographic paper, and "the high quality of…presswork and binding, which alone would place the album in the 'fine book' class."

A notice in Adams's 1925 album for the Sierra Club's annual outing had earlier invited participants to visit his home to see other "Photographs of the High Sierra" by appointment. But on the title page of his 1927 album his professional status was clearly indicated with a price list, a business logo, and a notice that Parmelian prints could be provided on parchment, presented in a folder.[38] Adams now proposed himself to the community as a professional mountain photographer.

By 1926, when Bender first suggested the idea of a mountain portfolio, Adams already had eleven of the eighteen images that would make up the set, and he set out in search of additional subjects. Until 1927 all the photographs he had selected for the portfolio were of the high country or looking out over it from Glacier Point. He had only one image of a landscape feature situated in Yosemite Valley itself—the immense, towering form of El Capitan. But on the opposite side of the valley stood Half Dome, whose shadowed lichen-stained face would provide a dark complement to the light rock of El Capitan. Between them they made up a cosmic whole.

Half Dome gives the impression of a huge hemisphere of rock. Matthes had noted, however, that a study of its profile and rear side showed it to be "a narrow, elongated rock mass, the steep front and rear sides of which are essentially parallel."[39] It was, in effect, much more a vertical monolith than it appeared from the floor of the valley. Adams made a winter climb up LeConte Gully toward Half Dome with his friends Cedric Wright, Charles Michael, Arnold Williams, and Virginia Best in April 1927. They climbed the west shoulder of Half Dome to a high granite shelf known as the Diving Board, exactly halfway up the full height of Half Dome's cliff-face. From here, only its side confronted them. Adams was prepared to wait more than an hour for the sun to move so that he could capture on film "the solemn effect of half sunlight and half shadow." On the first exposure he used the yellow filter prescribed for high mountain work, but then he decided to experiment to see whether the Wratten 29 filter would render Half Dome as the "brooding form" he envisioned, and would "reveal the monolith" (fig. 2.3).[40] Opposite the cliff and halfway to the top, the ground glass gave a view as close as one could get to the physical experience of climbing the sheer rock-face. The slight perspective distortion of the extreme oblique view compressed the Dome into a vertical tower, emphasized by the line of shadow in the center. That *Monolith* carries subtle connotations of mortality is suggested by a letter from his friend Sara Bard Field, to whom

Fig. 2.3. Ansel Adams, *Monolith, The Face of Half Dome, Yosemite Valley*, 1927, gelatin silver print

he sent a print shortly after he made it. She wrote back, "from such a rock as this must Sappho have taken her legendary leap to Death."[41] In combining the close-up texture of the cliff-face with a fragment of the Sierran panorama that included the distant Tenaya Peak, Adams conflated in a single image Yosemite Valley with the High Sierra. Between the foreground rock ledge with pine tree and the distant landscape, Half Dome stands like a great headstone, symbol of the insurmountable fact of mountain experience.[42]

Outside the ranks of the Sierra Club, mountain photography was not a genre to which many photographers in the 1920s, particularly pictorialists, were willing to

commit themselves, as articles in the photographic press testified. One writer lamented the lack of mountain peaks as pictorial subjects, despite "the appeal of the mountain, infinite with its gigantic rocks and ledges relieved by swirling cloud or drifting mist; its majestic course of erosion or the delicate carvings of ice-scratches, expanses of summit tundra, and wind-stunted and twisted trees." Another article acknowledged the potential of the mountain subject, but warned that success would be achieved only by a photographer with considerable personal experience who "must be at heart a mountain-climber."[43] There was, however, a genuine enthusiasm among mountaineers for using the straight photographic style with its rendering of accurate detail.

The English writer Arthur Gardner was one of its first proponents in *The Art and Sport of Alpine Photography* (1927). Gardner advocated two main approaches: the wide landscape and the "mountain portrait." As with human portraiture, he remarked, success with the mountain subject was possible only with "patience, knowledge and intimate study of the individual character." It followed that the best mountain photographer would also be a climber, although this was not absolutely essential. But in order to produce a fine mountain portrait it was necessary to choose a prominent peak with a distinguished shape, preferably one symmetrically triangular or pyramid-shaped.[44] In *Sierra Nevada: The John Muir Trail,* Adams, too, often took the most triangular view of the mountain, especially in *Banner Peak and Thousand Island Lake* (plate 7), *Arrow Peak from Cartridge Pass* (plate 31), *Mount Pinchot* (plate 32), and *Rae Lakes* (plate 34). Gardner also recommended using trees, rocks, and streams as foils for the enhancement of the view, a device Adams had used since the late 1920s in the photographs taken on Sierra Club outings, often accomplished with a telephoto lens. Good examples are to be found in two photographs of 1927 that Adams included in *Parmelian Prints: Mount Galen Clark* and *On the Heights* (fig. 2.4).

Later in his career, Adams quoted to Nancy Newhall the final paragraph from *Adventures of a Mountaineer* (1940) by the English mountain photographer Frank Smythe. He told her it was so satisfying that he wished he had written it himself: "Nature is honest, there is no meanness in her composition, she has no time for fools, there is no place in her code for weaklings and degenerates. Out of her strength we gather our own strength. And it is good to be strong, to be able to endure, not as a brute beast, but as a thinking man imbued with the spirit of a great ideal." The undiluted, physical experience of nature, testing the mountaineer's resources to the limit, had a power of refinement, drawing out the highest expression of the individual as an intelligent and moral being. In 1929, Smythe had written that "the religion of the mountain is...a leaning towards a power of infinite wisdom. Thoughts, music, the things we call inspiration spring from the mysterious reservoirs of Nature."[45]

Fig. 2.4. Ansel Adams, *On the Heights, Yosemite National Park*, 1927, gelatin silver print

Smythe wrote and largely illustrated with his own photographs twenty-seven books between 1929, two years after beginning his climbing career, and his death in 1949. With three Everest expeditions to his credit, and as a technically proficient photographer, Smythe was well qualified to publish books of his alpine photographs, as well as his writings on mountain photography. *The Mountain Scene* (1937), with seventy-eight of his photographs printed in gravure, was clearly intended as a large-format picture-book. Prefaced with a short technical essay, the pictures were divided into geographical sections, each accompanied by an extended caption that ranged from the narrative to the mystical: "In the still frosty air, when there is not a single breath of wind to send the feathery crystals of snow pouring like salt from the branches, the ear strains itself but discovers only silence—a silence charged with the vital forces of the Universe, visible and invisible.[46] Adams was probably familiar with this book. He would have appreciated its pantheistic spirit, so similar to that which he admired in the works of Edward Carpenter.

Since the 1880s, mountaineers in California had been searching for a route for a trail along the north-south crest of the Sierra Nevada. J. N. LeConte's contemporary Theodore Solomons, a charter member of the Sierra Club, established portions of the route in 1894 and 1895, naming the peaks of the Evolution Group (Mounts Darwin, Huxley, Haeckel, Spencer, Wallace, and Fiske) along the way.[47] The most

important advance, however, occurred in 1908 when LeConte, James S. Hutchinson, and Duncan McDuffie discovered the first truly high mountain route south from Yosemite to Kings Canyon. After John Muir's death in 1914, William E. Colby, cofounder with Muir of the Sierra Club, proposed that this trail should be dedicated to Muir because it encompassed so much of the region he had known and studied so intimately. A grant of ten thousand dollars from the California State Legislature in 1915 initiated construction of the trail, and subsequent appropriations further improved it, as did the help of the National Forest Service, through 1931.[48] Running just over two hundred miles, the John Muir Trail begins at the LeConte Lodge in Yosemite Valley, leads eastward to the high country, and then runs south along the Sierra crest to end at Mount Whitney.

The high elevation of the John Muir Trail became its most significant feature in the early years of the Sierra Club outings because it permitted ordinary club members who were basically fit to experience the pleasures of mountaineering and climbing. At the Lyell Base Camp on the Muir Trail, for instance, they were already at nine thousand feet, from which a climb to the summit of Mount Conness, Mount Dana, Mount Gibbs, or Mount Lyell was not more than an additional 4,000 feet. In 1920 the Sierra Club made its first trip through the completed portion of the John Muir Trail. The photographer Herbert W. Gleason reported that a good part of the trail was "above 10,000 feet elevation, and often reaching points 12,000 and even 13,000 feet above sea level."[49]

The geological age of the Sierra Nevada peaks provided considerable educational value for Sierra Club summer outings. Matthes's research showed that the northwesterly orientation of mountain crests that had escaped glacier action, such as the Clark Range, the Cathedral Range, Kuna Crest, and the main divide, meant that these crests were probably part of a long-vanished mountain system of the Cretaceous period, 75 million years old. Therefore many of the peaks lying on the route of the John Muir Trail were preglacial.

The first Sierra Club high-country outing had been organized by Muir and Colby in 1901. Their aim was to enhance people's aesthetic and moral experience of wild nature firsthand by providing a socially cohesive activity for the club that would be like the outings conducted by the Mazamas, a hiking organization of the Pacific Northwest. High trips involved pack trains to carry sufficient quantities of food and equipment for groups of up to two hundred people for two to four weeks.

In the 1920s and 1930s many active Sierra Club members had known Muir personally. A memoir by William A. Magee appeared in the *Sierra Club Bulletin* in 1936 accompanied by seven Adams photographs, most of them taken on the Sierra Club's high-country outing in the summer of 1935.[50] Adams was thus fully engaged with maintaining the Muir legacy through photography of the high mountain trail named after him. The memory of Muir's achievements bonded the club members in

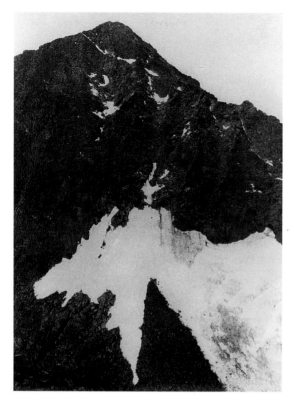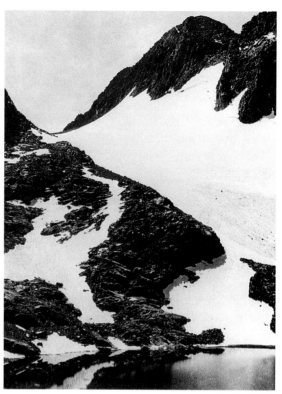

Fig. 2.5. Ansel Easton Adams, "Mount Ritter from Banner Peak," gelatin silver prints, "Photographs of Sierra Club Outing 1929" album, photographs 144 and 145, Sierra Club Pictorial Collections, Bancroft Library, University of California, Berkeley

the High Sierra. As Adams wrote high-mindedly in an article about the 1931 trip, "the secret of the strength and continuance of the Sierra Club lies in the unification of intricate personal differences as the foundation of composite intention and desire."[51]

Beginning with his appointment as official photographer for the Sierra Club's 1928 outing, Adams also took on the responsibility of assistant manager for the trips, establishing each day's route, selecting campsites, and taking every opportunity to make his own photographs. His companions later saw these in the many albums that he compiled from 1927 through 1945.[52] The making of photographic albums was a Sierra Club tradition. Marion Randall Parsons (1917), François and Edith Matthes (1919), and William Colby (1924) were among those who had already assembled albums for the club. Cedric Wright would also continue the tradition (1936, 1947–49, and 1955).

On the 1929 outing, Adams made half a dozen studies that included Mount Ritter, perhaps because this was Colby's last trip as outing leader, and Colby had been the close friend of Muir. Thirty of the company ascended Banner Peak. Adams photographed Mount Ritter from Banner, often using a telephoto lens, portraying the peak both as the birthplace of glaciers and as Muir's pyramidal holy mountain

(fig. 2.5). Here Muir had undergone an experience of cosmic consciousness when he almost fell from its face. Moving gradually from terror to a preternatural state of calm, in which he saw the texture of the rock "as through a microscope," Muir finally achieved the summit to behold the vast panorama of the Sierra Nevada from this mountain centered like an "axis mundi."[53]

A separate album of seventy photographs made by eight participants on this 1929 outing was dedicated to Colby on his retirement when he stopped making the high-country trips. The images Adams contributed to the album were selected from his own much larger album of the trip from halfway down the John Muir Trail back to Yosemite. "Sierra Club Outing 1929: Blaney Meadows to Yosemite Valley" contains 204 images.[54] Adams's later recollection that few of the photographs made on these trips were of vast landscapes, that "most were details, minutiae of nature, and the moods of light and weather on a single mountain or valley," is misleading.[55] Allowing for a certain number of documentary shots of campers and the pack train, and fewer than a dozen close-up nature studies (of which there were an increasing number in the albums for 1930–32), the 1929 album is primarily geological and glacial in focus, including photographs of glaciation on top of Devil's Postpile.[56] In general, the album is assembled from the point of view of a Sierra Club member's high mountain experience. Its alpine character is epitomized by one of the images reproduced in the *Sierra Club Bulletin* the following year, *The Sierra Crest Near Bear Creek Spire*, with its dramatic white sheet clouds against a black sky, with glacial ice and snow patches bringing out the mountain's forms and textures (fig. 2.6).[57]

In 1937, Walter A. Starr, who served with Adams on the board of directors of the Sierra Club, asked Adams to produce a book of photographs as a memorial to his son, Walter A. Starr Jr. (known as "Peter"), who had died climbing in the Sierra Nevada in 1933. Walter Starr Sr. had made his own contribution to the development of the High Sierra trail system in 1896 when he and Allen Chickering made the first continuous journey from Yosemite to Kings Canyon. In 1934 he had organized the posthumous publication of his son's *Guide to the John Muir Trail*. Francis P. Farquhar pointed out in his foreword that, although there were no longer any undiscovered peaks or passes and there was no further need to build new trails, there still remained "countless half-told secrets of the rocks and trees and a myriad unexplored aspects of the everchanging scene."[58] Starr offered to cover the expenses of the entire production of a pictorial survey on the condition that it be of the highest quality and with the best possible reproductions. Adams was given carte blanche, for something he had "always wanted to do—to gather my best Sierra photographs together—as that period of my life is quite definitely over."[59] Most of the photographs printed in *Sierra Nevada: The John Muir Trail* (1938) were made originally on the Sierra Club summer outings: *Banner Peak and Thousand Island Lake* (plate 7)

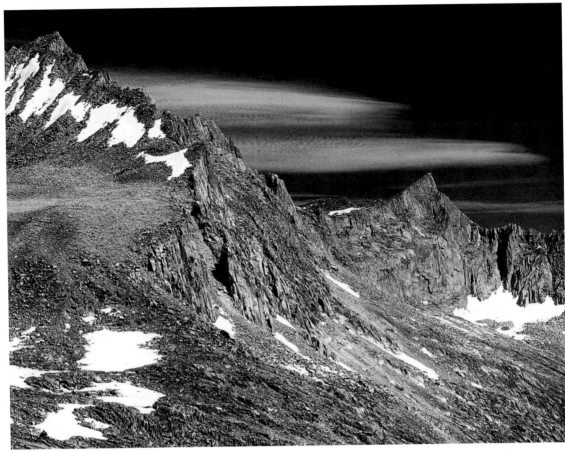

Fig. 2.6. Ansel Adams, *The Sierra Crest Near Bear Creek Spire* [*Mount Abbott, Sierra Nevada*], 1929, gelatin silver print

appeared first in an album of 1929, although it was made much earlier (the negative dates from 1923); and fifteen more photographs had appeared in albums from 1930 and 1933; seven in the album for 1935; and four in the one for 1936.

But to make the book complete, Adams went with Walter into the High Sierra in July 1937 to take photographs of the Minarets, where Peter had died. The Minarets stand to the south of Mount Ritter, a ridge of pinnacles approximately 700 feet high. Peter had died alone on the Michael Minaret and was buried where he fell.[60] With Walter, Adams now made first ascents of two 12,000-foot peaks nearby. Writing in Peter's *Guide to the John Muir Trail,* Vincent Butler imagined the traveler reaching Peter's last camp at Lake Ediza with the towering Minarets beyond: he would be "reverent, in his reverie" at the memory of this young martyr to Muir and mountaineering.[61] Adams's dedication in his book reads: "To the memory of Walter A. Starr, Jr. He sought and found the high adventure great mountains offer to mankind." The book's publication also coincided with the centenary celebration of John Muir's birth.

Writing in 1937 to National Park Service Director Arno B. Cammerer, Adams offered to provide the NPS with prints of his very large collection of mountain photographs, which he still considered the most important aspect of his work. On January 24, 1936, he had shown his photographs at a special session of a National Park Service conference to promote the establishment of a national park in the region of Kings Canyon.[62] A year later he asked the Yosemite National Park superintendent, Colonel C. G. Thomson, whether any progress had been made on establishing a Kings River National Park. Thomson assured him that a positive outcome was imminent. The following month, he wrote to Cammerer that by summer he expected to finish the pictures for a portfolio of fifty photographs titled *Sierra Nevada: The John Muir Trail.* He hoped the portfolio would aid passage of the bill concerning Kings Canyon Park then in Congress, and suggested that if the park were established before the book was printed, it could be presented as a celebration of the event.[63] Clearly, Adams saw the book as combining several functions: an elegy for Peter, a celebration of Muir, and support for the wilderness lobby in Congress.

As designer and typographer for his book, Adams chose Wilder Bentley, a craftsman printer whose Archetype Press in Berkeley he knew through the Roxburghe Club of printing enthusiasts.[64] In the early 1930s Bentley had presented a series of twelve public lectures at the University of California at Berkeley on the "History and Esthetics of Fine Printing." In 1934 he and his wife established the Archetype Press, printing a variety of original books on commission. Three years after the publication of Adams's book, Bentley wrote an article for *U.S. Camera* about the evolution of the project and his own role as designer. He answered the criticism that the tipped-in photoengravings simulated actual photographs by explaining that tipping in the plates was the only way to avoid the halo of oversprayed varnish around a reproduction that had been printed as well as varnished on the same stock. Adams had passed this technique on to Bentley from his experience with the London publisher The Studio in the production of *Making a Photograph* (1935). "Modern," Adams explained to Bentley, "means the appropriate contemporary means in contemporary function."[65] Varnished photoengravings now replaced the Dassonville-paper photographs of his first book, the arts-and-crafts style *Taos Pueblo* (1930).

Adams was to stand by photomechanical reproduction for the rest of his life. Although he had some initial difficulty in obtaining a sufficiently high quality of reproduction from the Lakeside Press of Chicago, eventually he was wholly satisfied with their 175-line-screen photoengravings.[66] David Brower recalled: "The John Muir Trail book was in process, and Ansel delighted in comparing actual contact prints of some of the subjects with same-size halftones, in very fine screen, of the subjects as interpreted by Ansel's then favorite engraver. . . . It was difficult to tell the original from the copy. If there was a new route to excellence in a photographic technology, Ansel either led the climb or pushed others up it." Adams told Bentley

that although Lakeside was taking a loss on the job, the photoengravers were "pleased beyond words to have the chance to find out the procedure on such work," which suggests that Adams was teaching them exactly how it should be done.[67]

Bentley's concept for the design of the book was based on the idea of an exhibition of photographs in which each image was centered on the page as if framed. The idea may have come to him at a show of Adams's photographs in the art gallery of the University of California at Berkeley in January 1938. Bentley decided to tip in the reproductions and intervening captions alternately on recto pages only, with all versos blank, despite the lavish amount of paper that decision required. But Adams did not want the book priced out of the reach of the average Sierra Club member, and from the beginning of the project tried to keep Bentley's costs of production down. He proposed a cased portfolio rather than a bound book, and later he tried to persuade Bentley that the captions could be placed opposite the plates, thereby cutting the number of pages by half and saving substantially on paper costs and binding.[68] Bentley, however, insisted on presenting the images on one side of the page only, isolated from both photographs and captions, in order to evoke the reverence and reverie required for high mountain subjects. The absence of a caption on the page allowed the reader to experience the subject fully as "out of context, as beholder," which Bentley felt appropriate to the mountain experience, "considering the grandeur of the subject matter and human inadequacy to give such grandeur effectual names."[69] He chose for the typography Goudy's New Style, which he thought would convey "an inspirational quality as though incised in granite." Predictably, the Archetype Press went out of business just two years after the book was published, and in the *U.S. Camera* article Bentley solemnly referred to the book as a memento mori worthy of the press itself.

In December 1938 a complimentary copy of the book was sent to Secretary of the Interior Harold Ickes, who was working on a revised bill for a national park at Kings Canyon. When yet another version, the Gearhart bill, was finally passed in 1940, Adams was able to write to Walter Starr that *Sierra Nevada* had played a part in the establishment of Kings Canyon National Park, and that the book was certainly "functional even if not profitable."[70] This consolatory comment perhaps reflected Adams's anxiety that the book could have been useful even if it turned out not to be a financial success.

As Adams's book neared the final stages of production, he received a copy of Walker Evans's *American Photographs* (1938) from the Museum of Modern Art in New York. Although it contained "some really swell photographs," he felt that too few of them transcended the literal document to have been published by an art museum. MOMA, he felt, was playing at social documentary without deep moral commitment, unlike his friend Dorothea Lange, who pursued documentary work without artistic pretensions but went beyond the elementary aims of the picture

story. He accepted that *Sierra Nevada* was no more suitable than *American Photographs* for publication by an art museum because such a large percentage of the content was representational.[71] By implication, only a few of the pictures in the book surpassed this category. He did not name them, but they should surely have included *Lake near Muir Pass* (plate 19), *Rock and Water* (plate 45), and *Lake and Cliffs, Kaweah Gap* (plate 49), later known as *Frozen Lake and Cliffs* (fig. 2.7).

In *The Mountains of California* (1894), John Muir wrote, "When a mountain lake is born, it is an irregular, expressionless crescent, inclosed in banks of rock and ice, —bare, glaciated rock on the lower side, the rugged snout of a glacier on the upper."[72] When the Sierra Club members made their high-country outing in the summer of 1932, such a glacier lake was of great interest to them. Adams's album for that year contains a series of seven images ranging from the panoramic view of the area around Eagle Scout Peak to a nearer view of a lake framed by cliffs and ice.[73] As he circled the lake, he saw the relationships among rock, snow, and dark lake ever more clearly and at ever closer range. The print in the album of *Lakes and Cliff, Kaweah Gap* carefully preserves the cliffs' reflection in the dark surface of the foreground lake, with the triangle of snow and rocks symbolizing the glacier in microcosm. He finished the series of photographs in the album with a different version taken from the left bank at an angle that captured an image of much greater three-dimensionality (fig. 2.8).

Lake near Muir Pass was specifically singled out by Adams for its reflective properties, in an interview in the 1970s (fig. 2.9)[74] The phenomenon of the perfect reflection on the surface of a lake of a snow-covered mountain range, the rock forms visible beneath the surface, came about because the deep blue of the cloudless sky created the conditions for the mirror-form. This is more than a one-to-one optical reflection like Carleton Watkins's doubling of single cliffs in *Mirror View, El Capitan* (circa 1866), or *Washington Column* (circa 1866).[75] Adams's photograph doubles the mountain range reflected in the lake, transforming the reflection into a horizontal winged figure floating over an illusory summit of submerged rock in the lake bed. Edward Carpenter, in *Towards Democracy*, offered such a lake as a metaphor for the mind's reflection of the infinite, where "at last the mountains and the sky shall glass themselves in peaceful beauty.... And Love himself shall come and bend over and catch his own likeness in you."[76] The integrated cosmos offered a window within the mirror, a glimpse through the reflection of nature to the universal self. This Symbolist image of intense mountain experience was what Alfred Stieglitz called an "equivalent," conveying an interpretive response.

When Adams sent Stieglitz a copy of *Sierra Nevada* in December 1938, he suggested that his desire for artistic expression had not yet been completely fulfilled: "The next book will be much more intimate and much more concerned with photography for its own sake." But Stieglitz wrote to Adams to congratulate him, call-

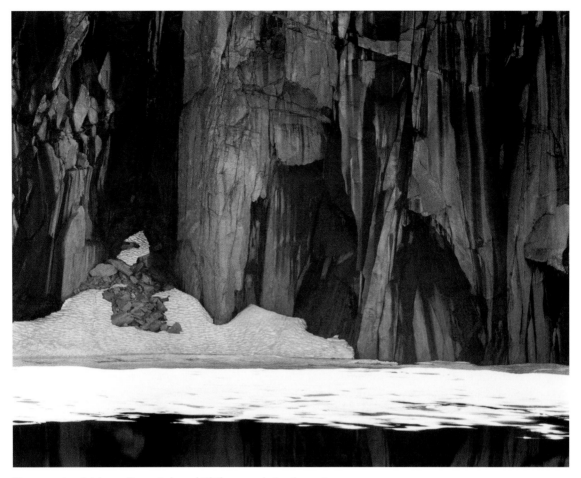

Fig. 2.7. Ansel Adams, *Frozen Lake and Cliffs*, 1932, gelatin silver print

ing the book "perfect photography,...perfect workmanship."[77] Adams responded gratefully but somewhat defensively, explaining that he had photographed specific sites in order to tell the story of the famous trail. That was an emphasis quite different from his foreword to the book, where he claimed that the factual qualities of the landscape had been "submerged in favor of purely emotional interpretative elements," and that the work was "a transmission of emotional experience." Perhaps he feared that Stieglitz's reference to "perfect workmanship" damned him with mere technical praise, even though Stieglitz himself had been known as a master technician at the turn of the century. But Stieglitz's concept of "perfection," in the Nietzschean sense, referred to a work of the artist in which the object and its essence were completely united. Adams also aspired to the transmission of pure emotion but was too modest to accept that the photographs fully conveyed the high mountain experience, even though his ultimate aim had been to produce, like Stieglitz, photographs so fine that they vibrated with a higher degree of emotional consciousness.[78]

Fig. 2.8. Ansel Easton Adams, "Below Kaweah Gap," gelatin silver print, "Sierra Club Outing 1932" album, photograph 161, Sierra Club Pictorial Collections, Bancroft Library, University of California, Berkeley

The suspension of self-awareness that contributes to the creation of the mystical state of mountain consciousness had been described by Leslie Stephen in 1871 as a "sleep of the mind which may be enjoyed with open eyes and during the exertion of muscular activity," in which "thought becomes indistinguishable from emotion."[79] Under conditions of physical challenge the working of the intellect is suppressed and intuition comes into play. Mountaineering is, therefore, a symbolic experience but also a physically real one, in which extreme concentration on physical and optical co-ordination momentarily blurs the distinction between means and ends.[80] It is an engrossing activity that places such demands on all the resources of the body, of conscious thought and of intuition, that it induces a sensation of holistic integration and personal transcendence, in which, according to another writer, "there is little distinction between self and environment; between stimulus and response; or between past, present, and future." This sensation is similar to that of R. M. Bucke's cosmic consciousness and Cedric Wright's sense of "mountain communion."[81]

In an article for the *Sierra Club Bulletin* in 1931, Adams emphasized the capacity for snow both to reveal the forms of mountains and to "clarify" them. At the summit of Tenaya Peak, looking over the whitened Sierra ranges, skiers felt themselves

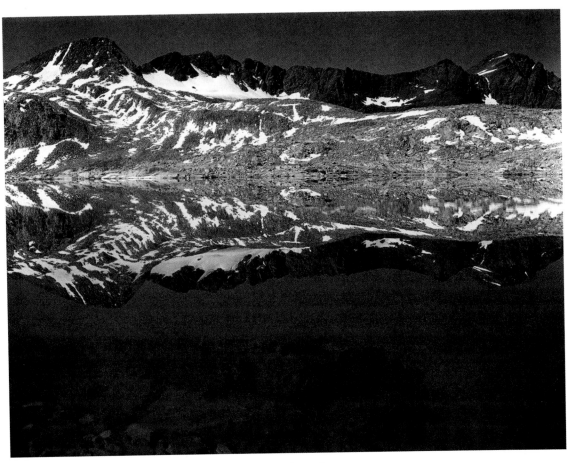

Fig. 2.9. Ansel Adams, *Lake near Muir Pass*, c. 1933, gelatin silver print

"on an Earth-gesture of high stone," in the presence of "great mountain spirits" in "white robes of devotion...standing in silence before the intense sun." The alpine conditions of Tuolumne Pass were described as a heavenly landscape: "a world of surpassing beauty, perfect and intense."[82] To John Muir, too, the mountain scene appeared so completely spiritual that the viewer seemed dissolved in it, while at the same time everything was full of "warm terrestrial life delightfully substantial and familiar."[83] This transcendent immanence, the spiritual lodged firmly in reality with the exact textures and substances of life, was for the mountaineers the essence of mountain experience.

Adams's mode of photographic expression in the mountains developed from this inclusive perception of things, mountain immensities and tiny particularities of detail seen all at once, in the clear air and bright light of the High Sierra. Nancy Newhall's biography of Adams, *The Eloquent Light* (1963), quotes an early fragment he wrote about a climb near Mount Clark: "The silver light turned every blade of grass and every particle of sand into a luminous metallic splendor.... I was sud-

denly arrested in the long crunching path up the ridge by an exceeding pointed awareness of the *light*.... I saw more clearly than I have ever seen before or since the minute detail of the grasses, the cluster of sand shifting in the wind, the small flotsam of the forest, the motion of the high clouds streaming above the peaks."[84]

Why mountain climbers should receive impressions and experiences that are unavailable to those living at sea level was answered in 1929 in an *American Alpine Journal* article on the pages immediately following some Adams photographs of the Canadian Rockies.[85] The author suggested not only that the mountain represented physical challenge and mental purification but that the very shape of a mountain peak had the potential for stimulating a spiritual response. Although the viewer might perceive the mountain at a distance, coming close up to the rock-face itself was quite a different matter, one that involved a transformation of the individual through the direct experience of mountain ascent. Confronting subconscious fear, and triumphing over this fear, resulted in a special feeling of spiritual exhilaration.

Few experiences in rock climbing compare, in terms of sheer physical and psychological struggle, with the attempts to ascend Mount Everest. In November 1923 Adams had been offered an opportunity to represent the Sierra Club on the 1924 Royal Geographical Society expedition to Everest. He was forced to decline, probably for lack of funds. Later, he reviewed Hugh Ruttledge's *Everest 1933* (1934) about the expedition of a party that included F. S. Smythe, noting "an inspiring foreword by Sir Francis Younghusband."[86] Younghusband was a British military officer in India who had found his own blend of theosophy and nature religion in the Himalaya and had become president of the Royal Geographic Society in 1909. In the interwar period he wrote a dozen books on attempted ascents of Mount Everest and on mysticism.

When Younghusband's *The Heart of Nature* was published in 1921 it was greeted as a major work of nature literature, rivaling Coleridge and De Quincey.[87] It was reviewed in the *Sierra Club Bulletin* by Adams's friend Helen LeConte, who read Younghusband's narratives of "his unique experiences in the sublime places of the earth" as evidence of divine revelation in nature. Younghusband wrote about evolution not as a biological mechanism but as ongoing spiritual development, "Nature ever straining after higher perfection."[88] The sense of aspiration the mountaineer felt in the presence of mountains was simply a reflection of this striving for perfection. The physical effort of mountaineering was for him symbolic of ultimate spiritual challenge. Younghusband's belief in an essential spirit of nature, "the content within the outward form," drew upon such writers on science and philosophy as A. S. Eddington and Alfred North Whitehead, who conceived of the universe as a single organism. He believed that the cosmic spirit in nature manifested itself in "an unceasing interaction of the whole upon the parts and the parts upon the whole.... What was immanent responded to what was transcendent."[89] The whole,

or the macrocosm, as Adams wrote to Virginia Best in 1923, was represented in the microcosm: "In each blade of grass, each drop of water, we find the identical harmony of laws that are observed in immeasurably remote stellar systems."[90] It was Younghusband who introduced the young Manly Hall to the ancient esoteric texts in the manuscripts collection of the British Museum while Hall was writing his great work on comparative religion, *The Secret Teachings of All Ages* (1928). His extensive writings, including books on theosophy, psychology, and Eastern and Western mysticism, which Adams may have known of through Sara Bard Field, certainly fell into the category of the philosophic religions that Adams studied in his twenties.[91] Hall's *The Ways of the Lonely Ones* (1923) was a collection of parables about the quest to discover one's true mystical nature. Half of them centered on the motif of a snow-capped sacred mountain, symbol of an archetypal realm in which the physical aspires to the spiritual.

Clarence King's *Mountaineering in the Sierra Nevada* (1872), which ran to fifteen editions, was issued in 1935 in a new edition with a preface by Francis P. Farquhar. It included three photographs by Adams, who, emulating some of King's rock-climbing feats, had retrieved the original geological survey records that King had left on the summit of Mount Clark in a brass cylinder and had brought them back for the Sierra Club.[92] When Leslie Stephen had reviewed King's book, he praised the exciting narration while reserving judgment on some of its more extravagant climbing claims, but he ended by congratulating North Americans on "the possession of a chain of mountains...rivalling in height and picturesqueness of form, if not in extent of glacier and snow-fields, the Swiss Alps." In 1871, in *The Playground of Europe,* Stephen recounted his ascent of Mont Blanc in order to experience a sunset from the summit: "All the surrounding scenery is instantaneously and indelibly photographed on the mental retina by a process which no second-hand operation can even dimly transfer to others." Coincidentally, in the same year, Clarence King also used the sensitized photographic plate as the metaphor for the mountaineer's powers of perception, which allow nature to impress upon him "those vague indescribable emotions which tremble between wonder and sympathy."[93] But King, the scientist, assigned to the photograph the role of recording emotions evoked by nature rather than recording facts, whereas Stephen, the writer, resisted any sentimental impulse to invest the mountains with qualities of feeling.[94]

Stephen's essay "A Bye-Day in the Alps" was a classic of mountaineering literature that Adams, reviewing it in 1928, particularly noted for its "cool and gracious beauty."[95] But another essay, "Sunset on Mont Blanc," which also appeared in *The Playground of Europe,* contained a profoundly evocative image of an alpine moonrise that may have embedded itself deeply in Adams's imagination. Descending to the Grand Plateau from the slopes of Mont Blanc after sunset, Stephen described the opposition between night and day, rising moon and setting sun, and quoted the poet

Sir Philip Sidney, "with how sad steps, O moon, thou climbst the sky, / How silently and with how wan a face!" Stephen proposed the moon as "a vast perambulating tombstone, proclaiming to all mankind in the words of the familiar epitaph, 'As I am now, you soon shall be!'"[96] This sense of mortality and humility, which Stephen believed was the proper attitude for people to adopt in the presence of great mountains, resonates with Adams's later photograph, *Moonrise, Hernandez, New Mexico* (1941). The emotion of melancholy, of human insignificance beside the eternal peaks, was, Stephen felt, peculiar to the mountain scene.

Adams's epigraph to *Sierra Nevada: The John Muir Trail* was taken from Younghusband: "To those who have struggled with them the mountains reveal beauties they will not disclose to those who make no effort. That is the reward the mountains give to effort. And it is because they have so much to give and give it so lavishly to those who will wrestle with them that men love the mountains and go back to them again and again.... the mountains reserve their choicest gifts for those who stand upon their summits." It was not the climber as superhuman, relying on sheer will and physical strength, of whom Younghusband approved, but rather the climber "with grace and suppleness in the place of rigidity... and gentleness and consideration in proportion to strength."[97] The frontispiece to *Sierra Nevada* shows two climbers, not one, silhouetted on a rocky peak. If the epigraph served to eulogize Peter Starr, it was also ironic: if Starr had not been climbing alone he might not have perished on the Minarets.[98] Nietzsche, whose ideas Adams would have received through A. R. Orage and Mabel Dodge Luhan as well as from Stieglitz, presented the tragic hero as a single figure, "a bright image projected on a dark wall."[99] But in the Adams image two figures are silhouetted against white clouds, like Stieglitz's image of himself with a painter friend casting dark shadows on a dappled Lake George.[100] Such figures, who move against the backdrop of the infinite, symbolize the attempt of human beings to reintegrate themselves with nature by uniting the appearances of objects with their own pure emotions.

Objective Photography

In 1940 Adams was invited by the organizers of the San Francisco Golden Gate International Exposition to present "A Pageant of Photography." Historically and physically, it was the most ambitious exhibition that had ever been seen on the West Coast, with over two hundred photographs starting from the invention of the medium up to contemporary work in documentary, scientific, and art photography. Among the photographers of the American West whose works Adams exhibited were Carleton Watkins, Eadweard Muybridge, William H. Jackson, Timothy H. O'Sullivan, George Fiske, William E. Dassonville, and Alvin Langdon Coburn. In Ansel and Virginia Adams's *Illustrated Guide to Yosemite Valley* (1940), Watkins, Muybridge, and Fiske were named as the important early photographers in Yosemite. To prepare for this publication, Adams spent much time in the Yosemite museum looking at early photographs of the geology of the region.[1]

James Hutchings's *In the Heart of the Sierras* (1886), the book that fired Adams with the determination to see Yosemite in 1916, was profusely illustrated with photo-mechanical reproductions of works by a number of photographers, mainly George Fiske. Adams considered Fiske to have made the best photographs of Yosemite.[2] The son of a Congregationalist deacon from New Hampshire, Fiske had worked from 1860 to 1867 as an assistant to Carleton Watkins and as a printer for Thomas Houseworth and Company, the San Francisco photographic publishers.[3] Having established himself as an independent photographer in 1867, he made his first visit to Yosemite in 1872, and his landscapes were sold in the valley from 1874 onward. Although a commercial photographer dependent on sales of views to tourists for his income, Fiske was sufficiently concerned with the aesthetic reception of his work to send several of his albumen prints to John Ruskin in 1884.[4] Fiske made straight studies of Yosemite in winter his photographic specialty. He expressed his fascination with the metamorphic powers of snow and ice in photographs made around 1874. After Fiske died in 1918, the Curry Company in Yosemite bought up the 11 × 14-inch plates rescued from his darkroom fire of 1904, and during the 1930s

Fig. 3.1. George Fiske, *Yosemite Falls*, no. 26519, c. 1874, gelatin silver print on Dassonville Charcoal Black paper, printed by Ansel Adams c. 1931–32. Yosemite Museum, Yosemite National Park, California

employed Adams to produce postcards and photographs from Fiske's negatives on Dassonville Charcoal Black printing paper (fig. 3.1).[5]

William Dassonville had made his living as a studio portraitist (John Muir sat for him), but Adams also considered him one of the few creative photographers in the San Francisco area in the earlier period. Having lost his studio to the earthquake of 1906, Dassonville began photographing in the Sierra Nevada, and produced that same year a portfolio of views of Yosemite, including a general view of the valley with light cloud effects (fig. 3.2).[6]

One of Dassonville's friends, Alvin Langdon Coburn, traveled across the American West in 1911 with his friend and teacher Arthur Wesley Dow, and visited Thomas Moran, whose atmospheric style reflected the influence of J. M. W. Turner.[7] Of the series of photographs Coburn made in California, he included one taken in the High Sierra and one near Mt. Wilson in an edition of Shelley's *The Cloud* (1912).[8] The aerial perspective used by tonalists such as Dassonville and Coburn

Fig. 3.2. William E. Dassonville, *Yosemite Valley*, gelatin silver print, from *Yosemite Portfolio*, 1906. Yosemite Museum, Yosemite National Park, California

was expressed by the soft aesthetic of photogravure and by matte-finish photographic papers, whereas Fiske, with his sharply detailed albumen prints, was a straight photographer.

John Ruskin had epitomized the contest between hard-edged precision and tonal breadth of effect in his characterizations of John Millais and Turner: "Set them both free in the same field in a mountain valley. One sees everything, small and large, with almost the same clearness; mountains and grasshoppers alike; the leaves on the branches, the veins in the pebbles, the bubbles in the stream; but he can remember nothing and invent nothing.... Meantime the other has been watching the change of the clouds, and march of the light along the mountain sides; he beholds the entire scene in broad, soft masses of true gradation."[9]

As tonalist, aerial perspective gave way to modernist, focal perspective, Adams turned to nineteenth-century landscape photographers to find his precursors in the tradition of straight photography. He lent an album of prints by Timothy O'Sulli-

van, made for Wheeler's 1873 survey of the 100th meridian, to the Museum of Modern Art for Beaumont Newhall's 1937 exhibition "Photography 1839–1937."[10] In 1942 he went to considerable lengths to produce a nearly identical version of *Ancient Ruins in the Cañon de Chelle, N.M.* (1873), finding the exact location in mid-river and using a strong green filter in order to register the darkened effect of red streaks on the cliff due to O'Sullivan's use of orthochromatic plates.[11] That same year, Beaumont Newhall invited him to produce an exhibition for the Museum of Modern Art, "Photographs of the Civil War and the American Frontier." They went to the National Archives in Washington to have prints made for the show, and to the Henry Ford Museum in Dearborn, Michigan, to borrow photographs from its William Henry Jackson collection.[12] Adams's friendship with Jackson had begun when he had borrowed some prints from him for the "Pageant of Photography" exhibition, but when Jackson died, Adams confided to Stieglitz that although his technique was superb for his time, he showed no "revelation of the spirit." When Edward Steichen referred to Adams as "the last of the O'Sullivans" in the Western tradition of landscape topography, Nancy Newhall was incensed because she knew that spiritual revelation was Adams's prime motivation.[13]

In *Sight: An Exposition of the Principles of Monocular and Binocular Vision* (1881), Joseph LeConte Sr. listed four categories of perspective: *aerial,* in which objects grow paler and more indistinct as they near the horizon; *mathematical,* in which objects appear smaller the farther away they are; *monocular or focal,* rendered by a lens adjusted for precise focal distance; and *binocular,* involving spatial triangulation to discern distances between objects in space. The stereoscope held twin images made by a camera mounted with two lenses, side by side, imitating the effect of binocular vision. When the cards were placed in this optical device, eye and brain registered the two images as one, in startling, illusory depth.[14] Objects overlapping in the foreground produced in the viewer a feeling of being thrust into an imaginary space, furnished with objects as sharply demarcated as stage flats. In 1877 LeConte tried to reconcile the opposing views of evolution and creation in terms of "a stereoscopic combination of *two* partial surface-views into *one* objective reality," a metaphor he reasserted in *Evolution and its Relation to Religious Thought* (1888).[15]

Carleton Watkins, best known today for his mammoth-plate (18 × 22 inches) albumen prints of the 1860s and 1870s, in fact produced a much larger number of stereographs.[16] Compared with his stereo view of the identical subject, the mammoth-plate version of Watkins's *The First View of the Valley from the Mariposa Trail* suggests that his abrupt foregrounding of the two pine trunks originated in his stereoscopic conception of the scene (fig. 3.3). In the print, the apparently detached plane of tree trunks and foregrounded cliff sets off a second, somewhat paler, tone from mid-distance to horizon. This two-toned aspect, common to many of his photographs,

Fig. 3.3. Carleton Watkins, *The First View of the Valley from the Mariposa Trail*, c. 1865, gelatin silver print. J. Paul Getty Museum, Los Angeles

derives from their initial function as stereographs, which depended on the physiological tension between near and distant focusing.

Eadweard Muybridge, however, who also made stereographs, seemed determined to avoid their binocular effect in his mammoth prints of Yosemite.[17] In *Yosemite Cliff at the Summit of the Fall*, the gradual progression in tone from the shadowed valley below through the peaks to the pale distance demonstrates Muybridge's English predisposition toward aerial perspective (fig. 3.4). When Muybridge returned to England in 1860 and took instruction in photography, Roger Fenton was still active in London. Fenton had exhibited a number of landscape photographs made on the River Conway in the mountains of North Wales, many of which were published in *Stereoscopic Views in North Wales* (1858) and *The Conway in the Stereoscope* (1860). In this Conway series, he was working with both stereoscopic and conventional cameras, but the large format prints show no evidence of stereoscopic foregrounding devices. As in *Rocks at the Head of Glyn Francon*, they show continuous progression of tone from foreground to distance, employing the diffusion inherent in mist for aerial perspective. By 1878 Helen Hunt Jackson, who had seen the works of both Watkins and Muybridge, was in no doubt that Muybridge's were superior in composition and breadth of effect, with skies reminiscent of Turner's cloud-studies.[18]

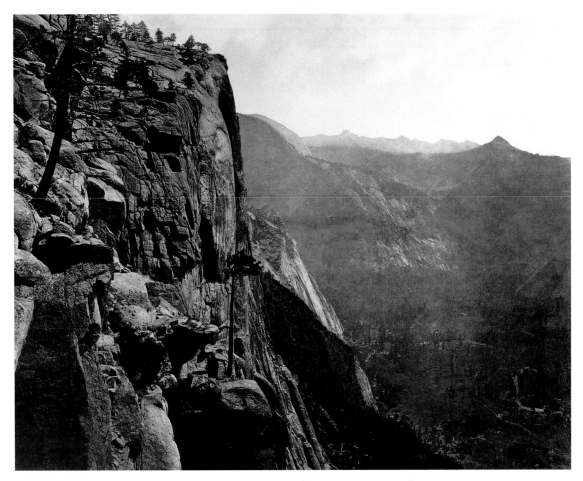

Fig. 3.4. Eadweard Muybridge, *Yosemite Cliff at the Summit of the Fall*, no. 45, 1872, albumen print. Yosemite Museum, Yosemite National Park, California

If Watkins favored the sharp definition of the stereograph and Muybridge breadth of effect, Adams's *Moro Rock* combined sharpness with soft gradation (fig. 3.5). Determined to render both the succession of mountain ridges emerging from the haze and the hard surface of the cliff, he employed modest filtration and reduced development to keep the values of the foreground at the desired level of contrast.[19] Similar in both composition and atmospheric effect to Muybridge's *Yosemite Cliff at the Summit of the Fall*, it places the viewer at a conjunction of endless progression and immediate perception. Two partial views united in one solid reality were achieved by high accutance, a term Adams later defined as "the ability of the lens to render separate, fine detail distinguishably." Acceptable sharpness in all important planes and proper tonal separation were required to maintain the "impression of substance."[20] Emotional expression was not to be indulged at the expense of substantiality of form. This was the conviction that underpinned the attitude toward photography of Group f/64, briefly coming together in Oakland in 1932–34.

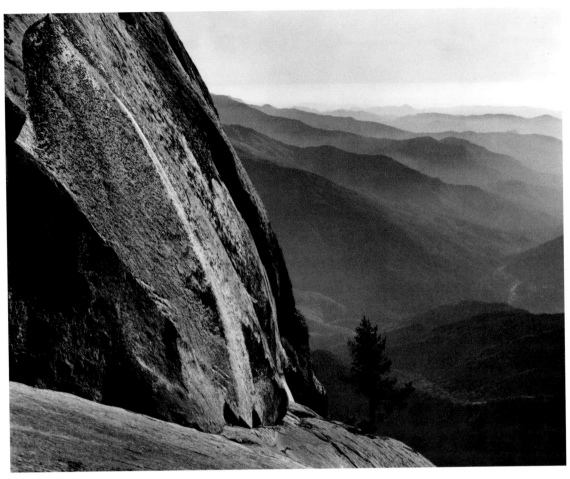

Fig. 3.5. Ansel Adams, *Moro Rock*, c. 1945, gelatin silver print

The gallery for photography established by Ansel Adams's friends Willard Van Dyke and Mary Jeannette Edwards in 1932 was conceived in emulation of Stieglitz's gallery "291" as a meeting place for artists and, like 291, was known by its street number: "683 Brockhurst." In the fall of that year Van Dyke and another member of the group, Preston Holder, discussed with colleagues the idea of adopting a collective name in order to bring to public awareness the kind of photography they now believed in. At a dinner party that autumn they suggested the name of the aperture setting "US 256," but Adams countered with its new designation, "f/64," which offered much more elegant typographic possibilities.[21] The need for agreement on a name was impressed upon them when Lloyd Robbins, director of the De Young Museum, who had previously given Cunningham, Weston, and Adams solo shows, offered them a group exhibition. The inaugural exhibition of "Group f/64" opened on November 15, 1932.

Adams was first introduced to Edward Weston at a dinner party given by Adams's

patron Albert Bender in early autumn 1928. Although later Adams recalled having been unimpressed by the work Weston brought to show that evening, it may not have been Adams's first sight of Weston's photographs, which had been included in at least three exhibitions in the San Francisco Bay area in the previous year.[22] Adams himself probably brought along mountain landscapes of the Sierra Nevada, some of which he had published the year before in *Parmelian Prints of the High Sierra,* and possibly some photographs taken in Taos and Santa Fe earlier that year. During the summer, Bender had purchased three of Weston's photographs of trees (perhaps the studies of junipers he had been working on that spring) from his show at the East-West Gallery in San Francisco. As an art collector, Bender could well have brought to the attention of his young friend Adams *Creative Art* magazine's recent publication of excerpts from Weston's daybooks from the years 1923–28, illustrated with seven photographs.[23] The excerpts referred to a change in Weston's artistic aim from "interpretation" to "presentation," and to his desire to "record the quintessence of the object" before the lens.

On his visit to Taos in 1930 Adams was introduced to the photographer Paul Strand. Twelve years Adams's senior, Strand had been pursuing the straight photographic aesthetic for more than a decade. When Adams showed him a copy of his portfolio, *Parmelian Prints of the High Sierra,* Strand was shocked at the euphemism "parmelian" to dignify the prints, and asked Adams, "What *are* these prints, are they lithographs?, what are they?... Well, why don't you *call* them photographs?"[24] For his part, Strand showed Adams negatives he had made during his own visit in Taos, and Adams was struck by their formal strength and their technical clarity. The negative offers the neat expression of the camera image, undiluted by translation into the print. Strand's intransigent personality and sharp negatives, translucent with the August light of the New Mexico summer, convinced Adams that straight photography, which relied on its inherent technical means rather than on artistic pretension, was the way forward.

When Adams returned from the Southwest, he found Imogen Cunningham, Edward Weston (with whom he had now become friends), Willard Van Dyke, and others of his West Coast colleagues also moving in the new direction that photography was taking.[25] Two important articles on Weston were published in November 1930: one in *California Arts and Architecture,* an arts magazine that would review Adams's *Taos Pueblo* the following spring; and one in the *New York Times Magazine.* In both articles Weston was quoted as emphasizing the importance of previsioning the image (the photograph as conceived on the ground glass before exposure) and of directly presenting "the texture, rhythm, force in nature."[26] This West Coast group associated with straight, unmanipulated photography was now wishing to distance itself from the pictorialist tradition of salon photography.

Imogen Cunningham, a friend of Weston's since 1920 and a member of the Pic-

torial Photographers of America, had submitted work regularly to the pictorialist salons, although by the late 1920s her early romanticized works were succeeded by nature studies in close-up. Weston had been a charter member of the Photo Pictorialists of Los Angeles in 1914, and although he was producing hard-edged formal compositions by the mid-1920s, he continued to send photographs to the salons well into the 1930s. Weston and Van Dyke had first met at the Salon of the Pictorial Photographic Society of San Francisco in 1928 when Weston's work was exhibited. Considering Adams's growing aspirations to photographic art, it would have been odd if he, who lived not far from the Palace of the Legion of Honor, had not also visited the exhibition there.

During 1931 and 1932 the idea of "pure" photography was being collectively formulated by Weston, Adams, and their colleagues, yet the Camera Pictorialists of Los Angeles, with whom Weston had first exhibited in 1918, were still including photographs by him.[27] Adams himself also belonged to a pictorialist group in Northern California, the California Camera Club. He had met William Dassonville there in about 1926, and as late as 1930 was involved in a joint exhibition with him.[28] *Taos Pueblo,* for which Adams's illustrations were printed directly on Dassonville paper, was to this extent a pictorialist venture.

Until the photographer Anne Brigman, whose pictorialist nudes had appeared in Stieglitz's *Camera Work,* left Oakland for Los Angeles in 1929, her studio at 683 Brockhurst was a regular gathering place for the younger generation of photographers. Adams knew Brigman's work well and owned the issue of *Camera Work* in which it was featured in January 1909.[29] When Willard Van Dyke and Mary Jeannette Edwards were planning to set up a photographic gallery, they chose Brigman's old studio. But in 1930 Edward Weston declared his public break with pictorialism and set the tone for the aesthetic stance of "purist" photography in "Photography —Not Pictorial," an article that appeared in California's main photographic magazine, *Camera Craft.* The article was largely extracts from his daybooks, including quotations from a 1926 review by the Mexican muralist David Siqueiros proposing that instead of conveying an impression of a thing, the photographer should now realize its actuality: "The physical quality of things can be rendered with utmost exactness: stone is hard, bark is rough, flesh is alive."[30]

In November and December 1931 a one-man show of 150 of Weston's photographs was held at the De Young museum in San Francisco, and the exhibition was reviewed by Adams. He paraphrased Weston's conviction that the realism of the lens served to prevent excessive subjectivity: the photograph must be "unencumbered by connotations—philosophical, personal, or suggestive of propaganda in any form."[31] With the zeal of the fresh convert, Adams espoused the "austere aesthetics" of "the prime message of photography—absolute realism." He even found some of Weston's photographs wanting in this regard, arguing that his direct presentation of

form was sometimes encumbered with "decorative" elements, especially in the case of his studies of peppers and other vegetables.

In a letter a few weeks later, Weston tried to explain to Adams the real motive behind his formal treatment of objects. He reminded Adams of a phrase he had used from time to time, "to make a pepper more than a pepper," which he now abbreviated to "a pepper *plus*"; "photography as a creative expression must be 'seeing' plus. ...The 'plus' is the basis of all arguments on 'what is art.'"[32] Weston was calling for a uniquely photographic way of seeing, "a presentation of the significance of facts ...transformed from things...*seen,* to things *known.*"[33]

In the three years since their first meeting, Adams had also advanced in photographic style from pictorialist to straight. In 1931 Francis Farquhar, editor of the *Sierra Club Bulletin,* reviewed Adams's photographs of Sierra Nevada subjects, describing him as a nonmanipulative, straight photographer, "emphatically a realist," whose compositions drew upon the design "inherent in the subject itself."[34] Farquhar's review was illustrated by seven photographs from Adams's recent exhibition at the Smithsonian Institution. In November 1930 the director of the department of photographs at the Smithsonian Institution, A. J. Olmsted, had invited Adams to exhibit sixty of his photographs in the Arts and Industries Building. Adams's work was brought to Olmsted's attention by H. S. Bryant, also of the Smithsonian, to whom Adams's mountain landscapes had been recommended by the mountaineering photographer F. Russell Bichowsky, then living in Washington. Ironically, while Adams was making progress toward straight photography as an end in itself, Bryant responded to the prints as works of graphic art, recommending them to Olmsted on the basis that "most of them closely resemble etchings." In early January 1931, however, "Pictorial Photographs of the Sierra Nevada Mountains" was reviewed in terms that showed a purer appreciation: "There has been no juggling with mechanical processes to produce effects, which often is the case with many photographers. Here there is the straightforward impression on the plate which has been achieved with thought and selection."[35]

During these crucial years 1930–32 Adams enthusiastically embraced the challenge of finding a basis for photographic art in terms of its technical constraints. He wrote to Mary Austin in August 1931 of his excitement over "a new photographic technic." After his own one-man show in San Francisco in February 1932, he was even more confident about it: "I have really arrived at some technical and emotional basis on which I feel I can and will grow."[36] He had adopted smooth, glossy-surfaced papers that produced a print of a sufficient range of tones to re-create closely what he had visualized on the ground glass.[37] In early 1932 he had purchased his first Weston light meter, which now offered him much greater control over exposure.[38] As early as 1924 Edward Weston had felt this same drive toward the utmost technical achievement in photography, putting aside his diffused lenses for a

new Rapid Rectilinear that could be stopped down to the aperture setting "f/64" for maximum depth of focus. "Now I start a new phase of my photographic career," he wrote, "with practically the same objective [lens] that I began with some twenty years ago."[39]

In late 1931 the poet Kenneth Rexroth visited Weston, whom he had known since their meeting in Mexico in 1925, to discuss the philosophical basis of the kind of photography in which he believed Weston was engaged. By the end of the year, Weston received from him the second draft of an essay, "The Objectivism of Edward Weston: An Attempt at a Functional Definition of the Art of the Camera." *Hound and Horn,* where photographs by Charles Sheeler and Walker Evans had been published in 1930, was a likely venue for an essay by a poet on photographic aesthetics. Rexroth proposed to the editor, Lincoln Kirstein, a selection of photographs and letters by Edward Weston, and a 3,000-word essay by himself. But although Kirstein liked the Weston material, he rejected Rexroth's work.[40] Nevertheless, the objectivist ideas Rexroth expressed found their way into the Group f/64, which was organized the following year.[41]

During 1929 and 1930 Rexroth had immersed himself in the works of A. N. Whitehead, whose most recent books, *Science and the Modern World* (1925) and *Process and Reality* (1929), proposed an objectivist approach to aesthetic knowledge. For the objectivist the sense perceptions of the individual enabled him to "know away from and beyond [his] own personality," to take in by direct experience the qualities of objects that connected him to an ever changing world of things and events. Weston's writings from the late 1920s offered the same kind of objectivist advice that Rexroth recognized in Whitehead: the photographer should reject "incoherent emotionalism" in favor of presenting the subject in front of the lens "objectively."[42]

The poet William Carlos Williams wrote concerning the art of Charles Sheeler that "it is in the shape of the thing that the essence lies," a formalism based on objectivist theory to which Williams was also committed.[43] Imagist poetry had demanded precise, clear description in place of vague metaphor and literary allusion, and rejected romantic themes in favor of direct presentation of the thing. Extending this precedent, Williams and other American poets including Louis Zukofsky, Charles Reznikoff, Carl Rakosi, and George Oppen, announced in 1931–32 the renewal of Imagism (1912–13) as Objectivism. In 1932 Zukofsky published a collection of works by these poets, *An "Objectivists" Anthology,* including three pieces by Rexroth. When Rexroth went to see Weston in Carmel, he was already in correspondence with Zukofsky about Whitehead's "systematic attempt to give the universe coherence."[44] Whereas the Imagist poets had celebrated transcendent moments in the immanent world, Objectivists now recognized in objects certain quintessential qualities. In photographic seeing this involved cool deliberation, suppressing

self-conscious pictorialism to release the distilled essence of an object's significance, as Weston phrased it, through "absolute impersonal recognition." The Objectivist poets drew a specific analogy between their use of language and the "objective," the lens through which rays of light converge to bring an object into focus, emphasizing detail "130 times over."[45]

In "The Objectivism of Edward Weston," Rexroth began by inventing a new term to describe Weston's photographic style—"Realfotography," shortened later to "Realfoto."[46] Weston had been introduced to the new German photography of the 1920s through art magazines in Mexico, and he selected the West Coast photographs for the "Film und Foto" exhibition in Stuttgart in 1929. These included botanical studies by Cunningham, who had studied in Dresden in 1909, and photographs by Albert Renger-Patzsch, whose work was well known to Weston and Adams by 1930.[47] Weston, Adams, and Van Dyke probably also saw a 1930 exhibition of Bauhaus work at the Oakland Museum.[48]

In a note appended to the end of his essay, Rexroth changed the somewhat political-sounding "Realfoto" to the more philosophical "objective photography." Although he disavowed any desire on his or Weston's part to establish a radical or avant-garde movement, it is conceivable that his philosophical terminology, as well as his left-wing political stance, may have contributed to Weston's discomfort about being part of a cult, an anxiety that led to the disbanding of Group f/64 in 1934. Weston's remark to Adams that photographers, "especially those taking new or different paths, should never become crystallized in the theories through which they advance," exhibits his uneasiness about Rexroth's application of theory to his art.[49]

Rexroth described Weston's photography as a "historical process which has reached fulfillment, a becoming which has become." He was alluding to Whitehead's *Process and Reality* (1929), where reality is envisaged as "the becoming of actual entities."[50] Henri Bergson's concept of the world in flux, acknowledged by Whitehead as one of his influences, was also referred to in Rexroth's essay: "This camera does not resemble seeing, it is not in competition with the eye. For the eye functions in a continuous stream of minutely shifting attentions, its world is a world of flux (contrary to Mr Wyndham Lewis, it is a quite Bergsonian organ), while the still camera has only one temporally limited orifice pointed at reality: the instant of exposure."[51]

In a letter to Ansel Adams in January 1932, Weston made a comparable point: "Photography is not at all seeing in the sense that the eyes see. Our vision is binocular, it is in a continuous state of flux, while the camera captures but a single isolated condition of the moment."[52] Rexroth's interpretation of Weston as an objectivist may well have stimulated this lengthy letter from Weston to Adams, in which "pure photography" was defined. Weston wrote that he had been inspired by Constantin Brancusi's works; he was drawn to them not for their abstract qualities but because they were founded upon rhythms and essential qualities in nature. "Nature has all

the abstract (simplified) forms that Brancusi or any other artist could imagine. With my camera I go straight to Brancusi's *source*." This idealist source yielded not external shapes of things but quintessences; the objectivist supplied the inner eye necessary to perceive this innermost essence of things.

Weston's statement for his first show at Delphic Studios directed the photographer to give a "direct presentation of things in themselves," and Adams, in the first of his *Camera Craft* articles in 1934 described the photographer's subject visualized as "a thing-in-itself."[53] Weston would have known the Kantian meaning of the "thing-in-itself" (*Ding an sich*) as the ideal that stands behind the appearance of the real. To reveal the thing-in-itself was not to describe its outward form but to apprehend its essence. William Carlos Williams expressed it as "No ideas but in things"—the only way for the artist to make contact with qualities of the Absolute, with abstract ideas, was by embracing the real things in which those ideal qualities reside. That Adams understood this may be seen in his text for a later book, *My Camera in Yosemite Valley*, in which he advised intense contemplation of the subject until it became "its sublimated self"—quintessentialized.[54]

Brancusi himself wrote that those who called his work abstract were mistaken: "What they think to be abstract is the most realistic, because what is real is not the outer form, but the idea, the essence of things." Rexroth presented Weston as a Whiteheadian objectivist pursuing life essences "in the centers of gravity of rocks and peppers" and "in the pressure lines of cabbages and onions."[55] Weston wrote in his daybook in April 1930, "The intuitive understanding and recognition . . . must be confined to a *form* within which it can burn with a focused intensity." Only in this way, he suggested, could the profound effect of the work of Brancusi be explained.[56] Rexroth considered Brancusi a revealer of form, an artist whose works were not so much created as "aided into existence," just as objects in the world were "parsed into significance" out of the aggregate of experience.[57] This was also the objectivist method in photography.

As an aesthetic theory, objectivism focuses on the relation of the individual to a universe of objects as well as on the more or less subjective or objective attitude toward that relation that the artist demonstrates. The work of art cannot ultimately avoid the impress of the artist's personality, however much the objectivist may wish to minimize it. Two years before his conversations with Kenneth Rexroth, Weston acknowledged the subjective aspect of the act of photographic creation: "Recording the objective, the physical facts of things through photography does not preclude the communication in the finished work, of the primal, subjective motive."[58] But two years after Rexroth's essay came to his attention, Weston declared photography's ultimate goal to be the "absolute, impersonal recognition of the *significance of facts*," indicating the influence of objectivism.[59] The idea that Weston had instilled in the other members of Group f/64—that only by the greatest self-discipline in suppress-

ing the artistic ego could the "impersonal lens-eye" concentrate the essence of "things *seen* into things *known*"—had certainly modified their attitude to pictorialism.

In an article on "The New Photography," Adams cited the distinction drawn by R. H. Wilenski between the light and dark shapes of naturalistic chiaroscuro and "architectural" form in art. Wilenski specifically identified architectural form in the work of the German photographer Karl Blossfeldt, whose botanical photographs had recently been published in London.[60] Blossfeldt's extremely close studies of leaf, stem, and bud transformed "the apparently ragged constituents of a tangled hedgerow into a series of structures informed with … a most evident order … and logic."[61] Blossfeldt's photography was for Wilenski proof that nature, looked at closely enough, revealed "truth of form." This classicizing tendency toward the ideal form in nature was often expressed by Adams in his reference to the artist's role in creating "configurations out of chaos."[62]

"Everything is structure," wrote the Purist Amédée Ozenfant in his *Foundations of Modern Art* (1931), and it is humanity's task "to disentangle apparent chaos." His statement that even microscopic natural phenomena appeared to "obey the laws which control the cosmos" was illustrated by a microphotograph of a diatom, and with photographs by Blossfeldt of magnified fern tendrils and leaf buds. Ozenfant and his coeditor of the journal *L'esprit nouveau*, Charles-Edouard Jeanneret (Le Corbusier), had published their manifesto of "Purism" in *Après le cubisme* (1918). The aim of the Purist artist was "to conceive clearly, execute loyally, exactly without deceits." Technique was "only a tool, humbly at the service of the conception."[63] Purists wished to reintegrate the object fractured and fragmented by Cubism, preferring to present whole forms through a precision of technique in paintings with unbroken contours and smooth surfaces.

In 1934 Adams published a series of articles in the magazine *Camera Craft*, setting out Group f/64's belief in the artistic potential of a straight objective style and establishing his reputation as a technical authority. The pictorialist photographer William Mortensen launched a countermanifesto in which he stated that the symbolic meanings of things, "not the things themselves," were the proper subject of art. Further, because the ends justified the means for the artist, photographic art should not be restricted to purely photographic techniques.[64] In a letter to Mortensen, Adams argued: "The Purist shuns sentimental-subjective connotations that undermine the power and clarity of the real photographic expression. … The objective attitude in no way implies that photography is not emotional. I am surprised that you are not aware that objectivity is only the tool of intense expression."[65]

Adams may have written as spokesperson for Group f/64, but Imogen Cunningham also contributed to its creed. In 1927 she provided seven photographs for *Aesthetic Judgement* (1929), by D. W. Prall, the University of California philosopher of aesthetics. Prall held the photographer's equipment to be intrinsically no less capable

of producing art than that of the painter: "To suppose that the degree of mechanical complication of tools prevents their full domination and control by a great artist is to overestimate tools and to underestimate artists. Paint brushes and pencils are mechanisms, and canvas and paint are as artificially manufactured as films or other photographic supplies."[66] Only through the clear perception of surfaces, Prall asserted, by the perfection of technique in the most characteristic qualities of the medium, could experience be fully apprehended by intuition.

What Adams referred to as "the microscopic revelation of the lens" was the power of photography to express the realness of a thing by the shock of its overwhelming textural specificity; to "make objectivity thrilling" through supreme technique.[67] Such texture, "one of the most important elements of photography," was the product of "detail plus depth of tone," but tonal values in the negative must be made to conform with the desired emotional results. It was in the deeper registers of tone that "the emotional quality of substance and texture" was revealed.[68] Texture, seemingly representing only visible surfaces, can present things as being more than physical objects. The first illustration in Adams's *Making a Photograph* (1935), *Boards and Thistles,* had been reproduced the previous year in *Camera Craft* with the caption, "An Objective Composition from Nature."[69]

In the fall of 1931 a London art-book publisher launched a new photographic annual, *Modern Photography*, as a special number of *The Studio* magazine. It included photographs by Tina Modotti (a close-up of a mother holding a naked child on one hip), Edward Steichen (an extreme close-up of a foxglove), and Imogen Cunningham (*Portrait of Gertrude Gerrish, Dancer*). It may have been Cunningham who introduced Adams and the others to the new annual and encouraged them to send in work. In this initial volume the reproductions in *Modern Photography* were printed in fine half-tone engraving on a glossy art paper and on the same page as the text—a suitable and straightforward reproduction technique for the new photography. In an introduction, the English writer G. H. Saxon Mills suggested that the best of modern photography included not only work with solely artistic claims but work that was a hybrid of art and documentary photography. In this halfway position "between the subjective and objective," Mills wrote, the camera found its true realm of expression. Adams wrote to Van Dyke suggesting that Group f/64 would be well served if the London publisher, The Studio, agreed to publish a collection of straight photography, because it had worldwide distribution.[70]

In the 1933–34 volume of *Modern Photography* (now published by The Studio separately from its own magazine, *The Studio*), Adams was dismayed, however, to find a photograph he had submitted reproduced in brown tones, and another by Weston printed in shades of blue. The only color recognized as photographic by purist photographers was the black produced by silver bromide papers, and Adams

was by this time firmly committed to the glossy aesthetic of half-tone engraving.[71] In February 1934, invited to send a photograph for the next annual, he took the opportunity to educate the editor and publisher, Charles Geoffrey Holme, on the demise of pictorialism and the emergence of a new style of photography in which faithful reproduction and appropriate printing techniques were important for expressing the new aesthetic. He offered some additional advice, suggesting that he include such photographers "working in the purer phases of the medium," as Willard Van Dyke, Dorothea Lange, Consuela Kanaga, Clarence Kennedy, Ralph Steiner, Henwar Rodakiewicz, Walker Evans, and Berenice Abbott, and articles by leading contemporary photographers.[72] Adams was immediately invited to write an introductory article himself to be titled "The New Photography" and to be delivered by April 14. A week after receiving it, Holme offered him the opportunity to publish a book for a new instructional series, and in a matter of days Adams had prepared a prospectus.

Adams hoped to provide a "practical-logical-aesthetic foundation for the serious student" that would define the basic properties of the medium and relate them to aesthetic expression. He would accomplish this with a "simple and dynamic text," a few line diagrams, some demonstration photographs of his own illustrating technical principles, and a portfolio of twelve photographs by Stieglitz, Strand, Sheeler, and Weston. He insisted upon a high quality of reproduction, for which he specified fine half-tone engravings on plate paper (coated art paper that has been calendered, that is, pressed between rollers for a smoother, shinier surface), and he even included samples of recommended typography. With regard to photomechanical reproduction, he strongly advocated the use of fine copper half-tone engraving as "the only medium which can convey the photographic *blacks*."[73] The Studio had in fact already employed such fine half-tone engravings, printed by Herbert Reiach, a London printer of fine art reproductions, in previous publications. Many readers have mistaken Adams's reproductions, overprinted with varnish and tipped in, for actual photographs.[74]

Making a Photograph: An Introduction to Photography (1935), published in London and New York, was number eight in The Studio's "How To Do It Series."[75] A one-page foreword by Edward Weston was followed by Adams's introduction, declaring his intention to demonstrate "the basis of 'straight' photography," and reminding the reader that "the finest works of photography have been produced without departure from the simpler aspects of technique or the most straightforward and honest aesthetic motivation." Ten of the thirty-four photographic illustrations in the book were specially made as technical demonstrations. Others illustrated advertising practice, action photography, architectural work, commercial portraiture, and photo-documentary.[76] Of the remaining images, another ten were representative of Adams's personal or noncommercial work with Group f/64.

When Adams told Stieglitz of a group of young West Coast photographers aspiring to "f/64," Stieglitz's famous retort that he was already "f/128" (twice as sharp) was metaphorically, if not actually, true; he had been making straight photographs for more than twenty years.[77] The "f/64" claim regarding high definition that Adams, Weston, Van Dyke, and Cunningham made for their group was not new but it was polemical in pictorialist circles. In 1930, two years before the group's founding, the English photography critic F. C. Tilney wrote that sharp definition was, according to pictorialists, intrinsically bad: "They refer to it as 'F:64' disparagingly, and having learnt that detail is 'finnicking,' these scholars imagine that they are to hold detail anathema."[78]

In the section of Adams's book subtitled "Aesthetic Considerations," he emphasized that "expression must remain purely *photographic*," without imitation of other media; only those materials and techniques should be used that would preserve the recognizable parentage of the image. Adams recommended a 4 × 5-inch camera and a good anastigmatic lens so that near and far subjects could be seen with equal clarity. First developed by Zeiss in 1889, anastigmatic lenses were corrected for the optical faults of chromatic and spherical aberration. The image seen through such lenses registered more distinctly and sharply on the ground glass of the camera and on the negative. But in the early 1920s in California, the pictorialist Karl Struss had produced his own lens, designed to maximize the effects of optically uncorrected glass and "possessing all possible errors, and giving, as a result of its optical defects, a very soft...quality of definition."[79] The pictorialist's aim was to render things imagined rather than things seen directly.

Adams had not always been entirely immune to the romanticizing tendencies of pictorialism himself. In about 1920, he wrote on the back of a soft-focus photograph he had made of a path on a hillside, "This is what Mr. Dittman said reminded him of 'A steaming pile of horse manure in a rainstorm.'" Frank Dittman, the commercial photofinisher for whom Adams worked in his teens as a laboratory assistant, was a professional who did not patronize the pictorialist salons. Willard Van Dyke admitted that commercial photographers, "with their emphasis on detail," had to some extent influenced Group f/64.[80] Photo-illustration was booming in the 1920s, and for young photographers like Adams, who built a house in 1930 next to that of his parents with a studio for his photographic business, photographic commissions from San Francisco companies, hotels, and department stores were an important source of income.

For professional photographers who sought fine definition, the introduction of the coated lens in the 1930s reduced lens flare and increased sharpness in the negative.[81] Comparing the capacity for registering the visual spectrum of light in the older orthochromatic negative film, which lacked sensitivity to red, against that of the newer panchromatic film, invented in 1906 by Wratten and Wainright, which

was sensitive to all colors, one writer noted that the making of a picture with panchromatic film was much easier because the final print was closer to what the eye saw.[82] This technological development also contributed to the ease with which the visualized image, perceived on the ground glass, could be transcribed as directly as possible onto the negative.

For Adams, the full range of tones from white to black was needed to represent subject matter objectively. But these tones also required certain inflections for their emotional expression, and those could be achieved by techniques basic to the medium. Pure bromide papers produced the deepest of blacks; their densities could be further enhanced by the use of amidol and of metol and hydroquinone, used together as developers, recipes for which were provided in an appendix to *Making a Photograph.* He considered the concentrated amidol formula best for giving maximum brilliancy of image and depth of tone.[83] "Papers that do not reflect the maximum amount of light," wrote Adams, "serve to restrict the clarity and intensity of the photographic values." In the 1930s photographic papers were coated with *barite* (barium sulphate) suspended in gelatin in order to obtain a brilliant white base and to prevent the emulsion from sinking into the paper.[84] Such glossy-surfaced papers, which Adams advocated, gave an impression of deeper blacks than matte papers because their mirror-like surface created only a single angle of reflection, whereas matte papers, with their textured surfaces, broke up the light into multiple reflections, giving a diffused, soft effect.[85]

The idea of tone control that Adams employed later in his "Zone System," using a scale of ten light intensities corresponding to different tones from white to black in the print, was introduced in *Making a Photograph.* Differences in the response of particular negative chemistries to under- and overexposure had been first charted in 1890 by Ferdinand Hurter and Vero C. Driffield.[86] With specific negative densities charted as tones, Adams was able to offer a system of relationships between exposure and density. Modern negative emulsions and developers now gave a considerable degree of tonal control by permitting the expansion or contraction of the range of values through magnitude of exposure and length of development.

Adams later demonstrated even greater tonal control by means of the new exposure-meter technology through which one subject-area of the image could be established as the key tone, shifting the range of tones relative to it up or down the exposure scale for "emotional amplification."[87] Exposure measurement had been hitherto limited to the "actinometer," a strip of paper sensitized to simulate the properties of the negative emulsion in use, which measured the time of exposure necessary for a relatively accurate rendition of subject brightnesses in the overall scene. It measured the incident light level but not individual reflectances of subject areas.[88] The early Weston meter, which Adams obtained in 1932, made both brightness range and key tone readings possible. Unlike other meters, it was calibrated in candles per square foot,

which allowed rapid calculations of exposure.[89] These new controls, in combination with negative emulsion, developer, time of development, and filtration, allowed the photographer to contract or expand the contrast range and thereby alter the degree of separation between tones in the negative, transforming mere shapes into emotional values.

In 1930 F. C. Tilney noted that some photographers were using the new panchromatic plate and color filters to lower the sky value in relation to the foreground, and he objected to this practice on the grounds that the tones produced were not naturalistic.[90] Adams's experiment in 1928 with panchromatic plates and filters to produce the dark skies of his *Monolith, The Face of Half Dome* fell into this category (see fig. 2.3). Now, in *Making a Photograph,* his description of the controls exercised upon the negative of *Frozen Lake and Cliffs* shows how his advanced technical skills were being put to creative purposes (see fig. 2.7):

> 4 × 5 camera, 18 in. lens; normal exposure, under-developed; print on contrast paper, slightly under-developed. An exceedingly difficult problem—the intensities of the subject are extreme. Contrast paper was used to intensify the values of the dark cliff. The under-development of the negative prevented the snow and ice from "blocking." The balance of values depends entirely on the exposure of the print; if too little, the result is very harsh—if too much, the cliff-values are hopelessly flattened. A case where extraordinary procedure is required to preserve "emotional" values.[91]

Great emphasis was placed on the print-making procedure in the execution of this image. Adams, unlike Weston, preferred to print by enlargement rather than by the true purist method of contact-printing, even at the possible sacrifice of a degree of fineness in gradation, because of the greater opportunity it gave him for expression.[92]

There are clear signs that Adams and Weston did not concur absolutely on the degree of personal expressiveness open to the photographer. The six paragraphs making up Weston's foreword to *Making a Photograph* were rewritten from a longer essay, "Photography," published the previous year. Weston describes his notion of previsualization as the moment when the object is most significantly revealed to the imagination of the photographer, the moment when its form is most directly seen: "The previsioned image on the ground-glass is perpetuated at the very moment of clearest understanding." This is most effectively accomplished by means of the view camera and the contact print, the negative development and print being simply an extension of the photographer's momentary experience. Adams phrased it somewhat differently: "The photographer visualizes his conception of the subject *as presented in the final print.*"[93] Although Weston does say that the previsioned conception must be complete in every detail, his emphasis is on the revelatory experience in the presence of the object, whereas Adams sees the print as the ultimate revela-

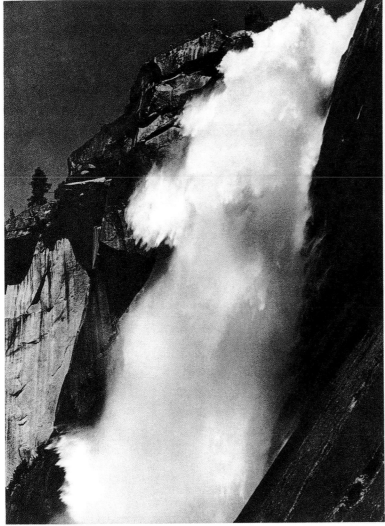

1. ANSEL ADAMS : Nevada Fall. Yosemite Valley, California.

A superb study of water, considered by the photographer his best landscape photograph.

Fig. 3.6. Ansel Adams, *Nevada Fall, Yosemite Valley*, photogravure from C. Geoffrey Holme, ed., *Modern Photography 1934–35*, London and New York: The Studio and Studio Publications, 1935, Plate 1

tion. Because Group f/64 was engaged in a crusade against emotionalism and sentimentality, Weston warned against postvisualized expression as "an objectification of one's deficiencies and inhibitions." For Weston, the object's essence was in the negative (and its image in the contact print); for Adams, felt expression was in the printed enlargement, over which considerable expressive control could be exerted.

Adams had a major exhibition of his own work at the Mills College Art Gallery in Oakland in early spring 1933, and immediately afterward traveled east with the aim of meeting Alfred Stieglitz, Edward Steichen, and other famous New York photographers. He took letters of introduction from Albert Bender and others, and he made arrangements for exhibitions of his work on the East Coast.[94] The impact of

Fig. 3.7. Ansel Adams, *Self-Portrait*, c. 1936, gelatin silver print

his first meeting with Alfred Stieglitz at his New York gallery, An American Place, was profound and formative, and one of its effects was to motivate Adams to open his own gallery in San Francisco.

By 1934 he was also becoming aware of the dangers of his perhaps excessive emphasis on technical mastery. Initially he felt he had received the ultimate accolade in Stieglitz's response to his work as "technically perfect," but then he began to appreciate that it was only half a compliment, an implied criticism of affective inadequacy.[95] *Making a Photograph* may have served as the technical manual of the f/64 movement of perfect photography, praised by Stieglitz as "straight and intelligent," but Adams soon realized that depth of feeling was just as important as technique. He wrote to Willard Van Dyke, "Technical perfection is not the only thing. I am

aware in my own work of the necessity of adding *something else* to my photographs than the striving after pure technical expression."[96] This "something else" (Weston's "plus") was a quality of intuition in the photograph that would be meaningful to a Stieglitz steeped in German idealism and psychoanalysis.

By the time he came to write an introductory statement for his exhibition at An American Place in 1936, Adams was no longer satisfied with the modest capacity of the camera to render the subject objectively. He now called for subjectivity in every aspect: "Photography is a way of telling what you feel about what you see. And what you intuitively choose to see is equal in importance to the presentation of how you feel—which is also intuitive."[97] That he had been influenced by Stieglitz is clear. Ten years earlier, Stieglitz had told Weston something similar: "We only know what we feel."[98] The objectivist resistance of the artist's imposition of personality on the work, Weston's "impersonal revealment," ought not to preclude the psychological impulse of the subjectivist to make the world real by an intuitive, affective response to it.

In *Modern Photography 1934–35,* Adams's photograph *Nevada Fall, Yosemite Valley* was described in the caption as "a superb study of water, considered by the photographer his best landscape photograph" (fig. 3.6). It is possible that his talks with Stieglitz may have opened Adams to the Symbolist qualities of ephemeral forms, as demonstrated in Stieglitz's own cloud studies, which he called equivalents. In the billowing cascade of Nevada Fall, Adams as an f/64 member had found himself dealing objectively with the scene, but under Stieglitz's influence he may now have appreciated its subjective potential.

The final illustration in *Making a Photograph,* of a weathered pine in the mountains, was made on the occasion of a Sierra Club high-country trip in the summer of 1932.[99] Soon after he had been offered a one-man show by Stieglitz, Adams set up a self-portrait in which he appeared to photograph himself with a view camera in front of this print on the wall (fig. 3.7). It was an objectivist revelation now recast as a subjectivist symbol of the kind that Stieglitz would recognize.

Expression as Equivalent

On his second visit to Taos, New Mexico, in 1930, Adams was deeply impressed by meeting with Paul Strand and the painters Georgia O'Keeffe and John Marin, three members of the Stieglitz circle completely committed to the art of landscape. Three years later, in March 1933, and with the confidence of his recent cofounding of Group f/64, he traveled to New York to see Alfred Stieglitz himself. On his return to San Francisco, he wrote to Strand about his visit, "I am perplexed, amazed, and touched at the impact of his force on my own spirit. I would not believe before I met him that a man could be so psychically and emotionally powerful." [1]

In inscribing to Adams a copy of *Camera Work,* Stieglitz wrote, "In memory of the hours at An American Place & to a photographer who respects Photography & who isn't lost in theory or formula." [2] The rejection of theory and formula is reflected in the writings of the philosopher F. S. C. Northrop, who interviewed Stieglitz for his book *The Meeting of East and West* (1946). Northrop, a pupil of A. N. Whitehead, differentiated the "aesthetic component," or the direct intuitive experience of nature, from the "theoretical component," by which he meant all forms of scientific and religious doctrine. He exemplified the idea with a reproduction of a painting by O'Keeffe, *Abstraction No. 3* (1924), which somewhat suggests a pebbled stream-bed (fig. 4.1): "Although something actually observed in nature is faithfully portrayed, the subject matter is such that the external physical objects, of which this is the aesthetically immediated component, cannot be identified; and one is thereby forced to apprehend the aesthetic component of reality by itself for its own sake. One has pure fact with all its emotive quale and ineffable luminosity, before the inferences of habit and thought have added their transcendent references to the external three-dimensional objects of common sense or scientific belief, to the theological objects of traditional Western religious faith, or to the future pragmatic consequences of reflective action." [3] This quale of feeling, in its immediacy of perception, was independent of the abstracting intellect. The painter Arthur Dove wrote, "There is no such thing as abstraction. It is extraction.... If the extract be clear enough its value

Plate XI ABSTRACTION NO. 3.
GEORGIA O'KEEFFE. 1924
Courtesy of An American Place

THE AESTHETIC COMPONENT — THE DIFFERENTIATED
AESTHETIC CONTINUUM

Fig. 4.1. Georgia O'Keeffe, *Abstraction No. 3*,
1924, halftone from F. S. C. Northrop,
The Meeting of East and West,
New York: Macmillan, 1946, Plate 11

will exist." Adams also referred to the aesthetic component of his work as extraction
rather than abstraction.[4]

Northrop attempted to resolve the duality of emotive quale and formulaic
thought in the work of art by "epistemic correlation" of its immediately appre-
hended aspect with its theoretically known aspect. The artist was, therefore, indis-
pensable for interpreting the complex philosophical problems of the time: "What
cannot be grasped by everyone literally in terms of the concepts by postulation of
the scientist and scientific philosopher can be suggested and presented analogically
with vividness and moving power, by recourse through epistemic correlation to the
concepts by intuition of the artist."[5] Reason should give way to intuition where
necessary.

In 1909, the Italian philosopher Benedetto Croce had already proposed that art
was produced by such epistemic acts of intuition, the objectification of impressions
from external reality. Both Stieglitz and Strand, who read Croce, affirmed his view
that, "if photography have in it anything artistic, it will be to the extent that it

Fig. 4.2. Ansel Adams, *Picket Fence, Sierra Nevada*, c. 1936, gelatin silver print

transmits the intuition of the photographer."[6] In his *Aesthetic,* Croce presented the theory of "intuitional cognition" as a means of knowing that was absolutely indistinguishable from an act of expression, in which intuition was objectified through form and extracted from the flux of sensation.[7] Artistic expression was, therefore, realized in actuality and released in emotion.[8]

Croce's ideas were taken up and enlarged upon by his English disciple R. G. Collingwood in *Principles of Art* (1938). Collingwood distinguished between craft and art by focusing on the problem of the expression of emotion. The work of art was the artist's expression of his or her feeling; furthermore, until the artist actually expressed the emotion, he or she had no understanding of what that emotion was. The sense of release experienced in the psychic unburdening of a previously unformed and unexpressed feeling Collingwood termed "aesthetic emotion." This fits well with Stieglitz's classic equation, "To show the moment to itself is to liberate the moment." To be fully conscious of an intuition was to release its expression com-

pletely. Croce's theory of expression was expanded by Collingwood to include the idea that the viewer of the work of art is as much engaged in the act of expression as the artist, and thus becomes an artist by participation. "When someone reads and understands a poem," wrote Collingwood, "he is not merely understanding the poet's expression of his, the poet's emotions, he is expressing emotions of his own in the poet's words."[9]

In May 1934, Adams hinted to Stieglitz that he badly needed a venue at which to present his recent work. A year later, giving Stieglitz a copy of *Making a Photograph* (1935), he recalled, "My visits with you at An American Place remain my greatest experiences in art—they opened wide and clear horizons." In January 1936, following a trip to Washington to represent the Sierra Club at a National Parks conference, he returned to New York and was offered an exhibition at An American Place, Stieglitz's last gallery, to be held at the end of the year. Back in California he wrote, "My visit with you provoked a sort of revolution in my point of view—perhaps the word simplification would be better."[10]

On his return from the Sierra Club high-country outing in August 1936, he wrote to Stieglitz to say how pleased he was with the photographs he had made on the trip, adding that for the forthcoming exhibition he would send more prints than could be shown, so that Stieglitz would have greater freedom of selection.[11] On October 11, Adams sent Stieglitz thirty-eight mounted and glazed photographs, with an unspecified number of additional loose prints.

The exhibition at An American Place, which opened in November 1936, included forty-five photographs, hung by Stieglitz himself. In his sequencing of the show, Stieglitz placed two extreme close-ups of weathered wood side by side. The greatly magnified pickets in *Picket Fence, Sierra Nevada*, though rough-hewn and cracked from exposure, stand as six triangular units through which runs a horizontal fence plank, apparently straight-planed except for a knothole forcing a curve in the grain of wood, a sign of the essentially organic nature of the object (fig. 4.2). Next to it was placed *Tree Detail, Sierra Nevada*, magnified to an even greater degree, showing a detail of broken layers of bark on a tree, probably fallen but presented as growing upright (fig. 4.3). Light coming from the upper left picks out the profile of this miniature mountain ridge against a dark wood-grain sky, which also seems to draw the energy of the image upwards at a slight angle. By placing this organic but formally similar object next to the handmade one, Stieglitz made these metaphors doubly metaphorical as microcosmic equivalents of the natural and the human scenes.

On visiting the show, Adams wrote home to his wife in exhilaration, "I am now definitely one of the Stieglitz group. You can imagine what this means to me."[12] His exhibition statement revealed the progress he had made in three years under Stieglitz's tutelage:

Fig. 4.3. Ansel Adams, *Tree Detail, Sierra Nevada*, c. 1936, gelatin silver print

Photography is a way of telling what you feel about what you see. And what you intuitively choose to see is equal in importance to the presentation of how you feel—which is also intuitive. If you have a conscious determination to see certain things in the world you are a potential propagandist; if you trust your intuition as the vital communicative spark between the reality of the world and the reality of yourself, what you tell in the super-reality of your art will have greater impact and verity.... In this exhibit at "An American Place" I have tried to present, in a series of photographs made during the past five years, certain personal experiences with reality. I have made no attempt to symbolize, to intellectualize, or to abstract what I have seen and felt. I offer these photographs to the intelligent and critical spectator only for what I believe they are—individual experiences integrated in black-and-white through the simple medium of the camera.[13]

His Bergsonian description of intuition as a "vital communicative spark" may also be partly attributed to his reading of D. H. Lawrence, who insisted that a rich awareness of life must come from an acceptance of the "vivid relatedness" of hu-

man beings with nature, and that the meaning of true religion lay in "direct contact with the elemental life of the cosmos."[14] Adams insisted, however, that these remained personal connections with the real world: individual experiences, transmitted in his case by means of photography.

Adams wrote to his assistant, Patricia English, about how Stieglitz had hung the show, relating pictures to each other, and the parts to the whole, in a way that brought out qualities in them that Adams had not been consciously aware of. Adams felt that Stieglitz had revealed him to himself. The juxtapositions of the prints on the wall, he wrote to Patsy English, "actually psychoanalyzed me."[15] The prints were not organized thematically, but "were related to one another in such a way that both my strength and weakness were indicated. 'An American Place' is a laboratory —and that is what makes it so exceedingly important." Adams saw Stieglitz's gallery as a place where art achieved a Northropian power equal to that of science, the power to disclose the meaning of facts by means of intuition. As master of these spiritual experiments, Stieglitz assisted Adams in his epistemic turn from objectivist to subjectivist. Transcendence for the objectivist lay in the revelation of essence, a quality derived from the object itself; Adams had witnessed its achievement in Weston, but most of the other Group f/64 members had not attained such a subtle charge of transcendence.[16] Transcendence for the subjectivist came through the creation of the equivalent, a term Stieglitz explained to Adams as follows: "I perceive something of interest and significance; I recognize a photograph; I make the photograph. I show it to you as an equivalent of something that I felt and responded to."[17] If, having experienced such an equivalent, the viewer was moved to create a work of art himself or herself, Stieglitz was doubly satisfied. Such a degree of sympathetic attention had been brought to bear on the work that the viewer, becoming for a moment one with the photographer, had achieved a corresponding state of feeling.[18] Through the viewer's effort to bring his or her consciousness and emotional sensitivity to the same level as the artist's, the viewer became in effect the artist's equal, in an equilateral triangle of equivalent response.

In Maurice Denis' *Théories, 1890–1910,* which Francophile members of the Stieglitz circle—Edward Steichen, Paul Haviland, and Marius de Zayas—knew by heart, the Synthetist painter substituted Zola's definition of naturalism with a new Symbolist ideal for artists: "We have replaced the idea of 'nature seen through the medium of a temperament' by the theory of the equivalence or the symbol. We assert that the emotions or states of the soul evoked by some spectacle involved in the artist's imagination are signs or plastic equivalents capable of reproducing these emotions...without the necessity to furnish the copy of the initial spectacle; that with every condition of our sensibility there must be a corresponding objective harmony which is capable of translating it."[19] Denis, however, still equated the equivalent with the symbol, even as he tried to separate the affective aspect of the work

Fig. 4.4. Ansel Adams,
*White Gravestone, Laurel Hill
Cemetery, San Francisco,*
c. 1936, gelatin silver print

of art from its formal expression. In subsequent discussions of the equivalent by members of the Stieglitz group, there was an unfortunate conflation of the two terms "symbol" and "equivalent." Whereas an abstract symbol is purely representative of a philosophical or religious doctrine, the equivalent is a symbol extracted directly from the world and harmonized aesthetically. In the equivalent, Northrop's theoretical or doctrinal component was taken for granted, and according to Adams was meant to remain so: "I firmly believe that if a photograph *needs* verbal explanation or interpretation it has failed in its essential objective, which is to transmit a visual experience."[20] The doctrinal component was to remain unspoken.

Wassily Kandinsky's *Über das Geistige in der Kunst* (1911), a nexus for the ideas of all the painters in Stieglitz's circle, was another important source for the conception of the spiritual in art. Even before it was translated into English as *The Art of Spiritual Harmony* by M. T. H. Sadler in 1914, parts of the text were made available in the United States through the extracts translated by Stieglitz himself and published in *Camera Work.* Kandinsky, who had read Rudolf Steiner's *Theosophy* (1904), called upon artists to seek "the inner spirit in outer things."[21] He described three existing kinds of art: mere imitation of objects; impressions of nature; and an "inner feeling expressed in terms of natural form—a picture with *Stimmung*," to which the viewer responded harmoniously; that is to say, equivalently.[22] Weston was deeply impressed with Kandinsky's book, which he received in August 1927. He referred to the painter's writings in a daybook entry in 1930 about artistic revelation: the flame ignited in the artist by subject matter, the creative understanding by which he related the mundane world to the esoteric realm, had to be composed as a form; otherwise it would flare briefly and then just smolder: "This is mysticism,—of course! How else can one explain why a combination of lines by Kandinsky, or a form by Brancusi, not obviously related to the cognized world, does bring such intense response."[23]

Adams had begun to appreciate, under Stieglitz's tutelage, the expressive limitations of his Group f/64 photographs. In *Thus Spake Zarathustra*, Nietzsche wrote that "for the creator to appear, suffering itself is needed, and much transformation." In his book on Nietzsche, A. R. Orage had described tragedy as "the dream world of a Dionysian ecstasy."[24] After his meetings with the remarkable Stieglitz, Adams realized that that had been missing from the Apollonian style of Group f/64. He needed an element of psychological instability if he were to engage with the world subjectively as well as objectively, perhaps even the Dionysian shock of an extra-marital affair. Doubtless Stieglitz quoted to him Nietzsche's test of a good marriage, as "being able to endure an occasional 'exception.'"[25]

Living the fullest possible emotional life properly prepared the artist for his or her work, even if it meant inviting tragedy. Unlike Stieglitz and Weston, Adams finally eschewed the divorce that might result from an extramarital relationship, even if he did indulge his memory of an affair in the photograph *White Gravestone, Laurel Hill Cemetery, San Francisco,* which he referred to as "the White Tombstone" (fig. 4.4). It was Patsy's favorite photograph. Stieglitz singled it out as the best in Adams's exhibition, assigning to it the affective aspect of an equivalent, locating in it the artist's most deeply felt emotion.[26] Another photograph, not exhibited in the show, combined some of the formal and symbolic aspects of the White Tombstone with an actual experience of the High Sierra. *White Stump* was made during the summer that Virginia and Patsy both joined him on the Sierra Club outing of 1936, the lengthwise crack through the tree stump perhaps suggesting a threat to the continuity of those relationships (fig. 4.5). The whiteness and upward motion of both

Fig. 4.5. Ansel Adams, *White Stump,
Sierra Nevada, California*, 1936,
gelatin silver print

the subjectively angled tombstone and the stump was an equivalent of grief, even of lamentation.

Stieglitz's idea of subjective equivalence was a recurrent theme for a quarter of all the contributors to a major Festschrift, *America & Alfred Stieglitz* (1934), which Adams must have read as soon as it appeared.[27] Paul Rosenfeld proposed that the photographer could offer the viewer a subjective kind of experience: "an equivalent of some vision excited by a previous experience," objectified in the form of particular subject matter, later recognized as expressive. Such a photographer possessed the highly refined intuitive ability defined in a quotation from Schopenhauer as

"perfect objectivity; an objective direction of the spirit as opposed to a subjective one directed towards one's own person and its will." Perfect objectivity, derived from intuition, forged a link between artist, object, and responsive viewer. In this enlightened state, objective intuition "finds something that is both distinct and universal, momentary and eternal, of the many and the one: a kind of culmination of the entire universe onto one of its parts and moments—events past or approaching—that, for all their instantaneity, share the infinity and eternity of the whole. And with the tactile, visual, or auditory rhythmical symbols...communicated to it there...it reveals that ever changing and still permanent harmony, order, and law of nature."[28]

Rosenfeld stressed that Stieglitz's equivalents were naturalistic and spontaneous, even when they were also embodiments of eternal ideas, "symbols of the Most High." He also suggested that Stieglitz's photographs employed formal equivalence to represent psychological forces. The rectangular frame of the photograph was often divisible into "two or more rhythmically disposed, intrinsically interesting primary units," which were in turn made up of groups of smaller units.[29]

In *The Art of Spiritual Harmony,* Kandinsky named Giovanni Segantini and Ferdinand Hodler as two of his most important predecessors.[30] By the mid-1890s, Hodler had developed a theory of compositional equivalence that he called parallelism. By means of formal reiteration he expressed his own inner feeling by relating layer upon layer of multiple, but not identical, parallel elements. With his basic concept of the unity of life and the underlying structure of the universe, he applied it not just to figurative works like *Die Nacht* (1890) but also to his landscape compositions.[31] In *Thunersee mit Grundspiegelung* (1904, fig. 4.6) he created lateral regions of distinct but related substances: from foreground of stones, to reflective and translucent lake surface, to mountain peaks with clouds high above, much as Adams would in *Lake MacDonald, Glacier National Park* (fig. 4.7).

In 1911, Georg Simmel suggested that the Alps defied artistic representation because there was no way to adequately express their vast scale. Even Hodler and Segantini, he argued, with all their artistic devices of stylization, accentuation, and effects of tone failed to convey the massive extent of the Alps. Formless and chaotic, without any sense of unity, especially in the highest snowbound regions, the Alps offered a landscape that was ahistorical and therefore, paradoxically, transcendent. Because all substances in nature were related to each other, things became form only in relation to something else, but the highest alpine region allowed no such sense of relation. Beyond even the sublime, it was an entity unto itself that defeated the attempts of most artists to represent it because it was immeasurable and unimaginable by human standards.[32]

Three of the most important painters of the Stieglitz circle traveled to Europe for their artistic education and to meet the mountain challenge: John Marin, Arthur Dove, and Marsden Hartley. In 1932, Hartley wrote that he had learned to know

Fig. 4.6. Ferdinand Hodler, *Thunersee mit Grundspiegelung*, 1907, halftone from Ewald Bender and Werner Y. Müller, *Die Kunst Ferdinand Hodlers*, 2 vols., Zurich: Rascher Verlag, 1941, 2:99

the essence of the mountains through Segantini's example of understanding "the THING-ness of things, causing the mere human soul to penetrate the substance of everything." Equally, he found Hodler had expressed through his paintings "the grandeur and the austerity of the mountain, its force, its formalities, its exclusiveness, its hauteurs, its ultimate independence." Those who had come into contact with the mountains knew more of the basic element of experience than those who had not.[33] In Adams, whom he met at Stieglitz's gallery in 1933, he would have found a common enthusiasm for the art of mountains.[34] In Hamburg that summer, Hartley was impressed by a film he saw about German alpine climbing, which effected in him "a conversion to nature." With the revelation that he was at heart "a mountain person and a snow person," he embarked on a series of mountain subjects in the Bavarian Alps.[35] Stieglitz showed them at An American Place in the spring of 1936. On November 27, 1936, a group show of the Stieglitz circle opened, including paintings by Hartley. Two weeks earlier, Adams was in Stieglitz's gallery for his one-man show.

In 1933, Adams recalled his introduction to John Marin's work in Taos as his "most immense experience in art," and when he returned to California from his

Fig. 4.7. Ansel Adams, *Lake MacDonald, Evening, Glacier National Park, Montana,* 1942

visit to New York that year, he carried with him a copy of the *Letters of John Marin,* privately published in 1931. The friendship between Marin and Adams had been quickly established on the common ground of a love of music. In the autumn of 1936, when Adams arrived in New York for his own exhibition of photographs at Stieglitz's gallery, a retrospective show of 225 works by Marin selected by Stieglitz had opened at the Museum of Modern Art, and Stieglitz asked Adams to make a set of installation photographs for him.[36]

Marin's *Tyrol Series* (1910), *Castorland, New York* (1913), *Hudson River, Hook Mountain* (1925), *White Mountain Country* (1927), and many of the landscapes created in New Mexico in 1930 often employed the parallelism of relations among foreground, sky, and mountain established by Hodler during Marin's European years, 1905–10.[37] Charles Caffin saw Marin's time in the Tyrolean Alps as the formative experience of his artistic development, suggesting that the mountains had taught him how to wield formal control over colossal forces of nature. In Taos, Adams witnessed at first hand Marin's attempts to register the immense forms of nature as musical

Fig. 4.8. John Marin, *Storm over Taos, New Mexico*, 1930, watercolor over graphite. National Gallery of Art, Washington, D.C., Alfred Stieglitz Collection

equivalents.[38] In *Storm over Taos, New Mexico* (1930), a group of tiny adobe house blocks is held between two layers of color: one consisting of a vast thunderstorm merged with sacred Taos Mountain above, and the other of strips of green and golden fields below (fig. 4.8).[39]

In 1942 Adams used *Half Dome, Yosemite Valley* to describe what he called "sector analysis," by laying over it a diagram of geometrical relationships (fig. 4.9). He claimed that photographic composition differed from composition in other graphic media because it depended on the tension between the camera's ability to convey the real form of the object and the artist's desire for its depiction in two dimensions; forms represented in the subject were divided into the flat shapes organized on the ground glass. To compose photographically, the photographer should adjust to his or her satisfaction the "sectors of lines of force or direction evolving from the subject." Formal composition was the result of the imposition of intellect tempered by emotion, whereas intuitive composition was the product of emotion tempered by intellect and experience: "A very pertinent musical analogy may be made in this regard; a phrase of strict notation and meter is performed with elasticity depending on its tonal dimensions and 'shape' and on its emotional weight and emphases. Formal relations in photography, as in all art, should be similarly elastic and flexible."[40]

Landscape parallelism, or formal equivalence, may be discerned in Adams's

Fig. 4.9. Ansel Adams, *Half Dome, Yosemite Valley*, 1923, halftone from Ansel Adams, "Geometrical Approach to Composition," *The Complete Photographer* 30:5 (10 July 1942), fig. 6

Moonrise, Hernandez, New Mexico (fig. 4.10), which can be usefully compared with Hartley's *[Cemetery], New Mexico* (1920), owned by Stieglitz and reproduced in *America & Alfred Stieglitz* (fig. 4.11). Both Hartley and Adams owed an evident debt to Segantini, whose *Death in the Alps* (circa 1898–99), the final panel of the triptych *Nature, Life and Death* (1896–99), presents a similar subject and similar composition (fig. 4.12). The subdued note of a burial scene in the foreground is juxtaposed with a panorama of snowcapped mountains, above which stretches a long cloud shape with a glowing, spherical center.[41]

Adams later recalled that he had been taking a second exposure when the light suddenly faded from the crosses, so he packed up and continued on his way. It was the light on the crosses in relation to the moon that had captured his interest, a light that originated not from the moon but from the sun behind him.[42] The occasion lasted only a moment but it was an affective equivalent, drawing on Edward Carpenter's comparison of *Towards Democracy* with Whitman's *Leaves of Grass* as "of the moon compared with the sun."[43] In *Moonrise*, Adams embodied Whitman's sun radiance through Carpenter's moon mystery.

Fig. 4.10. Ansel Adams, *Moonrise, Hernandez, New Mexico,* 1941, gelatin silver print

In "A Personal Credo, 1943," Adams described the primary creative stage of making a photograph, which he called "pre-visualization": "It exists at, or before, the moment of exposure of the negative. From that moment on to the final print, the process is chiefly one of *craft*; the pre-visualized photograph is rendered in terms of the final print by a series of processes peculiar to the medium." Simplification of the principles of sensitometry allowed him greater control over tonal values than had been possible previously. The Zone System, as he called it, was a method of regulating tonal relationships in the negative, "simply a way of thinking about values and controlling them."[44] After he had established the tonal relationships, he was prepared for the expressive phase of making the print.

In *Moonrise,* Adams perceived from the beginning that the sky could be blacker, but he also knew that darker printing overall would mean sacrificing detail in the

Fig. 4.11. Marsden Hartley,
[Cemetery], New Mexico, 1920,
halftone from *America & Alfred Stieglitz*,
New York: Literary Guild, 1934, Plate 15

Fig. 4.12. Giovanni Segantini,
Death in the Alps, c. 1898–99; final panel
of the triptych *Nature, Life and Death*,
1896–99, photoengraving from Luigi Villari,
Giovanni Segantini: His Life,
London: T. Fisher Unwin, 1901

lower half of the photograph. In 1948, therefore, he intensified the negative in the church and cemetery area of the image, which allowed him to darken the sky somewhat more while still retaining clarity in the foreground.[45] With heavier printing and the use of selenium toner for heightened contrast, the crosses became even more sharply picked out, the high mesa beyond was subordinated to a middle tone, and the contrasted snow of the mountaintops merged with the white of the sheet of clouds. Progressively, a strong set of parallel bands was established: adobe church with crosses, mountains and clouds, moon and void. One of his early poems is

Fig. 4.13. Ansel Adams, *Minor White*, 1958, gelatin silver print

quoted in Newhall's biography: "O moon, you stare as a white cave from the cold stone of the sky / And the long mesas flow far under your silence."[46] In *Moonrise* the technical controls that Adams had perfected enabled him to realize the full gamut of formal and tonal equivalence: an objective harmony with an inferred theoretical component, namely, the mortality of individual human existence confronting the eternity of the universe, the theme of life and death.

In 1945 Adams and his friend the architect Eldridge T. Spencer conceived the idea of developing a department of photography in the California School of Fine Arts (today the San Francisco Art Institute), to be administered by the San Francisco Art Association, of which Spencer was president.[47] Headed by Adams, the department began in the fall of 1945 as a series of monthlong courses. Minor White (fig. 4.13), a photographer who had been living in New York since being discharged from the army after the war, was assisting Beaumont and Nancy Newhall on an informal basis in the department of photography at the Museum of Modern Art. When Edward Steichen was appointed curator, White turned down an offer to stay on as his assistant and applied, on the Newhalls' recommendation, to teach in the new photography department at the California School of Fine Arts. He brought to the department principles of aesthetics and art history from his course at Columbia University with Meyer Schapiro, and ideas about expressing emotion through photography from Stieglitz, whom he had met in February 1946. Like Adams, he had also struggled with Stieglitz's concept of the equivalent, as it had been expressed in *America & Alfred Stieglitz*. In 1947 White described the equivalent as an affective objectification of the artist's emotional state. He gave as example Stieglitz's story of

having a special feeling about some person and then discovering an image in clouds to convey the same feeling to a viewer of the photograph.[48] In 1951 White further narrowed his definition: equivalence reflected the artist's unconscious state.[49]

With Adams, the Newhalls, Dorothea Lange, and others, White cofounded the magazine *Aperture* in 1952 and became its first editor. The following year he left San Francisco for Rochester to work as exhibitions curator under Beaumont Newhall at George Eastman House. In 1955 *Aperture* published a long article by Dorothy Norman, "Alfred Stieglitz—Seer." Here, in the first of her three published accounts of Stieglitz's life and work, she ascribed a psychoanalytic function to his work, recounting his efforts toward self-understanding through photographs of "those moments that would enlighten him about the cause of his own heartache."[50] Stieglitz had used a cloud photograph as a diagnostic tool for interpreting the psychological profiles of his visitors, asking them to turn it on all four sides, then tell him which way they preferred it. In *America & Alfred Stieglitz,* Evelyn Howard, a physiologist, had placed the equivalent within a framework of experimental psychology, explaining that in studying the reactions of different people to his work Stieglitz had noticed that certain pictures provoked identical responses from different people, and that, insofar as these results were predictable, they were scientifically sound.[51] Stieglitz hoped that, by evolving spiritually, human beings would eventually achieve a kind of divinity in which people would suffer the sorrows of others simply by experiencing them in photographs.

White's three-hour critiques of third-year students' work at the California School of Fine Arts were, effectively, group therapy sessions intended to disclose the unconscious mind of the photographer hidden beneath the image. A high point for the students each year was a five-day trip to visit Edward Weston, study his prints, and be psychically challenged by the subject matter of Point Lobos. Here, White said, the students "crossed the borders of picture aesthetics into the realm of the therapeutic."[52] The interpretation of an image was a strictly personal affair.

By 1959 when White published the special issue of *Aperture* entitled "The Way Through Camera Work," he was prepared to define the equivalent as "a name for our most spiritual and poetic use of photography." The issue opened with a quotation from Stieglitz, "In all of camera work the only freshness is spirit, and spirit is the only quality in art that forever eludes imitation," but it closed with an editorial aphorism suggesting that Stieglitz's use of the affective equivalent had now been surpassed: "Through the everyday looking-glass runs the way of camera beyond affirmation and negation." In this esoteric sense of the equivalent, the commonsense world of things no longer held value because meaning could be discovered only on the other side of the mirror through introspection of the unconscious.[53] This reappraisal and enlargement of the meaning of the equivalent took place in the context of Zen Buddhism, Gurdjieff's ideas, and psychoanalysis.

But Adams shared D. H. Lawrence's dislike of the talk-therapy of Gurdjieff and psychoanalysts. He rejected the attempts to articulate unconscious states and personal fantasies, and he disliked White's emphasis on the purely personal nature of photography. "Witness some extremely esoteric and valueless non-objective painting (and photography) in contradistinction to the photography of Stieglitz," wrote Adams, "I'm FOR Stieglitz! But Stieglitz transcended the transitory."[54] Stieglitz's cloud equivalents, Adams suggested, although perhaps esoteric at times, transcended personality and temporality to achieve a level of symbolic significance that was generally accessible. For Adams, the concept of self was essential as a means of expression of the material world precisely because it was "burdened with the responsibility of world-relationship." With good-humored persistence, Adams continued throughout their long friendship to resist White's belief that the photographer had "only one subject—himself."[55]

For White the naturalistic propensity of photography was a dangerous deception, because it perpetrated "the illusion that *life itself* is the only reality." White, collaborating in 1957 on an article with another photographer, Walter Chappell, claimed that the equivalent transcended this illusory use. They categorized Adams's landscape photographs as documentary: "In the sense of 'pure reporting' or 'direct transference,' Ansel Adams reporting the natural scene is as documentary as Lewis Hine, who reported the social scene."[56] White formulated Adams's approach to photography as "the camera used as a musical instrument to interpret a score composed by somebody else."[57] The somebody else was, of course, nature itself.

In 1937 Adams had made two photographic expeditions into the High Sierra with Edward Weston. Between those two trips Weston made a series of three photographs of advancing waves taken from a fixed camera position on a 400-foot cliff above a beach near Orick, on the coast of Humboldt County, California (fig. 4.14).[58] When Nancy and Beaumont Newhall first visited California in 1940, Adams drove them to Yosemite, then on to Weston's home in Carmel, where Weston showed them the prints he had made in the past three years while on his Guggenheim Fellowship. On the drive back north to San Francisco from Carmel, Adams and the Newhalls, "visually invigorated," stopped several times to photograph along the coastal highway.[59] Nancy recalled how on one of these stops Adams photographed straight down on the swirling sea breaking on the beach below, making a series of exposures. Edward Carpenter had once asked, "Why, looking down from a cliff upon the sea, do we isolate a wave and call it *one?* It is not isolated; no mortal could tell where it begins or leaves off; it is just a part of the sea. It is not one; it is millions and millions of drops; and even these millions are from moment to moment changing, moving."[60]

Arthur Dove was the painter of Stieglitz's circle whose work was on exhibition in An American Place when Adams first arrived there in 1933.[61] Stimulated by Kandin-

sky and Bergson, and encouraged by Stieglitz, Dove developed a symbolism of metamorphic forms that drew on fundamental principles of life. Reproduced in *America & Alfred Stieglitz,* his painting *The Wave, or Sea Thunder*, with its forms of dark headland set against shoreward-curving patterns of waves, was an image that predated and may have influenced *Surf Sequence* (fig. 4.15, fig. 4.16).[62]

To emphasize the perpetually changing quality of waves, Adams needed to show the land as constant and unchanging. In the darkroom he dodged (held back light from certain parts of the image during exposure) and burned (increased the light in other parts) to maintain the tonal value of the beach and wet sand in relation to the line of surf. It was also very important that the sea foam itself should be as sharply defined as possible. To catch the form of the wave in motion, he used a fast shutter speed, employing medium-grain rather than fine-grain film. A degree of graininess would, paradoxically, "enhance the illusion of sharpness of the form."[63]

John Varian, the poet, had written of the single wave: "Child of the storm-kissed sea … rolling in beauty and strength, / In-drawing, swift-curling, all-folding, all-cleansing." Vaughn Cornish, who studied the physics of sea waves, sand dunes, snow drifts, and cloud forms, had written of these matters scientifically.[64] In *Surf Sequence,* the sequence as a whole tells us that the surf is composed of a series of images of waves breaking upon a shore. But the single image momentarily challenges our powers of recognition by appearing to present the elements of a mountain landscape: a dark river bed, an eroded cliff, and a cloud. In a poem Adams wrote and sent to the Newhalls, the struggle of creative evolution is expressed by analogy with the tidal forms of land and sea:

> *There is no peace in the yearning*
> *Sky-thrust of ice and stone. No peace*
> *In crests of granite waves flung high*
> *On the slow tide of the land.* [65]

Weston's wave rhythms become sun-reflecting cloud banks in an immense sky, whereas Adams's surf forms remain substantially related to the earth. White distinguished between optical metamorphosis in Weston and mental metamorphosis in Stieglitz, but he did not include Adams in his account. Adams combined perceptual metamorphosis in the two-dimensional photograph with a conceptual element that was not derived from the unconscious but from a philosophy of process. But when Adams showed Stieglitz this sequence he failed to receive the approval he had hoped for. He feared that Stieglitz found the photographs lacking in emotional power, that they were too purely "decorative."[66] But Adams required his photographs to allude, first and foremost, to our relation to the real world rather than to the otherworldly existence to which Stieglitz usually referred.

In the early 1950s White composed a long treatise that combined the theories of

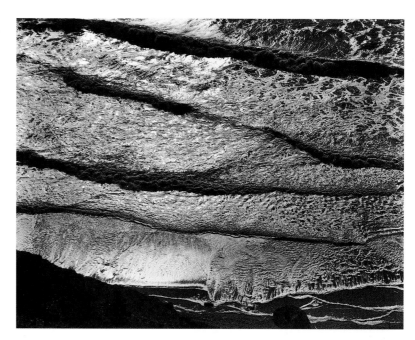

Fig. 4.14. Edward Weston, *Surf, Orick*, 1937, gelatin silver print, single photograph from a sequence of three. Center for Creative Photography, University of Arizona, Tucson

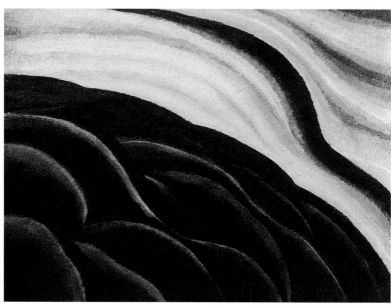

Fig. 4.15. Arthur G. Dove, *The Wave, or Sea Thunder*, c. 1926, halftone from *America & Alfred Stieglitz*, New York: Literary Guild, 1934, Plate 10

Heinrich Wölfflin with the study of mysticism and psychoanalysis. It included White's readings of photographs by Adams, Dorothea Lange, Henri Cartier-Bresson, Manuel Alvarez Bravo, Paul Strand, and Edward Weston, interpreted either as "bridges to experience," transcriptions of reality conveying a sense of the viewer's purely visual participation in the original scene, or as "sources of experience," which severed all obvious connections with the external world to create an imaginative

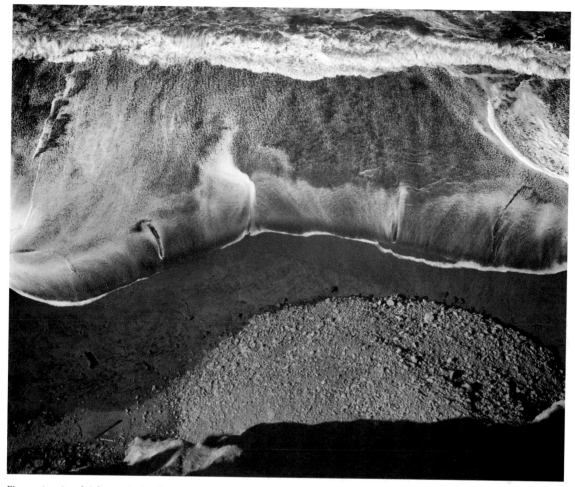

Fig. 4.16. Ansel Adams, single photograph from *Surf Sequence, San Mateo County Coast, California*, 1940, gelatin silver print

metamorphosis in the mind of the viewer.[67] White identified Adams's *Mount Williamson* as a bridge to experience ("We witness the Power and the Glory"), but he considered a photograph of a cypress by Edward Weston as a source of experience.[68] Adams confessed his inability to follow White's distinctions. "Praise be to the external event," declared Adams, "which is seen with maximum empathy and compassion!"[69] He could be deeply moved by a print that White had given him, describing its effect on him as magic, perhaps in Waldo Frank's sense of the term: "Magic . . . transfigures the objective world into terms that can be humanly experienced, and it transfigures personal experience into terms that are sensed as the mystery, and the *good*, of all life."[70] But Adams explained that, as a positivist, he had great difficulty dealing with White's extreme esotericism. He recalled much later how he had even accused Stieglitz of being esoteric, and how Stieglitz had chastised him for his rashness. "What I had thought of as an objective discussion seemed to

Stieglitz a questioning of his most basic principles, that he felt were absolutes of un-compromising excellence for the benefit of the human spirit."[71]

Adams wrote to Patsy English of his frustration at being unable to find words for his emotions: "Some big things are too big to describe directly; it is necessary to symbolize their values by sounding other notes in the same harmony."[72] He visual-ized the new Golden Gate Bridge as being harmonious with his current emotions: red steel against "the bronze-green hills, and the water and sky that are built up from the same gray-blue vapors." He was looking around him for "things that rep-resent moods and feelings—Stieglitz did it in his cloud pictures—called Equiva-lents." On the same day, he wrote to his best friend, Cedric Wright, of a sudden emotional revelation: "I saw a big thundercloud move down over Half Dome, and it was so big and clear and brilliant that it made me see many things that were drift-ing around inside of me; things related to those who are loved and those who are real friends." From this letter we might infer that love was equivalence, "reflecting and illuminating the powers and the thoughts and the emotions that are within you, and flashing another kind of light from within," but friendship was metaphor, a sharing between equals of spiritually uplifting experiences in nature, "things like thunderclouds and grass and the clean reality of granite."[73]

True art, Adams suggested, combined the two modes in an interaction between objective essences and subjective experiences, "inner folds of the awareness of the spirit." The objective and subjective should be balanced in "the taking and giving of beauty" and be firmly grounded in connections between things: "It is the re-creation on another plane of the realities of the world...the realities of earth and men, and of all the interrelations of these."[74] Dorothy Norman, Stieglitz's colleague at An American Place, in a poem titled "Art Is an Equivalent," defined the work of art as a spiritual epiphany:

Art is Equivalent Expression
For what we cannot entirely Renounce
Or Achieve
In our lives—
Yet Realize fully
In Spiritual Clarity.[75]

In 1948 Adams published *Portfolio One,* dedicating it to Alfred Stieglitz. The photographs were prefaced by a short artistic statement: "To photograph truthfully and effectively is to see beneath the surfaces and record the qualities of nature and humanity which live or are latent in all things. Impression is not enough. Design, style, technique,—these, too, are not enough. Art must reach further than impres-sion or self-revelation. Art, said Alfred Stieglitz, is the affirmation of life. And life, or its eternal evidence, is everywhere."[76] It was the eternal evidence of life, the quali-

Fig. 4.17. Ansel Adams,
Alfred Stieglitz, An American Place,
1938, gelatin silver print

ties beneath the surfaces of things binding nature together at a deep structural level, the underlying creative process of the universe, that Adams took as the ultimate subject of his work. He ended his introduction, "Expressions without doctrine, my photographs are presented here as ends in themselves, images of the endless moments of the world," thus affirming Northrop's aesthetic rather than theoretical component of nature as lived experience.

Each of the photographs in the portfolio, Adams wrote, was "selected because it is, in some way, an 'equivalent' of something I feel about Stieglitz....In a sense, all of Stieglitz is there—the dignity, devotion to life, slight touch of the showman,

Fig. 4.18. Ansel Adams, *Clouds Above Golden Canyon, Death Valley, California*, 1946, gelatin silver print

tenderness, slight element of 'corn,' bleakness of personal life, etc."[77] The final two photographs are a striking comparison of direct and indirect portraits. *Alfred Stieglitz, An American Place* positioned Stieglitz directly in front of a Marin seascape, between the light from a window on the right and Arthur Dove's painting *The Goat* centered on the wall to the left, an icon of the life force and sexual potency (fig. 4.17). About the indirect portrait, *Clouds Above Golden Canyon, Death Valley, California*, Adams wrote that "most people like it the best. Perhaps they feel what it is—a sort of apotheosis of Stieglitz; an equivalent of an equivalent."[78] It bears a certain resemblance to Stieglitz's own *Equivalent* (fig. 4.18, fig. 4.19). Both pictures feature

Fig. 4.19. Alfred Stieglitz, *Equivalent*, 1924, gelatin silver print. National Gallery of Art, Washington, D.C.

feathery cloud forms above a low mountain horizon, but while Stieglitz worked at twilight for maximum contrast, throwing the mountainside into black silhouette, Adams captured white clouds against a deep sky, with every detail of the mountaintop seen by the full light of day.

Carl Gustav Jung distinguished between the psychological artist, who selected from life experiences generally and produced unique insights, and the visionary artist, who made Dionysian revelations that were not entirely within his control and who, through archetypes surfacing from his unconscious, conveyed more of himself than he knew. Stieglitz, who read Jung's *Psychological Types* as well as his *Psychology of the Unconscious,* considered himself such a visionary artist.[79] Dorothy Norman called him a seer. Minor White also aspired to be a visionary artist, claiming it also for Edward Weston. White even suggested that various photographs by Weston represented his death wish, even though Weston firmly rejected this interpretation of his work.[80] But Adams always remained a psychological artist, even though Stieglitz, and later White and Newhall, made him feel that he should have

Fig. 4.20. Ansel Adams,
Banyan Roots, Foster Gardens,
Honolulu, 1948,
gelatin silver print

been more visionary. Although Stieglitz and White were esoterically inclined by nature, Adams was more pragmatically spiritual. He admitted that his own position was less obviously metaphysical than White's, explaining that his experiences of magic took place on "a different floor of the Divine Apartment."[81] His familiarity with theosophy through Ella Young, the Varian family, and A. R. Orage had nevertheless introduced him to the Logos, or manifest God, which emanated from the perfection of the Absolute. This source of beauty, beyond humanity, was as closely accessible to the psychological artist as to the visionary.

After White's death in 1976, Adams described his photographs as running like "a

Fig. 4.21. Ansel Adams,
Edward Weston, Carmel Highlands,
California, c. 1947,
gelatin silver print

golden thread between ages of darkness and light," creating out of his journeys into
"the profound world of the spirit" images that inspired his viewers with "beauty,
confidence, and enlightenment."[82] The two photographs accompanying his per-
sonal tribute to White were *Banyan Roots, Foster Gardens, Honolulu* (fig. 4.20) and
Clouds Above Golden Canyon, both from his portfolio dedicated to Stieglitz. The
image of clouds was the one he had described as his apotheosis of Stieglitz. Now
he transferred it, with all due respect, to White. But he did this while asserting the
rooted vitality of the banyan tree, perhaps consciously referring to his portrait of
Edward Weston (fig. 4.21). If Stieglitz's head was in the clouds, Weston's body was

Fig. 4.22. Ansel Adams, *Sierra Nevada, Winter Evening, from the Owens Valley*, c. 1962, gelatin silver print

rooted in the earth. That White and Adams shared these two artists as their progenitors was now acknowledged by Adams in a fond tribute to his friend Minor White.

In 1963 Adams published his fourth portfolio, *What Majestic Word,* and dedicated it to his Sierra Club friend Russell Varian. The fifteen photographs in folders were each accompanied by excerpts from Varian's environmental writings and from theosophical poetry by his father, John Varian.[83] In a preface, Russell's wife, Dorothy, noted that Adams had selected the photographs to serve as interpretations of the character of Russell Varian. In father and son, environmental ethics and theo-

sophical doctrine were fully harmonized. Human beings were entreated to return to a position of respectful interaction with the natural world, all created entities being recognized as fragments of the Universal Soul.

In the final photograph of the Varian portfolio, *Sierra Nevada, Winter Evening*, colossal curvilinear clouds unfurl across a deepening sky and are reflected in the water below, between cursive shapes of the exposed lake-bed, where spirit and matter are united in microcosm (fig. 4.22). The son says, "The wonder and eternity of the wilderness... / put man and his desires into proper perspective." The father bids, "Heaven-world, complete and beautiful, farewell! / The vision passes but the dream remains," echoing the motto of the Temple of the People, to which the Varians belonged: "Creeds disappear, hearts remain."

Intangible Values of the Natural Scene

In the summer of 1941, Secretary of the Interior Harold Ickes invited Adams to produce a set of photographic murals and panels of subjects from the national parks, undoubtedly because he had seen the photographs Adams had shown in Washington five years earlier supporting the campaign to make Kings Canyon a national park. Buoyed by learning that the murals and panels were to hang in the recently completed Department of the Interior building, Adams now proposed to Ickes that the new photographs should depict "the grandeur and influence of the Natural Scene," but that they would also display the benefits of conservation, good administration, and careful long-term planning. From October 1941 through June 1942, Adams photographed in Glacier, Carlsbad Caverns, Yellowstone, Grand Teton, Rocky Mountain, Grand Canyon, and Zion National Parks; in Canyon de Chelly, Saguaro, and Death Valley National Monuments; and at Boulder Dam, as well as at a number of Native American reservations in the Southwest. Despite his attempts to extend the project, it was terminated in July 1942 when America's involvement in the war made increasing demands upon the federal budget.[1]

In 1944 Adams proposed to the Guggenheim Foundation another "park project." Through a series of photographs and text, it would be an interpretation of the natural scene as experienced in the national parks and monuments, integrating much of the groundwork established earlier during his travels for the mural project.[2] The Guggenheim work was thus a natural extension of the work he had begun for the Department of the Interior. He visualized the outcome of this park project in the form of one or more books that would restore to the parks the "intangible values of the natural scene" through revealing "the spiritual and emotional impact of nature in both its most tremendous and most intimate aspects."[3]

The original plan for the mural project included a list of general subjects and characteristics of the parks that Adams believed deserved photographic interpretation. Under "The Elements of Nature" he listed: sun; sky; snow, ice, rain, and

wind; stone; earth; water (ocean, lakes, pools, rivers, and waterfalls); fire (volcanic); fauna; flora; and caverns.[4] Of thirty-one subjects of the natural environment described in this earlier plan, twenty appeared nearly a decade later in *My Camera in the National Parks* (1950). The first plate in the book, *Mount Rainier, Sunrise,* corresponds exactly to Adams's 1941 proposed interpretation of Mount Rainier: "Great snow mountain in winter. Mood of cold grandeur, clear sun, quietness." *Upper Yosemite Fall* (plate 17) embodied "Waterfall. Tremendous power, brilliant light, vertical qualities. Mood of movement and brightness," while the element of a Yellowstone geyser, originally intended to convey the same mood as the waterfall and to be paired with it, "delicate and strong together," was realized as *Old Faithful Geyser* (plate 14). An image he expected to find in Sequoia National Park, "Sequoia Gigantea. Mood of strength, richness of texture, age. Entire tree not essential; soaring fragment of bole more effective," manifested itself as *General Sherman Tree* (plate 19). For years, it seems, Adams had held in his imagination these ideal representations of nature until he found the practical means for their photographic fulfillment.

In "Problems of Interpretation of the Natural Scene" (1945), Adams saw himself caught between the need to communicate the literal aspects of nature in order to educate society to ensure its preservation, and his strong artistic desire to reveal "the deeper impulse of the world." He illustrated this article with sixteen photographs taken in the national parks and sixteen lines of running tags. Joined together, these phrases form two complete sentences: "The world of stone and space and sky reveals to all people the patterns of eternity. He who has known the jubilance of mornings and the endurance of arid lands attends the rituals of spring and becomes one with the world."[5]

Adams submitted a proposal to Houghton Mifflin in March 1945 to publish a photographically illustrated edition of one of John Muir's books: either *My First Summer in the Sierra,* or *The Mountains of California,* or *The Yosemite.* He may have had such a possibility in mind since seeing editions of Thoreau's *Walden* (1936) with photographic reproductions by Edward Steichen and of Whitman's *Leaves of Grass* (1942) with images by Edward Weston. The book-club market for such a work was substantial, mainly because of increased postwar travel to the national parks, but there was also a specialized photography market, in which Adams was confident he had already become quite well known.[6] By early summer, he had decided that the best approach would be to use selections from the texts of several different Muir books under a new title, *Yosemite and the Sierra Nevada* (1948), and to illustrate the book with sixty-four photographs arranged in a "symphonic" sequence of subjects.[7] Receiving the Guggenheim Fellowship in the spring of 1946 released him from full-time commercial work, and he obtained the assistance of Charlotte Mauk, his colleague as codirector of the Sierra Club and as fellow-member of the editorial board

of its *Bulletin,* to edit Muir's texts for the book. But it was Adams and Nancy New-hall who sequenced the photographs and selected the lines for the facing pages in October 1947.[8]

In early 1949 Houghton Mifflin agreed to co-publish with Virginia Adams a series of large-format books beginning with Adams's *My Camera in Yosemite Valley* (1949), quickly followed by Edward Weston's *My Camera at Point Lobos.*[9] Adams conceived the "My Camera" series as regional or thematic books by many different photographers, including Paul Strand, Minor White, Eliot Porter, Barbara Morgan, and Henri Cartier-Bresson. As subjects for further Weston books, he suggested "My Camera in Death Valley" and "My Camera on the Dunes." Adams envisioned these books as large, bound portfolios, 12 × 14½ inches, with reproductions as close to the original prints as possible and printed by the Walter J. Mann Company on heavy Kromekote paper in the finest letterpress. The photographic reproductions were varnished to match the brilliancy of the paper stock, and the books were spiral-bound with plastic ribs so that individual images could be removed for framing.[10]

When Adams was preparing his proposal for *My Camera in the National Parks* (1950), the next book in the series, Nancy Newhall suggested an exhibition on the parks to coincide with its publication. She urged him to consider either a show at the Museum of Modern Art to be organized by Steichen, or an exhibition at George Eastman House in Rochester, where Beaumont Newhall had been made museum director the year before. Adams responded that such an exhibition ought not to be merely a factual report on the attractions of the national parks but "a spiritual-emotional approach to the Natural Scene." He offered the exhibit to the National Gallery of Art and the Metropolitan Museum of Art, but both declined.[11] Only in 1952 were the Newhalls able to organize the show themselves at George Eastman House.

In 1950 two illustrated essays by Adams were reprinted in the Winter 1949–50 issue of the Wilderness Society's magazine, *Living Wilderness.* "Heart of the Earth Speaking" reprinted his introduction to *My Camera in Yosemite Valley* (1949). Here he wrote that to appreciate the spirit of Yosemite properly the visitor should "try to merge the enormous and the minute into one vibrant unity." In "The Meaning of the National Parks" (Autumn 1950), using part of the introduction to *My Camera in the National Parks,* he described the elements of nature as "symbols of spiritual life—a vast impersonal pantheism." Wilderness was "designated for the perpetua-tion of the intangible qualities of nature." One of the best ways of protecting na-ture was to encourage artists to work from it as their inspiration, their interpreta-tions enabling others to find a contemplative relation with it. This essay was written at the time of the campaign to save the wilderness area of Dinosaur National Monu-ment, Utah, from being inundated by the building of dams at Echo Park and Split Mountain. Although Adams recognized the practical needs of civilization ("People

Fig. 5.1. Ansel Adams, *Nancy Newhall, Tioga Mine*, 1944, gelatin silver print

must have land, and land must have water"), he made a strong plea for the survival of wilderness as sanctuary.

In February 1952 Nancy Newhall (fig. 5.1) discussed with Adams the possibility of a book that would not only narrate a history of westward expansion but would also embrace the national park concept and the background of the conservation movement. Combining photographs and text, it would show how human beings could live with nature in affirmation of its primeval majesty.[12] But this book project was displaced by a more immediate exhibition opportunity in 1954 when the Sierra Club Board voted to support a show about conservation for the LeConte Memorial Lodge in Yosemite. LeConte Lodge had by then lain disused for many years. The National Park Service wanted to see it converted to a geological museum but Adams argued that it could be put to better use as an exhibition space by the Sierra Club. In early April, Adams and Nancy Newhall visualized the show they planned as a "nation-wide interpretation of conservation problems in an expressive form," a demonstration of the principles of conservation to the public, and within a few

weeks Newhall was referring to it as "the Conservation Show." Rejecting the conventional concept of a display of inert specimens, Adams wanted to create an exhibit of photographs of the natural environment, transforming the lodge into a "living thing."[13]

In February 1954 Adams met with one of his fellow Sierra Club board members, the architect Eldridge "Ted" Spencer, to discuss his plans for a permanent educational exhibition space. Later that spring Adams invited Nancy Newhall to San Francisco to help him select the photographs for the exhibition and to prepare the captions. The selection was made from his Department of the Interior photographs of 1941–42 and from his Guggenheim Fellowship work. Based on a plan by Adams, Newhall devised a sample panel of photographs and text to present before the National Park Service and the Sierra Club board.[14]

"This Is the American Earth" opened at the California Academy of Sciences in San Francisco almost exactly a year later, on May 6, 1955, and was shown until June 5, while a second copy was exhibited at LeConte Lodge in early June. Both sets were toured nationally by the Smithsonian Institution to some twenty museums, universities, and libraries over the next two years. The show consisted of fourteen panels: eleven by Adams and Newhall; two on the contrast between modern American and native Californian methods of conservation by Sierra Club members Richard Reynolds and Frann Spencer Reynolds; and a further panel on planning in Yosemite by Ted Spencer.[15] On each of the panels, which measured forty inches high by seven feet long, between six and thirteen photographs were displayed nonlinearly in a variety of sizes. Of the 102 photographs in the exhibition, 54 were by Adams. The photographs were separated by subtitles to emphasize a theme, or by small paragraphs of text Newhall had written, and in some cases by natural objects such as a nautilus shell, a piece of crystal, or butterfly wings.

Four months before the show opened, Nancy Newhall wrote to Annemarie Pope, chief of the Smithsonian Traveling Exhibition Service, to interest the service in circulating the show.[16] The service may have offered the exhibition, as was its practice, to the United States Information Agency in the State Department for an international tour, because the following summer Adams reported to Edward Weston that he was now busy printing four copies of the show for the State Department, which accepted it for touring in 1957.[17] One of the reasons the USIA readily agreed to take it was that Edward Steichen had already prepared the ground for their interest in photographic exhibitions with "The Family of Man" in 1955.[18]

In their effort to transform "This Is the American Earth" from exhibition to book, Adams and Newhall set out, unsuccessfully, to attract the interest of a commercial publisher in 1955.[19] It was not until 1957 that the Sierra Club committed itself to publishing the book, its printing underwritten by a grant of fifteen thousand dollars from one of the club's wealthier members.[20] The book, *This Is the American*

Earth (1959), inaugurated the Exhibit Format series of books published by the Sierra Club.[21]

As early as 1953, Adams appealed to the Sierra Club's board of directors to disseminate information nationwide on conservation problems. He felt that the club's most effective contribution would be through increased publicity on important issues in the *Sierra Club Bulletin* and elsewhere. In 1956 he told the club's executive director, David Brower, that a dynamic artistic form of expression should be used to carry the cause of conservation to a wider audience, primarily through book publishing.[22]

By 1959 Brower's increasingly bold editorializing in the *Bulletin* was getting him into trouble. He began publishing articles on subjects that many of the board members felt were inappropriate for the Sierra Club. Responding to his vigorous criticism of public policies allowing logging and grazing permits in national forests, the board of directors of the Sierra Club formally resolved that the "motives, integrity or competence of an official or bureau should not be criticized" in the journal.[23] Brower realized that his only recourse would be to establish a separate book-publishing program that would give him greater freedom of expression. He also knew that he could wish for no better ally in this project than Adams with his vast experience of photographic book printing.[24]

Adams, Newhall, and Brower sought to transcend the level of the mere picture-book with a production that would inspire as well as educate, and that would attract support for its campaigns through a combination of aesthetically powerful images and words. "Exhibit Format" implied the experience of an exhibition of pictures and text transferred to the page, perhaps carrying an overtone of evidence as offered to a court of law rather than of a book placed on a coffee table. Published by the Sierra Club in December 1959, it was an immediate success and was promptly reprinted in early 1960.[25] The running text by Nancy Newhall is presented in free-verse form, and ranges in style from factual report to journalistic commentary to poetic evocation. Such short aphoristic lines as "What is the price of exaltation?" and "How lightly might this earth bear Man forever!" and "Tenderly now let all men turn to the earth" (iv, 70, 88) share a declamatory quality with the proverbs and poetic excerpts compiled by Dorothy Norman for Steichen's "Family of Man": "We shall be as one person," and "What region of the earth is not full of our calamities?" and "With all beings and all things we shall be as relatives."[26]

One of the influences on the conception of the book was the presentational style of *Life* magazine, in which the emotional impact of an image covering two entire pages at a glance outweighs the slight distortion and loss of detail as it runs across the fold. *Life* magazine was also the main source from which images were compiled for "The Family of Man." Despite the Newhalls' unhappy relationship with Steichen at the Museum of Modern Art, Nancy held a certain admiration for "The Family of

Fig. 5.2. Ansel Adams, *Mt. Williamson from Manzanar*, 1944, gelatin silver print

Man."[27] After seeing the heavily attended show in New York in early January 1955, Newhall imagined a Washington opening for "This Is the American Earth" that would rival it.[28] Reshaping her panel texts into book form, Newhall had ample time to study Steichen's precedent when the show was exhibited at George Eastman House during July 1956. Both books begin with photographs of stellar nebulae, and the fact that no such image occurred in the exhibition of "This Is the American Earth" suggests some influence of "The Family of Man" show on Newhall's later picture selection for the book. The two books of these exhibitions have just one photograph in common, an aerial photograph by William Garnett, *Snow Geese over Buena Vista Lake, California.*[29] In *The Family of Man*, it accompanies images of people making music. In *This Is the American Earth*, it falls opposite descriptions of the miraculous properties of wilderness (p. 63). Newhall's text transposes it to the "music of coyotes to the rim of moonlight."

Adams's photograph *Mt. Williamson from Manzanar* (1944) had occupied a key

Fig. 5.3.　Ansel Adams,
Burnt Stump and New Grass,
1935, gelatin silver print

position in "The Family of Man" exhibition. He always said that he had taken it
from the site of the Japanese American relocation camp, and from the time of his
concern for constitutional rights, which resulted in a book, *Born Free and Equal*
(1944), and an exhibition, "Manzanar," at the Museum of Modern Art in late 1944.
Steichen must have been aware of all this.[30] Entering "The Family of Man," the
viewer was invited to look through a transparent lucite panel that held photographs
of couples courting, toward a group of multiethnic family portraits in the middle
of the exhibition space, all the way back to a mural-sized print of Adams's photo-
graph on the far wall.[31] In the 1930s and 1940s Adams showed his positive commit-
ment not only to the constitutional rights of Japanese Americans but also to such
other wartime victims as Italian Americans, as well as to those of African, Hispanic,
and Native American origin.[32] But when "Volk aus Vielen Völkern" (Nation of
Nations) was shown in Berlin in 1959, *Mt. Williamson* (fig. 5.2) was exhibited not
in the context of ethnic groups but with *Burnt Stump and New Grass* (fig. 5.3).

However, it was also exhibited with a version in German of the final Whitman text from *Born Free and Equal,* beginning "To Thee, Old Cause." Apparently Newhall, as curator, was presenting freedom and equality in terms of Whitman's concept of divine average, all things in the human and natural scene sharing democratically in the divine, just as the poet's *Leaves of Grass* symbolized the union of individuals in society.

In Steichen's exhibition the earth was implicit—it was explicitly a world of people. Carl Sandburg noted in the introduction to the book version that the human face was the masterpiece of God. But in *This Is the American Earth,* the throngs of people in Ferenc Berko's *Bathers on the Ganges* (42–43) seem to support Newhall's text about problems of overpopulation, even though the crowds at the Ganges are seeking the same kind of spiritual renewal for which Sierra Club members might go to the High Sierra. The decision to deal with "the population problem," as David Brower and Nancy Newhall described it, was made in 1958 when they met in Rochester to finalize the text for the book.[33]

Contemporary documentary film significantly influenced Newhall's writing style. A documentary quality in her writing seems to have been appreciable even in the first version of her text, which she carried along on a research visit to Washington in the autumn of 1954. She wrote to Adams that several people in Washington had described it as a TV script.[34] Newhall distinguished between the narrative caption of documentary, however, and what she called, perhaps inaccurately, an "additive" caption. In 1952, she had written a manifesto for what she believed was an art form in which photographs and words were brought together to produce a more dynamic meaning. Narrative captions could only extend the meaning of the photographs, whereas additive captions allowed text and photograph to coalesce into one thing. Adams also believed that such fusions might "create a new order of expressive moods and symbols, transcending the obvious and the explicit."[35]

Another idea, that of an "overture" preceding the title, for which special permission had to be obtained from the U. S. Register of Copyright, may have been borrowed by Newhall from David Brower, who assisted her in adapting the exhibition to the book format, and who had suggested a similar sequence preceding the title for Adams's *Yosemite Valley* (1959).[36] This sequence opens with the first line of the text, "This is the American earth," and continues with "This, as citizens, we all inherit. This is ours, to love and live upon, and use wisely down all the generations of the future" (p. iii), on a double-page spread of *Sierra Nevada from Lone Pine, California* (fig. 5.4). This vast panorama of the eastern Sierra wilderness serves as a backdrop to a dark earth shape of silhouetted foothills with an illuminated pastoral foreground of a few cottonwood trees and a grazing horse. Although cooler than Albert Bierstadt, it offers a similarly paradisal vision. With "Blessed are the meek, for they shall inherit the earth" (Matthew 5:5), the text establishes at once the mani-

Fig. 5.4. Ansel Adams, *Sierra Nevada from Lone Pine, California*, 1944, gelatin silver print

fest destiny of the American people. "Ours to love and live upon" also asserts an accommodation of wilderness to agriculture.[37]

On the verso of the next opening, the text explains that, although human beings must conserve the earth's physical resources for the future, "Yet never can Man live by bread alone." The text facing the torrent of *Nevada Fall, Yosemite National Park* (p. v) asks, "What is the price of exaltation?" (p. iv). The photograph expresses both the terror and the exhilaration at seeing natural forces unconstrained; a small juniper tree beside the top of the falls serves only to emphasize overwhelming power by seeming to survive it.

The next spread shows a close-up of delicate undergrowth glistening with raindrops, *Fern in Rain, Mount Rainier National Park* (p. vi), and the rippled expanse of *Lake MacDonald, Evening, Glacier National Park* (p. vii; see fig. 4.7), with cloud reflections and a background of distant hills and valleys. These micro- and macro-worlds are unified by the formal resemblance between the fan of ripples on the lake in the first photograph and the fronds of leaves in the second, perhaps also drawing

Fig. 5.5. Ansel Adams, *Clearing Winter Storm*, c. 1940, gelatin silver print

on Carpenter's metaphor of regeneration, "Slowly out of the ruins of the past—like a young fern-frond... I saw a new life arise."[38] Newhall's question on p. vi, "What is the value of solitude?—of peace, of light, of silence?" restates an idea expressed by Bernard De Voto in a feature article on the national parks: "What justifies the national parks? First of all, silence." He wrote: "The experience of solitude, even the simple fact of quiet, has become inestimable."[39]

On the next opening, "What is the cost of freedom?" a question basic to American self-identity, is juxtaposed with a small photograph by Eliot Porter of a white bird, as if hovering over the snow-capped mountains of Adams's *Clouds and Peaks, Glacier National Park, Montana* (pp. vii–ix).[40] The hope implicit in bright mountain peaks is interpreted through the bird of peace as the symbol of a new covenant between human beings and nature. The title page, which follows, is a full-page reproduction of *Half Dome, Winter, Yosemite Valley*, which exchanges for the serene noon-

Fig. 5.6. Ansel Adams, *Sunrise, Mt. McKinley* [*Mount McKinley and Wonder Lake, Denali National Park, Alaska*], 1948, gelatin silver print

tide of *Clouds and Peaks* a dark sky, with clouds of snow blown aside to reveal the sheer cliff face of Half Dome, awesome defender of the wilderness preserve (p. xi).[41]

The book ends with Newhall's emotive text harmonically expanding Adams's three single images that run across three double-page spreads. "You shall face immortal challenges..." initiates the exaltation of *Clearing Winter Storm, Yosemite,* in which the dark, mist-wreathed tower of El Capitan and the pristine source of Bridal-veil Falls face each other across Yosemite Valley (fig. 5.5).[42] The next opening gives a large reproduction of Adams's *Sunrise, Mt. McKinley* (fig. 5.6). Its graphic black-and-whiteness produces an image of the slate wiped clean—the earth returned to a state of primordial purity. The four lines of text beside the image offer the hope that, should all the institutions of civilization pass away, as the book apocalyptically predicts, we will still be able to restore the realm of human thought, so long as we retain our relationship with wilderness.

This crescendo drops suddenly to a whisper. Adams's *Aspens, Northern New Mexico* features an individual tree, brilliant against a dark forest of trunks, radiating a light that seems to emanate from its glowing leaves (fig. 5.7).[43] Out of the past of the forest emerges this tree into the present, next to a delicate sapling with a few tentative leaves presaging the future. The text reads, "Tenderly now let all men turn to the earth."

In *My Camera in the National Parks* (1950), Adams had already presented the tree as a representative type in the parks. When Muir called the cliffs of Yosemite "types of endurance," he assigned to them a symbolic value inherited from the conventions of a landscape typology that associated particular landscape motifs with biblical events. Moralized and naturalized for millennia, this biblical typology discovered a divine glimpse of the presence of God in the landscape.[44] Such landscape motifs or types have either positive or negative interpretations, depending on the context. All creation exists between good and evil: the rock (as boulder or mountain) could stand for either vengeance or foundation; water (as waterfall or pool) for the deluge or salvation; the cloud (as thunderhead or mist) for divine wrath or ministry; the tree (as stump or seedling) for sacrifice or redemption.[45] This Christian psychological system, conveyed throughout the centuries in prints and illustrated books, has survived all kinds of stylistic change to comprise an eloquent language of types. As Ruskin wrote: "When this language, a better one than either Greek or Latin, is again recognized amongst us, we shall find, or remember, that as the other visible elements of the universe—its air, its water, and its flame—set forth in their pure energies, the life-giving, purifying, and sanctifying influences of the Deity upon his creatures, so the earth, in its purity, sets forth His eternity and His TRUTH."[46] Muir was no less firmly grounded in the Bible than Ruskin. He said he read landscape motifs as if they were pages of "mountain manuscript."[47] Astonished at the sheer magnitude of Yosemite's landforms of single types ("the rocks and trees and streams"), he saw them combining together dynamically to inspire in humankind the fullest appreciation of the powers of nature.

In *My Camera in Yosemite Valley* (1949), Adams followed Muir's metaphorical use of types by contrasting single types to stimulate emotional response, as in the sublime power of *Nevada Fall* in *This Is the American Earth* with the tiny tree at its apex (p. v). Trees are repeatedly superimposed against great cliffs, as in *Oak Tree and Cliffs of Cathedral Rocks* (plate 3); *North Face of Sentinel Peak* (plate 12); *Glacier Point, Apple Orchard, Winter* (plate 18); and *Cathedral Spires* (plate 19). Adams's interest in this combined type of tree-and-rock is clearly recognizable in a quarter of all the images in *Yosemite and the Sierra Nevada* (1948).

In *This Is the American Earth*, Edward Weston's photograph, *Cypresses and Stonecrop, Point Lobos, California*, presents the dead cypress on a slope grown over with succulents as a type of the tree emerging from rock (p. 59). On the next page is

Fig. 5.7. Ansel Adams, *Aspens, Northern New Mexico*, 1958, gelatin silver print

Adams's *Burnt Stump and New Grass, Sierra Nevada*. Both photographs represent dead trees that survive through transubstantiation—from cypress to stonecrop, and from pine to grass. Such aspects of renewal, Newhall's text tells us, are to be found in "music," "moonlight," and "metamorphosis more strange than dreams" (p. 62). *Stump and Mist, Northern Cascades, Washington*, with its dead stump, sapling, and mature pine in the mist, is an emblem of the three stages of life (p. 83). "You shall know not one small segment," the text declares, "but the whole of life, strange, miraculous, living, dying, changing." In *Moro Rock* Adams suggested an image of progressive evolution out of an amorphous background toward the sharply delineated foreground form of glaciated rock, upon which grows a little juniper—Muir's sturdy, storm-enduring mountaineer of a tree (see fig. 3.5). Standing for individual human consciousness, it somehow maintains its hold on the past and looks to the future. But in Cedric Wright's *Stump in Thunderstorm*, a dark anthropomorphic tree set against a turbulent sky reminds us how solitary is the struggle of the individual (p. 14).

According to Jonathan Edwards, "I felt God, if I may so speak, at the first appearance of a thunderstorm."[48] But thunderstorms, like trees, can also have several aspects: *The Tetons, Thunderstorm* (p. 15) draws us into a wilderness landscape where the clouds are terrible, whereas *Yosemite Valley, Thunderstorm* (p. 20) is heaven-sent, showing a landscape blessed with life-giving clouds. *Thundercloud* is ominously mushroom-shaped, with a fiery illumination at the top (backlit by the sun) and a dark column at the base, a downpour of rain that Adams printed heavily (fig. 5.8).[49] On the opposite page the reader is invited to connect the anxious expressions on the faces of his *Trailer Camp Children* with nuclear annihilation, as Newhall's text describes the threat of explosions, "worldwide, sky-high, above our lives. Death rides no longer a pale horse; Death rides a ray, an atom" (p. 35).[50] Her apocalyptic form of words draws upon an equivalent by Stieglitz, which he had described to her as "Death riding high in the sky," and it also refers to the painting *Death Riding a Pale Horse*, by Albert Pinkham Ryder, an artist championed by members of the Stieglitz circle.[51]

From June 1950, when the United States became engaged in Korea, *Life* magazine showcased the American way of life and its virtues. Perceiving the threat of war, Adams was concerned enough to write to President Truman, offering his services to the Office of Civil Defense to produce photographs relating to morale and education. The first hydrogen bomb explosion, in early April 1954, completely vaporized Elugelab Atoll in the Pacific Ocean. Footage was shown on American television, and *Life* covered the event extensively. One of the key images in the exhibition of "The Family of Man," but not published in the book, was a huge red and orange transparency of a hydrogen bomb explosion.[52]

In *This Is the American Earth, Crab Nebula* (p. 45), provided by the Palomar Observatory, signifies a terrible change threatening the universe: the beautiful, orderly *Spiral Nebula* (p. 1) has here turned into a cancerous cloud. Because we inhabit a "poisoned, gutted planet, rolling through dark noxious air," the type of the cloud now encompasses the theme of environmental pollution in Dick McGraw's *Smog in the Los Angeles Basin, from Mount Wilson* (p. 44).[53] But this black, toxic haze is challenged in Adams's *Cloud and Sun Halo, Death Valley National Monument* by an immense white-winged cloud of redemption, its beneficent force symbolized by the solar disc behind it (fig. 5.9).

In April 1949 the first of the Biennial Wilderness Conferences was organized in Berkeley, California.[54] A second conference in 1951 signaled increasing awareness of wilderness beyond the Sierra Nevada, while a third, in 1953, expressed the intangible values of the natural scene. In the early 1950s changes were beginning to develop in the attitudes of many Sierra Club members. The club's statement of purpose in its bylaws was amended from "to render accessible" to "to preserve." It is important to note that it was not changed to "to conserve."

The term "conservation" began to be applied in the late nineteenth and early twentieth centuries, signifying controls placed on the use of natural resources, particularly timber, in order to prevent the decimation of North American forests. Early conservation was anthropocentric, valuing nature in relation to human material needs. The term continued to be used in this utilitarian sense, but in the 1940s and 1950s its meaning was expanded under the influence of groups like the Wilderness Society to include the idea that wild landscape of no commercial value ought to be preserved. To oversimplify the contrast somewhat, conservationists Gifford Pinchot and Theodore Roosevelt were prepared to manage wilderness resources only when they were valuable to industry, whereas preservationists, including John Muir and Joseph LeConte, valued wilderness as a source of spiritual regeneration. As an artist, Adams's relationship with the world existed beyond either material conservation or wilderness preservation.

The Sierra Club believed in the 1940s that the Forest Service could protect wilderness more effectively than the Park Service.[55] But in the early 1950s the Forest Service changed its policy from custodial preservation of forests to increased production of timber through private enterprise, causing great concern to preservationists. In 1954 Bernard De Voto published a long denunciation of the attempts by Eisenhower's Republican administration to transfer publicly owned land, including parts of the national forests, to private hands and to reduce funding to the national parks.[56] Although an admirer of De Voto, Adams warned Nancy Newhall that some archconservatives in the Sierra Club, among them Walter Starr, thought that De Voto leaned too far to the left. When Newhall had traveled to New York to show him her first draft of the text for the exhibition in August 1954, he impressed upon her that it was of the utmost importance to bring home to all citizens the social impact of the government's exploitation of natural resources. But De Voto cautioned Newhall to scrutinize carefully any passage in her text suggesting that the value of birds and glaciers might somehow outweigh the value of people, the most important part of the ecological whole. In his opinion, human issues mattered more than any history of the national parks and the Forest Service. Responding to Adams, Newhall suggested that there should perhaps be two separate shows: one on conservation, and a different one on preservation.[57]

From quite another point of view, George Marshall (brother of Robert Marshall, a founder of the Wilderness Society) also confided to Nancy his concerns about the content of the proposed exhibition: he had understood the project as presented by Adams to be a photographic interpretation of the national parks and Yosemite, "including what Ansel calls 'the elements,' wilderness, extraordinary natural phenomena, and the contrasting beauty of minute details and space, etc." Now he was troubled about introducing the idea of resource conservation into an exhibition that had originally proposed to represent the spiritual values underlying wilderness

Fig. 5.8. Ansel Adams, *Thundercloud, Lake Tahoe*, c. 1950, gelatin silver print

preservation. For instance, he insisted that if dams were to be shown, it would have
to be clearly established that "dams and other raw material uses have no place in
National Parks or wilderness areas."[58]

While the panels for exhibiting "This Is the American Earth" were being assem-
bled in 1955, the Echo Park controversy was at its height. Newhall wrote to Adams
that, because the National Park Service was obviously incapable of preventing dams
from being built in its parks, "the principle of inviolacy" would have to be estab-
lished by congressional legislation. David Brower responded by producing *This Is*

Fig. 5.9. Ansel Adams, *Cloud and Sun Halo, Death Valley National Monument*, 1952, gelatin silver print

Dinosaur: Echo Park Country and Its Magic Rivers (1955), a preservationist publication. By the time Adams's and Newhall's book was published in 1959, however, the battle to save Dinosaur was already won, and the exhibition's largely negative view of dams was omitted.[59]

After the first draft of the Wilderness Bill was introduced by Senator Hubert Humphrey in 1956, Adams urged Newhall to accent the importance of wilderness in the book in order to support the bill.[60] Participants in the 1957 Wilderness Conference felt her statement, "The wilderness holds answers to more questions than we

yet know how to ask" was such an appropriate expression of humility before nature that they adopted it as one of their slogans, leading to a conference resolution on basic wilderness protection (*This Is the American Earth*, 62).[61] In 1960 the Sierra Club succeeded in its attempt to promote legislation for wilderness preservation partly by sending a complimentary copy of *This Is the American Earth* to every member of Congress while the bill was still under consideration. In 1964 the Wilderness Bill was finally passed.

The Wilderness Society's founders, Robert Marshall, Benton MacKaye, Aldo Leopold, and Robert Sterling Yard, described their ideal of wilderness in 1935 as an area of undisturbed land, devoid of roads or other constructions, and large enough to take two weeks to cross on a pack trip.[62] Only on such a journey could the awareness of the interdependency of all parts of nature, and the spiritual renewal of solitude, be fully experienced. This belief was derived, in part, from Muir's Ruskinian socialist view, shared by Edward Carpenter, that only the purity of wilderness could cure the ills of an excessively industrialized society.

Under the influence of the Wilderness Society, whose strong socialist principles kept it at the political forefront of the movement, a new environmental radicalism developed. The ethical and social commitment Adams held as a confirmed Democrat, and which found an outlet in his documentary projects, including collaborations with Dorothea Lange, was integral to his political pursuit of environmental preservation. In his introduction to *My Camera in the National Parks* (1950), Adams quoted some lines from Carpenter's poem "The One Foundation," expressing the relationship between human beings and nature, cosmic unity, and integration of human soul with universal spirit, without drawing attention to the intervening two-thirds of the poem relating to Carpenter's socialist ideals. Adams was all too aware of the rise of McCarthyism.[63]

That same year, Adams proposed to Houghton Mifflin a photographic book about the Western American landscape, including fifty to seventy-five photographs, "conceived as *equivalents.*" Only through correspondences between profound natural and psychic forces, as exemplified by the kind of equivalents that Stieglitz had made, would human beings embrace ideal conservation values. But Adams reassured his editor that the book would also accomplish a number of patriotic objectives: to give an idea of past struggles to establish "the American domain," to describe "the American scene," to instill confidence in "the American idea," and to "touch the conscience of the people to protect what they possess."[64] In the Cold War period, some of these nationalist goals were inevitably transferred to *This Is the American Earth*, but Adams's preferred use of the term "the Natural Scene" suggests that, for him at least, the intangible values of nature transcended politics. The philosopher Hermann Keyserling, in a passage carefully marked by Edward Weston, had sought to resolve the apparent conflict between nature and human society: "The latter limits,

the former liberates and helps us beyond the confines of humanity. And in so do-ing it raises our consciousness of the true root of things. For at the root all creation is one, and from the root emanate all the forces of evolution."

In the 1950s, Adams proposed that all government agencies concerned with nat-ural resources should be incorporated under a Department of Conservation that would completely reappraise the use of federal lands.[65] If human society were to survive on the planet, then tenderly, indeed, should it attend to the earth.

Landscape as Process

Alfred North Whitehead was appointed professor of philosophy at Harvard University in 1924. His already international reputation as a mathematician and author, with Bertrand Russell, of the groundbreaking *Principia Mathematica* was soon further enhanced by his *Science and the Modern World* (1925). Herbert Read, who wrote on aesthetics, considered it the most important book published in the realms of science and philosophy since Descartes. Its influence was felt by objectivists and subjectivists alike, both in Group f/64 and in the Stieglitz circle.[1] Whitehead proposed that the past philosophical assumptions underpinned by materialist Newtonian science should now be replaced with ideas based on evolutionary theory and theories of relativity. The model of quantum physics suggested that the most fundamental characteristics of the world were change and exchange.

In *Process and Reality* (1929), Whitehead elaborated his position: the elemental units of the universe, the electromagnetic particles newly discovered by science, were in a continual state of becoming; process, therefore, represented the true nature of things.[2] Process philosophy conceived the interactive organization of the whole universe as neither mechanistic nor vitalistic but organic. In the view of some historians, the work of Joseph LeConte Sr. was a precursor of Whitehead's process philosophy, for he had rejected both materialism and vitalism in the 1880s.[3] Helena Blavatsky, in her theosophical treatise *Isis Unveiled,* considered LeConte's belief in a life principle that linked divine agency with natural process as scientific support for her claim that spiritual properties might be discovered even in the "*inner* nature of the plant or stone."[4]

According to Whitehead, from relativity and quantum mechanics emerged the possibility of an "event metaphysics" in which the process of becoming and the dynamism of nature were preeminent. The philosophy of process recognized the value of every object and organism for its own significance, and for its interdependence within the continual transformation of reality: "Everything has some value for itself, for others, and for the whole."[5] In this fundamental sense Whitehead's

ideas were ecological.[6] His awareness that his ideas could potentially be applied to the environment is apparent in his convincing philosophical argument against land abuse: "Any physical object which by its influence deteriorates its environment commits suicide."[7]

In *Holism and Evolution* (1926), Jan Christian Smuts proposed that the evolution of humankind to its present level of personality and potential spirituality was evidence in itself of the constantly "complexifying" tendency of holism in the universe. Unlike LeConte, whose backward glance from the summit of the evolutionary hierarchy reassured nineteenth-century human beings of their preeminence, Smuts reminded his readers of the ethical message of evolution: "The Great Society of the universe leaves a place for the most humble inanimate inorganic structure no less than for the crowning glory of the great soul. To conceive the universe otherwise is to indulge in anthropomorphism, which may be pleasing to our vanity, but in reality detracts from the richness and variety of the universe." The sensitivity of all organisms to their environments was the principle on which the new science of ecology must be founded. Smuts referred to the entire field of nature as "the source of the grand Ecology of the Universe."[8]

Aldo Leopold began his long campaign on behalf of grand ecology in 1921, having served in the U.S. Forest Service for fifteen years. He became the first professor of wildlife management at the University of Wisconsin in 1933 and a founder of the Wilderness Society in 1935. His reputation was established, therefore, long before 1949, when his essay "The Land Ethic" appeared posthumously in *A Sand County Almanac*. In a 1942 article, with a photograph by Adams opposite its title page, he stressed perception of the living value of wilderness. He hoped that an awareness of ecology might eventually enter into the lives of ordinary people.[9] He elaborated on how this could be achieved in "A Conservation Esthetic." Recreation was valuable in direct relation to the intensity of a person's experience. The two main values of wilderness recreation were a feeling of solitude in nature and the perception of the natural processes of evolution and ecology. An enlightened ethical view of nature depended on developing this new perceptive faculty. For his part, Adams wrote that only profound faith in the natural world, transcending self-interest, would "create and perpetuate the concepts of an advanced society."[10]

Mourning the destruction of many of the giant sequoias in the Mariposa Big Tree Grove, LeConte had affirmed in 1890 that although trees certainly had practical value as lumber, they had aesthetic as well as commercial uses "for the spiritual wealth of *all*."[11] In "Problems of Interpretation," Adams argued that natural resources in wilderness areas should no longer be exploited and that the spiritual experience of nature should be preserved. In "The Meaning of the National Parks," he hoped that, in the future, we might be able to live ecologically with nature in a great community of cooperative beings. Nancy Newhall's research notes for the

Fig. 6.1. Ansel Adams, *Late Autumn Evening, Merced Canyon, West of Ribbon Creek*, 1944, gelatin silver print

exhibition "This Is the American Earth" show how profoundly she was impressed by Leopold's moral position: human beings had a responsibility to protect wild nature because it symbolized our original relationship with the earth.[12]

In Adams's *Late Autumn Evening, Merced Canyon* an ancient oak and a young fir stand in soft shadow (fig. 6.1). Because of the extremely low light, it was necessary to correct the exposure carefully, doubling the metered time in order to compensate for the slower response of the film.[13] The result was a slightly flat image that prevented the smaller tree from clearly articulating itself against the pale autumn light on the opposite bank. Adams did not usually permit the outline of any two significant objects ("subject values") in one of his photographs to merge or to lose their integrity in this way.[14] One of the core ideas behind his Zone System was that every object in the frame must be given its own "indication of *substance*" through texture, so that its tactile qualities could instantly be apprehended visually.[15] He believed that everything in a photograph should have significance. The photograph represented a model of the universal and sacred relation of things to each other. Because the young fir was insufficiently clear, the viewer could not interact fully with it within a community of forms. It therefore fell short of full aesthetic immediacy.

Fig. 6.2. Ansel Adams, *Early Morning, Merced River, Autumn*, c. 1950, gelatin silver print

Returning to photograph the subject again in *Early Morning, Merced River, Autumn*, Adams recognized the tiny tree as now perfectly aligned with the apex of the boulder (fig. 6.2). The far bank in shadow serves as a gray backdrop for the scene. The gesturing forms of the old oak contrast with the illuminated pyramid of the infant fir shooting, as if miraculously, from the boulder. The river, exposed at a shutter speed of half a second to create a slightly blurred effect, rushes eternally past.[16]

For Muir, this metaphysical event on the Merced River could be interpreted typologically in terms of the living tree springing from barren rock; but for Leopold, it might be ecologically interpreted in terms of the threatening encroachment of the fast-growing fir on the native California oak. For Whitehead, such a created entity consisted of a sequence of simultaneous "actual occasions, each with its own present immediacy," with each part of the subject having its own aesthetic presence as an extract from nature, but also relating to the qualities of adjacent parts of the whole.[17] For Adams, all the elements in the composition fell into place for him at a given moment, and so his experience of that process was neither purely objective nor wholly subjective; it was instead evidence of his own participation in a relational event that was subjectively symbolic but also perfectly ecological.

Newhall once wrote to Adams that she felt the source of the miraculous quality of existence to be present not only in stones, trees, and streams but also in human beings, who seemed to have evolved purely in order to express that sense of miracle. Compare Adams's own elementalism from his earlier days in Yosemite: "How I long to get back to it all—to feel the contact of everyday, commonplace, material, primitive things—Rock-Water-Wood and *unanalyzed* love and friendship (the only satisfactory kind)."[18]

Rock-Water-Wood also represented the elemental philosophy of John Cowper Powys, frequent guest of Adams's close friends Charles Erskine Scott Wood and Sara Bard Field. His charismatic lectures in the United States in the 1920s found their published expression in *The Complex Vision* (1920) and *In Defence of Sensuality* (1930).[19] Powys wrote that in the face of human folly the very rocks and trees would be forced, finally, to speak out:

The silent trees above my head
The silent pathway at my feet
Shame me when here I dare to tread
Accompanied by thoughts unmeet.

O Man, with destiny so great,
With years so few to make it good,
Such fooling in the eyes of fate
May well give speech to stones and wood![20]

When Adams wrote to Weston at the height of the Depression that he still believed there was "social" significance in a rock, he meant cosmic, ethical significance. According to Whitehead, people are objects, too, functioning within an arena filled with widely differing orders of objects, including rocks and trees.[21]

In Whitehead's epistemology of organism, art was a *gnosis* akin to religion, with its God "the intangible fact at the base of finite existence." Adams wrote that his symbols of spiritual life were equivalent to the "clear realities of Nature"; the natural scene was to be perceived in terms of both "great vistas and intimate realities." Compare Carpenter's description of creation itself as a cosmic work of art, "an everlasting evolution and expression of inner meanings into outer form, not only in the great whole, but in every tiniest part."[22] *Leaves, Frost, Stump, October Morning, Yosemite Valley*, is just such an expression of precise intimacy in which the lifetime of a seasonal leaf is related to the moments it takes for the sun to melt the frost, and the minutes elapsed in making saw-marks on a stump are related to the ages taken for the tree to produce its dendrological circles (fig. 6.3). In the act of artistic creation, intangible qualities of the natural world could be expressed across time, substantially.

Fig. 6.3. Ansel Adams, *Leaves, Frost, Stump, October Morning, Yosemite Valley*, c. 1931, gelatin silver print

In 1951 Adams wrote to Weston, "The complexities and conventions of life can never obscure the divine interplay of the spirit; as I progress towards fifty I am more and more certain of the enduring pattern of things."[23] This divine interrelation between things was constantly reinterpreted in the light of process, and as the conjunction between transcendence and immanence.[24] Art, Whitehead believed, was the emergence of a pattern within experience, and true aesthetic enjoyment was recognition of that pattern. He was moved to quote Shelley, one of Adams's favorite poets:

Worlds on worlds are rolling ever
From creation to decay
Like bubbles on a river,
Sparkling, bursting, borne away.[25]

But compare Shelley's evolutionary subjectivism with Adams's close observation of a lakeside scene in *Rock and Foam, Tenaya Lake* (fig. 6.4). It is the objective triangularity of the rock that produces the delicate arabesque at the lake's edge, each line of foam also modified by the tuft of grass on the right. Each bubble contributes to marking in detail the ebb and flow caused by the solidity of stone. John

Fig. 6.4. Ansel Adams, *Rock and Foam, Tenaya Lake*, c. 1960, gelatin silver print

Dewey wrote about forces of change in inanimate nature as like "a line of foam marking the impact of waves of different directions of movement." For William James, a clearly defined image of foam evoked the ephemeral status accorded to individual consciousness by pure science: "The bubbles on the foam which coats a stormy sea are floating episodes, made and unmade by the forces of wind and water. Our private selves are like those bubbles." [26]

The organic interconnectedness of all things, reconciling science with religion, demonstrated to Edward Carpenter that "this great world of Nature, just as much as the world of Man, is the panorama of a conscious life ever pressing forward towards Expression and Manifestation; and that these dots and scratches in the writing, these stones and stars and storms, are words appealing to us continually for our loving understanding and interpretation." Such interpretation was an act of exegesis, a confirmation of the sacredness of the text that was the natural scene. The con-

Fig. 6.5. Ansel Adams, *Morning Mist near Glacier Point, Winter, Yosemite Valley*, c. 1970, gelatin silver print

scious life, as expressed in natural typology, extended "outward from the subtle and invisible," as Carpenter put it, "into the concrete and tangible."[27]

In *Morning Mist near Glacier Point, Winter, Yosemite Valley*, a darkened, perhaps charred, tree stump supports a miniature glacier of fresh snow spreading downward (fig. 6.5). The eye touches crisp, granular snow, foregrounded against smooth, dark wood by a low camera angle. Through an incalculably fine mist, this stump is subtly connected with types of the blasted tree on the left and of the living pine in the middle. Typology and ecology meet here in universal laws of process embodied in the conjunction of wood grain with glacier-like drifts of snow.

In the transparent pond of *Siesta Lake, Yosemite National Park, California*, Adams polarized the light just enough to reveal submerged rock while preserving the mirrored surface through which fine leaves of grass appear rooted in masses of reflected cloud (fig. 6.6). At Walden Pond, studying a school of perch rising to its surface, Thoreau also simultaneously saw clouds reflected in it.[28] William James also proposed water in a pond as analogous to the world of the senses in which human

Fig. 6.6. Ansel Adams, *Siesta Lake, Yosemite National Park, California*, c. 1958, gelatin silver print

beings swam like fishes but occasionally broke the surface to reach the air of spirit above.[29] In an early conversion experience in the mountains Adams had seen the sublimation of subject-matter simultaneously in both the microcosm and the macrocosm, perceiving grasses and grains of sand as of the same order as clouds and mountain peaks, snow and rocks.[30] Using this nondoctrinal typology of forms, Adams created metamorphic equivalents by raising the level of the viewer's consciousness of eternity in present life.

In an introduction to a portfolio by Wynn Bullock, Adams wrote: "The beauty of the world results in a constant vibration of the spirit: the Shapes of nature—through the magic of art—become the Forms of the imagination. Photography clarifies the experience of this transition from Shape to Form as perhaps no other medium can do. There is always a relationship with reality, or actuality.... On this relationship we can create marvellous constructions of perception and clarification—and of communication."[31]

In *El Capitan Fall* the shapes of windblown water falling down the cliff and

Fig. 6.7. Ansel Adams, *El Capitan Fall*, c. 1940, gelatin silver print

across the silhouetted ridge both conceal and reveal the face of the mountain, the mist rising upward to take on a form that might be described as demonic, momentarily producing a night scene of the underworld (fig. 6.7). Through the magic of negative and print, that ghostly form transforms the noble guardian of Yosemite Valley into a fearsome ogre.

The same subject is presented under quite a different aspect in *Summit of El Capitan, Clouds* (fig. 6.8). "Seen encircled by lightly floating clouds detached from the world below," such a mountain is "transfigured and belongs not to earth but to heaven," wrote Vaughn Cornish. The attraction of such a mountain subject, he suggested, was its apparent durability in the face of uncertainty. In intense contemplation of nature, the consciousness of self was suspended, and nature no longer seemed an environment but a state of mind: "The conception...was of a Creative not a Created world. There was in all around no suggestion of beginning or end, but a vision of life without beginning and without end,... a picture of eternity alternative to that of a timeless state."[32]

Fig. 6.8. Ansel Adams, *Summit of El Capitan, Clouds*, c. 1970, gelatin silver print

One of Minor White's key concepts of spatial perception in photographs was of fluctuating space, in which the extreme close-up and the distant view oscillated within the same picture, causing an indeterminacy of scale in the mind of the viewer. For White fluctuating space was one of the few graphic ways of stating the truth of constant change.[33] In a series of lectures on photography at the Museum of Modern Art in 1944, Adams described his use of inverse scale, near objects rendered large against large objects rendered small. He employed this technique in the composition of *Mt. Williamson from Manzanar* (1944), an unconscious response to Ruskin's rhetorical question "What is a mountain but a rock writ large?" (see fig. 5.1). Inverse scale

Fig. 6.9. Ansel Adams, *Giant Sequoias, Yosemite National Park*, c. 1944, gelatin silver print

was effective, Adams suggested, so long as the entire image was clear, and clarity was not an optical concept but a profoundly emotional one.[34]

By bringing the camera very close, the photographer can display a foreground subject as greatly enlarged, forcing the viewer to focus on its detail. Clement Greenberg once suggested that it was this kind of sharp rendition that made possible a sense of ambiguity of substance, and Rudolf Arnheim said that an element extracted from its context not only changed its character but revealed entirely new properties in it.[35] In *Giant Sequoias, Yosemite National Park*, by perfect focus Adams clarified near and far, bark detail and redwood magnitude (fig. 6.9). The detailed surface on the

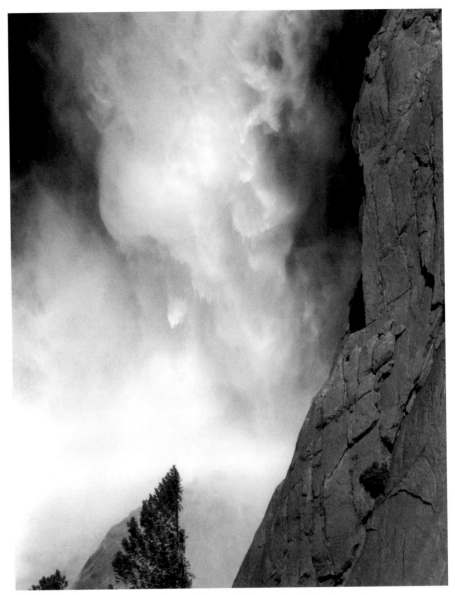

Fig. 6.10. Ansel Adams, *Base of Upper Yosemite Fall*, c. 1948, gelatin silver print

right, occupying half the frame, shows every ripple of centuries of tree growth. But from this angle, Adams's treatment presents it, metamorphically, as the fissured granite wall of the base of a cliff. Only by such perceptual transformation may wood turn to stone, and back again to wood.

Adams made photographs in which the identities of the waterfall and the cloud above were clearly separate, but when he made *Base of Upper Yosemite Fall* he was drawn to the changing shapes of the mist and falls emerging as a single, complex form: "At times the swirling mist would veil the more solid shapes of the falling

water, then clear to reveal them in great depth" (fig. 6.10).[36] Spirit and body were united in the image of floating, falling water, suggesting dissolution of consciousness but also resisting it. Compare Edward Carpenter: "Lo! to-day the falling waters... shaking the ground with their eternal thunder! Lo! above all rising like a sign into the immense height of the sky, the columned vapour and calm exhalation of their agony—The Arisen and mighty soul of Man!"

Regarding *Base of Upper Yosemite Fall,* Adams himself wrote that even the grandest landscape "may not interpret the direct excitement and beauty of the mountain world as incisively as sections, fragments, and close details."[37] Such close detailing suggested a cosmic whole through its parts. Whitehead's view was that there was no nature apart from transition, but that our vague sense of the totality of experience required detail, if it were to be fully understood by humanity.[38] An "infinitude" of detail within each finite fact, he suggested, was the way to one clear perspective on the universe. Through this could be grasped the intuition of holiness and of the sacred that was the foundation of all religion.[39]

Joseph LeConte Sr. found Christian faith perfectly compatible with the idea that our self-conscious spirituality represented the culmination of all levels of evolution, and he emphasized its moral significance.[40] R. M. Bucke's *Cosmic Consciousness* had for its subtitle *A Study in the Evolution of the Human Mind.* Carpenter used the term "exfoliation," borrowed from Whitman, to express the perpetual renewal of the Absolute within the individual, the husk of each past stage falling away to reveal the bud of the pure universal soul in humankind. For all these authors, the aim was to take an active role in one's own spiritual evolution. In *Varieties of Religious Experience,* James offered Whitman as an example of the mystical expression of a pantheistic and optimistic union with nature, and he declared Whitman the restorer of natural religion.[41] At the beginning of "The Meaning of the National Parks," Adams quoted Whitman's *Song of the Open Road*:

The earth never tires
The earth is rude, silent, incomprehensible
 at first; nature is rude and
Incomprehensible at first;
Be not discouraged, keep on, there are
Divine things well envelop'd
I swear to you there are divine things
More beautiful than words can tell.[42]

In this divine world of process Adams found all the shadings and expressions of a proper spiritual relation of the individual to nature. The world of nature, he believed, was not merely a material phenomenon, nor was the human species a complex accident. The qualities of nature, no matter how feebly observed through the

senses, comprised a more comprehensive reality, one that only artistic means could properly perceive or fully express.[43]

Adams wrote to Stieglitz that he often found himself brooding over rocks and clouds and "Things of No Value." Their divine quality was experienced as *tenderness*, which he defined as "a sort of elastic appropriation of the essence of things into the essence of yourself, without asking too many intellectual questions, and the giving of yourself to the resultant combination of essences." In "The Knowing of Things Together," James wrote that the most complete experience one could have was to know something both immediately or intuitively and conceptually or symbolically.[44] Adams knew things together by internalizing his experiences in nature and relating them to principles of universal process through making photographs of them.

Walt Whitman, whom Adams so greatly admired, wrote:

I will make the poems of materials, for I think they are to be
 the most spiritual poems;
And I will make the poems of my body and of mortality,
For I think I shall then supply myself with the poems of my Soul,
 of immortality.[45]

Adams achieved something similar with photographs. Through his matchless prints and near-perfect reproduction, this poet-photographer invites us to approach his sense of the earthly but divine performance both in nature and in art.

Works frequently cited have been identified by the following abbreviations:

AAA CCP	Ansel Adams Archive. Center for Creative Photography, University of Arizona, Tucson.
SCPC UCB	Sierra Club Pictorial Collections. Bancroft Library, University of California, Berkeley.
Autobiography	Ansel Adams (with Mary Alinder). *Ansel Adams: An Autobiography.* Boston: Little, Brown, 1985.
Conversations	*Conversations with Ansel Adams.* Interviews conducted by Ruth Teiser and Catherine Harroun in 1972, 1974, and 1975. Regional Oral History Office, Bancroft Library, University of California. Berkeley: The Regents of the University of California, 1978.
Examples	Ansel Adams. *Examples: The Making of 40 Photographs.* Boston: Little, Brown, 1987.
Letters	Mary Alinder and Andrea Gray Stillman, eds. *Ansel Adams: Letters and Images 1916–1984.* Boston: Little, Brown, 1988.
"Photographer and Reality"	Nancy Newhall. "The Photographer and Reality: Ansel Adams." 1951. Beaumont and Nancy Newhall Papers. Humanities, Los Angeles. An additional draft is held in the Ansel Adams Papers, Sierra Club Papers, Bancroft Library, University of California, Berkeley.

CHAPTER ONE *A New Consciousness.*

1. Ansel Adams, "Constellations," hand-drawn star charts in a bookkeeping ledger, private collection, 1911.

2. George Santayana, "The Genteel Tradition in American Philosophy" in *The Genteel Tradition: Nine Essays by George Santayana,* ed. Douglas L. Wilson, Cambridge: Harvard University Press, 1967, 37–64; first published in the *University of California Chronicle* (October 1911).

It has been suggested that this Californian may have been the Yosemite writer John Muir, who was heavily engaged in the campaign against Hetch Hetchy Dam in this period and may have been residing in Oakland near Berkeley. Michael Cohen, *The Pathless Way: John Muir and American Wilderness,* Madison: University of Wisconsin Press, 1984, 136. An alternative candidate is the Harvard philosopher Josiah Royce, born in the Sierra foothills in Grass Valley, California.

3. George Santayana, *Interpretations of Poetry and Religion,* New York: Charles Scribner's Sons, 1916, 270.

4. Allan Sandage, *The Hubble Atlas of Galaxies,* Publication 168, Washington, D.C.: Carnegie Institution of Washington, 1961, 4.

5. Adams shared his father's enthusiasm in the early twenties, helping him start a membership campaign for the Astronomical Society; his fascination with photographs of the moon and Mars was established in this period. Ansel Adams, *Conversations,* 221. Adams also included an exhibit of astronomical photographs in his "Pageant of Photography" at the Golden Gate International Exposition in 1939. Installation photographs of "A Pageant of Photography," Beaumont and Nancy Newhall Papers, Special Collections, The Getty Research Institute for the History of Art and the Humanities, Los Angeles.

Fragment by Charles H. Adams, n.d., read at his funeral in 1951, private collection. Quoted in Katherine Bracher, "Charles H. Adams," *Mercury* 24:1 (January–February 1995).

6. C. H. Adams to J. D. Galloway, 20 April 1923. Quoted in Anne Adams Helms, *The Descendants of William James Adams and Cassandra Hills Adams,* Salinas, Calif.: Anne Adams Helms, 1999, 191 (hereafter cited as *Descendants*).

7. Adams wrote to his father from Santa Fe that Mary Austin also shared their enthusiasm for Eddington's writings. Adams to Charles Adams, 1 June 1929, AAA CCP.

Arthur S. Eddington, *The Nature of the Physical World,* Cambridge: Cambridge University Press, 1928, 321.

8. Arthur S. Eddington, *Science and the Unseen World,* London: George Allen and Unwin, 1929, 44.

9. Eddington, *Nature of the Physical World,* 320.

10. *Conversations,* 30.

11. Adams to Virginia Best, 5 November 1923, private collection; Edward Carpenter, *Angels' Wings,* London: Swan Sonnenschein, 1898, 132, 14.

12. Adams to Virginia Best, 5 November 1923, private collection.

13. At the end of his life, however, Adams did acknowledge Stravinsky and Bartók as great musicians. *Autobiography,* 379.

14. He may have been made aware of this in relation to Henry Cowell, whose avant-garde music had won great acclaim and whom he met again after Cowell's recent concert tours of Europe and New York. Adams to Virginia Best, 27 March 1924, private collection. Adams maintained his interest in Cowell's career, writing to Albert Bender in April 1929 that Cowell "deserves all the praise and glory that may come to him." AAA CCP. Adams also stood by Cowell when he was later imprisoned in San Quentin for then illegal homosexual activities. Henry Cowell to Albert Bender, 20 May 1937, Albert Bender Papers, F. W. Olin Library, Mills College.

His stated reason for deciding against a career as concert pianist was that his hands were too small to permit him the range of the bravura virtuoso, thereby making it impossible for him to become a concert performer of the highest rank. *Conversations,* 75.

15. Adams to Virginia Best, 26 March 1923, private collection.

16. Ansel Adams, "The Merced Group," album of photographs, 1920, SCPC UCB. The photographs are approximately 3½ × 4½ inches, printed on a matte-surfaced paper.

17. Helen M. LeConte, *Reminiscences of LeConte Family Outings, Sierra Club and Ansel Adams,* typescript of interview conducted by Ruth Teiser, Sierra Club History Oral History Series, San Francisco: Sierra Club, c. 1977, 44, 64. Bancroft Library, University of California, Berkeley.

18. Ibid., 14.

19. Photographs published in the *Sierra Club Bulletin* 14:1 (February 1929) show that both made photographs on the Sierra Club outing to the Canadian Rockies in summer 1928.

20. William James, *The Varieties of Religious Experience,* London, New York, and Bombay: Longmans, Green, 1902, 420; Richard Maurice Bucke, *Man's Moral Nature,* London: Trübner, 1879, 176.

21. Richard Maurice Bucke, *Cosmic Consciousness: A Study in the Evolution of the Human Mind* (1901; reprint, New York: E. P. Dutton, 1947), 51; Cedric Wright to Charles Erskine Scott Wood, 20 November 1929, Cedric Wright Papers, Bancroft Library, University of California, Berkeley; J. W. N. Sullivan, *Beethoven: His Spiritual Development,* London: Jonathan Cape, 1927, 47.

22. Adams to Virginia Best, 28 September 1922, private collection.

23. Mary Street Alinder, *Ansel Adams: A Biography,* New York: Henry Holt, 1996, 11.

24. Robert G. Ingersoll, *Gods* Part I, Manchester: Abel Heywood; London: Watts, 1885, 16.

25. William James, *Pragmatism* (London, New York, Bombay, and Calcutta: Longmans, Green, 1907), 154. In a letter to Cedric Wright in the early fifties, Adams reminded him of their early interest in James's writings. Adams to Wright, c. 1950, AAA CCP.

James, *Varieties of Religious Experience,* 425.

26. Edward Carpenter, *From Adam's Peak to Elephanta,* London: Swan Sonnenschein, 1892, 156. R. M. Bucke owned many of Carpenter's works, including this one in which Carpenter coined the phrase, and two inscribed editions of *Towards Democracy.* Mary Ann Jameson, ed., *Richard Maurice Bucke: A Catalogue Based on the Collection of The University of Western Ontario Libraries,* London, Ont.: 1978, 72–73.

27. Nancy Newhall, *Ansel Adams: The Eloquent Light* (1963; reprint, Millerton, N.Y.: Aperture, 1980), 42–43.

28. Christopher E. Shaw, "Identified with the One: Edward Carpenter, Henry Salt and the Ethical Socialist Philosophy of Science," in Tony Brown, ed., *Edward Carpenter and Late Victorian Radicalism,* London: Frank Cass, 1990, 34.

29. Linda Dalrymple Henderson, "Mysticism, Romanticism and the Fourth Dimension," in Maurice Tuchman, ed., *The Spiritual in Art: Abstract Painting 1890–1985,* Los Angeles: Los Angeles County Museum of Art; New York: Abbeville Press, 1996, 222.

30. Joseph N. LeConte, Notebooks, vol. 47, Joseph N. LeConte Papers, Bancroft Library, University of California, Berkeley.

The album was presented to the Sierra Club. Although the photographs were not for sale, club members were invited to view them: "Ansel Adams extends to all members of the Sierra Club and their friends an invitation to examine his collection of Photographs of the High Sierra at his residence 129 24th Avenue, San Francisco every Wednesday at 8 o'clock and at other times by appointment." Inscription, inside cover, Ansel Adams, "Sierra Club Outing 1925," SCPC UCB.

Also see two uncredited photographs, "Marion Lake and Mrs. LeConte's Memorial," and "In Memory of Helen Marion LeConte (1865–1924)," *Sierra Club Bulletin* 12:3 (1926), plate 94.

31. Adams to Virginia Best, 22 September 1925, *Letters,* 24.

32. Edward Carpenter, *My Days and Dreams* (1916; reprint, London: Allen & Unwin, 1918), 105. Quoted in Sheila Rowbotham and Jeffrey Weeks, *Socialism and the New Life,* London: Pluto Press, 1977, 41.

Bucke, *Cosmic Consciousness,* 16–7.

33. Adams to Virginia Best, [11] May 1926, private collection.

34. Edward Carpenter, "O Joy Divine of Friends," *Towards Democracy* (1883; reprint, London: Swan Sonnenschein, 1905 [first complete edition]), 409.

35. Edward Carpenter, "The Songs of the Birds, Who Hears," *Towards Democracy,* 380; Adams to Virginia Best, 7 July 1926, private collection.

36. Cedric Wright, "Trail Song: Giant Forest and Vicinity: 1927," *Sierra Club Bulletin,* 13:1 (February 1928), 20–23.

The dedication to Carpenter heads Wright's draft typescript of the piece. Cedric Wright Papers, Bancroft Library, University of California, Berkeley.

37. See especially Adams's albums of Sierra Club annual outings, 1930–1932, SCPC UCB.

38. Ansel Adams, "Retrospect: Nineteen-Thirty-One," *Sierra Club Bulletin* 17:1 (February 1932), 1–11.

39. Helms, *Descendants,* 192, 194.

40. See Nancy Newhall, "The Photographer and Reality: Ansel Adams," typescript draft of an unpublished biography, 131 pp., c. 1950, Sierra Club Members Papers, Ansel Adams Papers, Bancroft Library, University of California, Berkeley. The pencilled annotations by Adams in this copy show that he edited it. A further draft, with many fewer hand-corrections by Adams but including Newhall's preface and table of contents, is held in the Beaumont and Nancy Newhall Papers, Special Collections, Getty Research Institute for the History of Art and the Humanities, Los Angeles. The pagination of the two drafts is the same.

41. P. D. Ouspensky, *Tertium Organum: The Third Canon of Thought. A Key to the Enigmas of the World,* London: Kegan Paul, Trench Trübner, 1923, 302–3, 230. A copy of this book, which went into seven printings in America between 1920 and 1930, was in Adams's library. Private collection.

42. Tom Gibbons, *Rooms in the Darwin Hotel: Studies in English Literary Criticism and Ideas 1880–1920,* Nedlands, Western Australia: University of Western Australia Press, 1973, 103. A. R. O. [Orage], "A Bookish Causerie: Past, Present and Future," *The Labour Leader* (25 July 1896), 258.

43. *Conversations,* 185, 198. Adams's portrait of Orage is reproduced in Carl Zigrosser, *My Own Shall Come to Me,* Casa Laura: privately published, 1971.

44. Newhall, *Eloquent Light,* 54. Adams maintained his lifelong interest in Scriabin. In 1957 a film, *Ansel Adams, Photographer,* was produced by Larry Dawson and directed by David Myers, with script by Nancy Newhall, narration by Beaumont Newhall, original music by Don Worth, and with a Bach partita and a Scriabin prelude played by Adams himself. Adams owned the sheet music of Scriabin's *Preludes No.3 and No.1* "Andante Cantabile," and *5 Preludes for Piano* and *6 Preludes for Piano* Opus 16, 1897. Private collection. Scriabin's student may have been Dane Rudhyar, a member of the Halcyon theosophical community, who had met Henry Cowell there in the early 1920s.

45. Margaret E. Cousins, "Scriabine: A Theosophist Master Musician," *The Theosophist* 46:2 (November 1924), 238.

46. Boris de Schloezer, *Scriabin: Artist and Mystic,* Oxford: Oxford University Press, 1987, 43, 122.

47. Adams to Virginia Best, 22 September 1925, *Letters,* 24; Paul Rosenfeld, *Musical Portraits,* London: Kegan Paul, Trench, Trübner, 1922, 183.

48. Adams to Virginia Best, 20 October 1924; 22 September 1925, *Letters,* 21, 23, 24; Adams to Virginia Best, 22 September 1925, *Letters,* 23–24.

49. William E. Colby to Cedric Wright, 19 June 1930, Cedric Wright Papers, Bancroft Library, University of California, Berkeley.

50. Adams to Albert Bender, November 1928, AAA CCP; Robinson Jeffers, *Themes in My Poems,* San Francisco: The Book Club of California, 1956, 23–24.

51. Robert Brophy, "Robinson Jeffers," *A Literary History of the American West,* Fort Worth: Texas Christian University Press, 1987, 398–415; *Troubadour* 1:8 (May 1929), 44.

52. Adams to Cedric Wright, c. 1926, AAA CCP; the poem is reproduced in Adams's *Autobiography,* 94.

53. Ansel Adams, "Tonquin Valley," "Night Wind," and "Crow's Nest," *Troubadour* 1:8 (May 1929), 19.

54. Newhall, "Photographer and Reality," 4.

55. John Varian, "Body of God," *Troubadour* 18 (May 1929), 6–7, from the first strophe.

56. Emmett A. Greenwalt, *The Point Loma Community in California 1897–1942: A Theosophical Experiment,* University of California Publications in History, vol. 48, Berkeley and Los Angeles: University of California Press, 1955, 21. See also Bruce F. Campbell, *Ancient Wisdom Revived: A History of the Theosophical Movement,* Berkeley: University of California Press, 1980, 158–60; and Bruce Kamerling, "Theosophy and Symbolist Art: The Point Loma Art School," *Journal of San Diego History* 26:4 (Fall 1980), 230–55.

57. Robert S. Ellwood Jr., "The American Theosophical Synthesis" in Howard Kerr and Charles L. Crow, eds., *The Occult in America: New Historical Perspectives,* Urbana and Chicago: University of Illinois Press, 1983, 118–19.

58. Hugo Seelig, *Wheel of Fire,* Oceano: Round Table Book Company, 1936, vii.

59. John Varian, *Doorways Inward,* Halcyon: The Halcyon Temple Press, 1934, title page, 25. The portfolio was produced as a means of raising funds for the acquisition of land at Castle Rock for a state park, which had been Russell's dream. Dorothy Varian, *Russell and Sigurd Varian: The Inventor and the Pilot,* Palo Alto, California: Pacific Books, 1983, 56.

60. Ella Young to Adams, 28 June 1927, AAA CCP. By 1929 Young was encouraging him to publish a book of his poems. Ella Young to Adams, 26 October 1929, AAA CCP. Adams once wrote that only Cedric Wright and Ella Young had ever seen all his poems. Adams to Wright, n.d., private collection. In Dublin, Ella Young had founded, with Maud Gonne, a women's Celtic revival group, called 'Finé' (the fingers) from the memberships of the Theosophical Society and the Hermetic Society. Ithell Colquhoun, *Sword of Wisdom: MacGregor Mathers and 'The Golden Dawn,'* London: Neville Spearman, 1975, 157.

Ansel Adams, "To Ella Young," n.d., AAA CCP.

61. *Conversations,* 169. An early portrait by Adams, possibly made on this trip, was later reproduced in Ella Young, *Flowering Dusk,* New York and Toronto: Longmans, Green, 1945.

62. Inserted in a copy of Ella Young, *The Tangle-Coated Horse,* New York and Toronto: Longmans, Green, 1929, in Adams's library, private collection. See *Autobiography,* 385.

63. Gavin Arthur, "Editorial," *Dune Forum,* Subscribers' Number [1933], 7. This issue, and numbers 1, 2, 4, and 5 were in Adams's library. Private collection.

64. Ella Winter was a writer and lecturer for the Communist Party and a California correspondent for *The New Masses.* [Gavin Arthur], "By Way of Introduction,..." *Dune Forum* 1:1 (15 January 1934), 5. "A Dunite," *Dune Forum* 1:4 (April 1934), 122. Social credit proposed that credit in society should be administered by a government credit office; it played a part in the development of the welfare state. See M. Weaver, *William Carlos Williams: The American Background,* Cambridge: Cambridge University Press, 1971, 103–14.

65. The subjects of the cover photographs by Chandler (Subscribers' Number [1933]) and Edward Weston (1:4 [April 15, 1934]), and by Willard Van Dyke (1:2 [February 15, 1934]), were Oceano dunes; by Brett Weston (1:1 [January 15, 1934]), a close-up of a cypress; and by Adams (1:5 [May 15, 1934]), a close-up of two anchors (a horizontal version of the same subject was exhibited by Adams at Stieglitz's An American Place in 1936). See Andrea Gray, *Ansel Adams: An American Place, 1936,* Tucson: Center for Creative Photography, 1982, plate 42. Knowing the political aspect of the magazine, Adams may have provided the photograph of anchors rather than of a landscape, by way of referring to the 1934 longshoremen's strike in San Francisco, documented by his friend Dorothea Lange.

Adams to Edward Weston, 4 September 1935, AAA CCP.

66. Edward Carpenter, *Civilisation: Its Cause and Cure* (1889; reprint, London: George Allen and Unwin, 1921), 76. Carpenter referred constantly to the American anthropologist Lewis Morgan, whose *Ancient Society* (1877) presented the classic definition of primitive communism. The book went through eleven U.S. editions from 1891 to 1921. Walt Whitman, *Democratic Vistas,* London: Walter Scott, 1888, 4. John Varian to Jack London, 26 August 1916, Huntington Library, San Marino, California.

67. Charles Erskine Scott Wood to Cedric Wright, n.d. [1930s], Cedric Wright Papers, Bancroft Library, University of California, Berkeley. Wood and Field were introduced to Adams by Bender around 1927.

68. Edward Weston, portrait of Powys and Jeffers, c. 1918, George Eastman House, Rochester, New York; John Cowper Powys, *Autobiography* (1934; reprint, London: Macdonald, 1967), 451.

69. J. C. Powys, *The Complex Vision,* New York: Dodd, Mead, 1920. See J. C. Powys, *Letters to his Brother Llewelyn,* Malcolm Elwin, ed., London: Village, 1975, 2:262.

70. Adams and his wife, Virginia, had hosted a lecture by Ella Young in their home in San Francisco in late spring 1930. Sara Bard Field to Adams, 10 April 1930, AAA CCP. Adams to Sara Bard Field, May 1930, AAA CCP.

71. Matthew Arnold, "The Buried Life" (1852), in *The Poems of Matthew Arnold,* ed. Kenneth Allott (London: Longmans, Green, 1965), 271–76.

72. Sara Bard Field to Adams, 28 May 1930, AAA CCP; *Autobiography,* 9.

73. *Ansel Adams: Photographer,* filmed and directed by David Myers, Larry Dawson Productions, 1957. He was quoting his statement for his exhibition at Stieglitz's An American Place in 1936.

A. R. Orage, "What is the Soul?" in *Selected Essays and Critical Writings,* eds. Herbert Read and Denis Saurat, London: Stanley Nott, 1935, 157.

74. Ansel Adams, "And Now the Vision," n.d., unpublished poem quoted in Newhall, "Photographer and Reality," 125.

75. Ansel Adams, "The Park Concept," in *These We Inherit,* San Francisco: Sierra Club, 1962, 14. Reprinted from *My Camera in the National Parks,* Boston: Houghton Mifflin; Yosemite: Virginia Adams, 1950.

George Santayana, *Platonism and the Spiritual Life,* London: Constable, 1927, 83–86.

76. This may have been a poem described by Nancy Newhall as "an early elegy": "O moon, you stare as a white cave from the cold stone of the sky / And the long mesas flow far under your silence," which she partially quoted in Newhall, *Eloquent Light,* 42.

Cedric Wright to Adams, 15 October 1958, AAA CCP.

77. From about 1949, Adams enlisted Nancy Newhall as editor for a long manuscript by Wright, the title of which, "Words of the Earth," was taken from Whitman's "A Song of the Rolling Earth" in *Leaves of Grass.* A dummy that Newhall had pulled together by extracting lines of poetic text and matching them with some of his photographs was rejected by Wright as an incomplete representation of his message on politics, world peace, and educational reform, so the Sierra Club could not publish it without offending him. But Adams tried very hard to persuade Brower to produce a limited edition gravure portfolio of Wright's photographs "while he is still with us." Adams to David Brower, 29 October 1959, AAA CCP.

78. *Autobiography,* 37. Adams dedicated another book he produced with Nancy Newhall, *Yosemite Valley* (1959): "To Cedric Wright, companion on the trails and of many journeys of the spirit, who has so beautifully affirmed the meaning of the high mountains."

79. Adams to Virginia Best, 25 April 1927, *Letters,* 30.

One of the club's five founders was Samuel T. Farquhar, editor at the University of California Press and brother of Francis P. Farquhar, Adams's Sierra Club associate. Compiled for the Roxburghe Club of San Francisco by Duncan Olmsted and David Magee, *Forty Years: A Chronology of Announcements and Keepsakes,* San Francisco: Robert Grabhorn and Andrew Hoyem, 1968, ii. Bender was also one of the founders of the Book Club of California. Oscar Lewis, *To Remember Albert Bender: Notes for a Biography,* San Francisco: Oscar Lewis, 1973 [privately printed by Robert Grabhorn and Andrew Hoyem].

80. A substantial collection of Roxburghe Club keepsakes assembled by Adams was donated to the British Library, London, by Virginia Adams in 1985. See British Library exhibition notes, *The Roxburghe Club of San Francisco,* London: The British Library Board, 1985, four-page leaflet.

Announcement, 8 December 1930, Roxburghe Club keepsakes, British Library, London.

81. *Parmelian Prints of the High Sierras,* which Bender financially supported and sold by subscription, was printed in an edition of 150, cased in a box bound in black silk with gold satin lining. "Parmelian" was a term invented to sound antique. "Par" (equal to) was combined with "*melas*" (Gk, black) to mean equal to the quality of the black obtainable in a fine inked print, as in Dassonville's "Charcoal Black" photographic paper, which Adams favored.

82. Austin's first choice, Acoma Pueblo, turned out to be unavailable. In early summer 1928 the Fox Corporation hired the filmmaker Robert Flaherty to produce a film about pueblo life in Acoma. Mary Austin expressed her concern to Adams that Flaherty might purchase sole camera rights at Acoma during his year of filming there, but Adams replied that he did not think that their proposed portfolio and Flaherty's film-making activities would pose any commercial conflict. Soon after, Austin reported to Adams that the "Acoma concession" had now gone to the Famous Players group (Charlie Chaplin, Mary Pickford, and Douglas Fairbanks), and that although a Hollywood Native American movie was not real competition, Acoma might expect higher fees for photography. Austin first offered the alternative of Zuñi, with its landscape features of Thunder Mountain and Inscription Rock, but it was Taos that was finally chosen. A series of books on the pueblos of Zuñi, Hopi, and Acoma was to follow *Taos Pueblo,* but was never realized. Adams to Austin, 4 April 1930, Mary Austin Collection, Huntington Library, San Marino, California.

83. In the late 1920s "book lovers from near and far linger...and forget the hours. The shelves hold

… all the important works on printing, ancient and modern, [and] significant exemplars from all the great modern European and American presses." Edward F. O'Day, *John Henry Nash: The Aldus of San Francisco,* San Francisco: San Francisco Bay Cities Club of Printing House Craftsmen, 1928, n.p.

84. Adams to Austin, 13 June 1928, Mary Austin Collection, Huntington Library, San Marino, California.

85. Adams to Albert Bender, 21 May 1929, Albert Bender Papers, F. W. Olin Library, Mills College, Oakland, California. In the 1970s Edwin Grabhorn remembered *Taos Pueblo* as having posed a serious printing problem: "The page size was so large that only one page could be printed at a time. The paper used was a special make and was supplied only on rolls, with the result that each sheet curled and hence the center space was never quite straight. Then the binder refused to accept the job; and so the type was reset, and sent to a trade pressroom [William Eveleth] to be printed on a larger press. Here the type was over-inked; and in the final analysis,…what was gained in accuracy was lost in effect." Elinor Raas Heller and David Magee, *Bibliography of the Grabhorn Press, 1915–1940,* San Francisco: Alan Wofsy Fine Arts, 1975, 78.

86. Mary Austin and Ansel Adams, *Taos Pueblo,* San Francisco: Grabhorn Press, 1930, prepublication notice). From the archives of Lawton Kennedy, private collection. The paper was made to order by Crane and Company in New England, with half of the stock delivered to the Grabhorn Press for the printing of the text. The other half was sent to the commercial photographer William E. Dassonville, who coated the paper with a silver-bromide emulsion. Adams made photographic enlargements on this paper with a daylight enlarger in his house in San Francisco. *Conversations,* 176, 569.

87. Bender to Adams, 17 August 1931, Albert Bender Papers, F. W. Olin Library, Mills College, Oakland, California. Despite worries about the state of the market, Adams and Austin decided to print one hundred copies and sell them at seventy-five dollars apiece. The edition was sold out within two years.
Louise Morgrage, "A Collector's Item," *California Arts and Architecture* (May 1931), 46.

88. Austin to Adams, 2 January 1931, Mary Austin Collection, Huntington Library, San Marino, California. For Austin, *Taos Pueblo* represented a publicity vehicle in her campaign to preserve the cultures of New Mexico, but she failed to convince the publisher to produce an inexpensive edition. Adams, however, was determined to establish himself from the start of his career as a producer of fine printed books. In the mid-1970s, he speculated whether a publisher with a greater distribution network, perhaps Morgan and Morgan, might do a facsimile version of *Taos Pueblo* and sell as many as twenty-five thousand copies. *Conversations,* 187. But when a facsimile was finally published by the New York Graphic Society at the time that Adams's photographs entered the art collectors' market in 1977, it was as a limited edition of 950, selling for $375.

89. Austin to Adams, 2 January 1931, Mary Austin Collection, Huntington Library, San Marino, California.

90. C. G. Jung, *Memories, Dreams, Reflections* (1963; reprint, London: Collins, 1974), 280.

91. Austin also included the songs of Los Hermanos Penitentes, and other Hispanic musical forms. Mary Austin, *The American Rhythm,* 2d ed., Boston and New York: Houghton Mifflin, 1930, 170.

92. She was appointed Associate in Native American Literature by Edgar Lee Hewett at the School of American Research in Santa Fe. Augusta Fink, *I-Mary: A Biography of Mary Austin,* Tucson: University of Arizona Press, 1983, 186.

93. Mabel Dodge Luhan was a leading propagandist for the myth of a Southwest paradise in the 1920s and 1930s. Her *Winter in Taos* (New York: Harcourt, Brace, 1935) reproduced Adams's photograph *The New Church* (plate 5) and in 1937, her book *The Edge of Taos Desert* included Adams's *South House, Woman Winnowing Grain* (plate 10) under the title *In the Pueblo.*
Mabel Dodge, "The Mirror," *Camera Work* 47 (1914–15): 9.

94. Marsden Hartley, "The Red Man," from *Adventures in the Arts,* New York: Boni and Liveright (1921; reprint, New York: Hacker Art Books, 1972), 13–24; Ella Young, *Flowering Dusk: Things Remembered,* New York and Toronto: Longmans, Green, 1945, 284.

95. The conditions under which Adams was permitted to photograph included a fee to the council, and a presentation copy of the book, which the members of the pueblo wrapped in deerskin and placed in their kiva for safekeeping. In *Conversations* (p. 178), Adams thought he remembered paying one hundred dollars, but in his *Autobiography* (p. 90) the payment is recorded as twenty-five dollars.

96. This is the only photograph in the book that Adams did not make in New Mexico. Adams pho-

tographed Tony Lujan sitting outside his studio when Mabel Dodge Luhan and Tony visited him in San Francisco in 1930.

Letters, 40. When he made the photograph, Adams may also have been thinking of the work of Gertrude Käsebier, another photographer of Native Americans, whose image titled *Red Man* (c. 1900) was reproduced in the first issue of Stieglitz's magazine, *Camera Work,* in January 1903. Käsebier photographed Sioux who were traveling with Buffalo Bill's Wild West Show in New York between 1898 and 1912. Barbara L. Michaels, *Gertrude Käsebier: The Photographer and Her Photographs,* New York: Harry N. Abrams, 1992, 30.

97. Robinson Jeffers, "New Mexico Mountain," from *The Selected Poetry of Robinson Jeffers,* 15th printing, New York: Random House [1959], 363.

98. It was alleged that for years the families of Tony Lujan and Antonio Mirabal had been gradually increasing their landholdings by accusing their neighbors of using peyote in religious ceremonies. Mirabal himself would arrest them, not as their chief but as a federal law enforcement officer, and impose huge fines. Since they could not pay, he would confiscate the land. Tony Lujan acquired properties using Mabel's funds, a use of outsiders' money formally condemned by the tribe in 1936. Members of the Native American Church, Taos, to Senator Elmer Thomas, August 1936, *The John Collier Papers 1922–1968,* ed. Andrew M. Patterson and Maureen Brodoff, microfilmed from the original papers in the Yale University Library, Microfilming Corporation of America, Sanford, N.C., 1980.

99. *Conversations,* 179, 184.

100. Adams to Mabel Dodge Luhan, 6 December 1937, Mabel Dodge Luhan Papers, Beinecke Rare Book and Manuscript Library, Yale University, New Haven. Quoted in Lois Palken Rudnick, *Mabel Dodge Luhan: New Woman, New Worlds,* Albuquerque: University of New Mexico Press, 1984, 259.

101. An exhibition of paintings by Taos and Santa Fe artists was held at the California Palace of the Legion of Honor the year after Adams made his exciting first trip to the Southwest with Bender. "Taos and Santa Fe at Frisco," *El Palacio,* 25:20 (17 November 1928), 327–28. Exhibitors included William Herbert Dunton (illustrator of the works of Zane Grey), Victor Higgins, John Sloan, Joseph Henry Sharp, Carlos Vierra, Eanger Irving Couse, Walter Ufer, Josef Bakos, and Ernest Blumenschein.

102. Carpenter, *Civilisation,* 9. Carpenter, an early feminist, also advocated this ancient Native American system of inheritance through the female line because it prevented women from becoming the property of men.

103. E. B. Tylor, the Oxford anthropologist, also marveled at societies like those of the Pueblos, in which the security of marriage, the family, the harvest, and ultimately the future of the tribe, rested with the women. E. B. Tylor, "The Matriarchal Family System," *The Nineteenth Century* 40:233 (July 1896), 81–96. By the turn of the century Austin was reading the reports of the Bureau of American Ethnology. In the 1930 edition of *The American Rhythm* (p. 64), she acknowledged the work of the ethnologists Frances Densmore, Franz Boaz, Alice Cunningham Fletcher, Alfred L. Kroeber, and Frank Hamilton Cushing. The importance of matriliny in Pueblo societies was also noted by the photographer Edward S. Curtis, in an article for *Scribner's Magazine.* E. S. Curtis, "Indians from the Stone Houses," *Scribner's Magazine* 45 (January–June 1909), 161–75.

104. See Dasburg, *El Rito* (fig. 22), in Sharyn Rolfsen Udall, *Modernist Painting in New Mexico 1913–1935,* Albuquerque: University of New Mexico Press, 1984, 61; Marin, *Dance of the Santo Domingo Indians* (1929), in Charles C. Eldredge, Julie Schimmel, and William H. Truettner, *Art in New Mexico, 1900–1945,* Washington, D.C.: National Museum of American Art; New York: Abbeville Press, 1986, fig. 103, p. 95.

105. Withers Woolford, "Modernism in New Mexico," *New Mexico Highway Journal* 7:4 (April 1929), 21. Also included in this issue devoted to tourism was an article on Southwest antiques by Austin's friend, Frank Applegate.

R. M. Schindler to Richard Neutra, 1920, quoted in Donald Hoffman, *Frank Lloyd Wright's Hollyhock House,* New York: Dover, 1992, 39. It was Neutra who later asked Weston to serve, with Edward Steichen, as one of the two American selectors of the international photographic exhibition "Film und Foto" in Stuttgart in 1929.

106. D. H. Lawrence, "Taos," *The Dial* 74:3 (March 1923), 251–54. Lawrence, "Pan in America," in *Phoenix: The Posthumous Papers of D. H. Lawrence,* ed. Edward D. McDonald, London: Heinemann, 1936, 24–27. Lawrence probably composed this at the Kiowa Ranch in Taos (c. 1924–5); the tree as he

described it bears a remarkable resemblance to the one still standing in front of that cabin. Georgia O'-Keeffe monumentalized the same tree in a painting she called "The Lawrence Tree" (1929). Although Lawrence's essay remained unpublished until 1936, it may have been circulated in manuscript form by one of his typists, Dorothy Brett or Willard (Spud) Johnson (Witter Bynner's companion). *Phoenix* was among the books in Adams's own library, private collection.

107. He recalled later, "There is in the book the great church of the Ranchos de Taos [a few miles south of the pueblo], which has nothing to do with Taos Pueblo and really should not be in the book. But it was so closely identified with the area!" *Conversations,* 177.

108. *Examples,* 91.

109. Most of the photographs published in *Taos Pueblo* were made by Adams on his visit in 1929, but he was simultaneously engaged on another collaboration with Austin, initiated as early as April 1928. This one was to be a book on the Spanish colonial arts of the region written by Austin and her friend Frank Applegate, and illustrated with photographs by Adams of applied and decorative arts and crafts. The project came to a halt with the death of Frank Applegate in 1931, and despite all her efforts Austin failed to find a publisher for it before her own death in 1934. Three months before Austin died, she wrote to Bender promising to approach the presses of the University of California and Stanford University about publishing the book. The Spanish Colonial Arts Society, founded by Austin, Applegate, and others in 1929 to encourage the production of Hispanic crafts, was a precursor of the Indian Arts and Crafts Board later established by Congress at John Collier's request in 1935.

110. *The Daybooks of Edward Weston,* ed. Nancy Newhall, Millerton, N.Y.: Aperture, 1973, 2: 149.

111. Ibid., 2:219, 248, 234.

112. Weston owned four of Keyserling's books in English translation. His copy of *World in the Making* (1927) is inscribed "Edward Weston, Carmel 1929." In June 1931 his friend and publisher Merle Armitage gave him the two-volume *Travel Diary of a Philosopher* (1925). His copy of *Creative Understanding* (1929) is inscribed "Edward Weston 1932," and his copy of *South American Meditations* (1932), "Edward Weston 1933." Special Collections, Getty Research Institute for the History of Art and the Humanities, Los Angeles. All these texts were copiously underlined in pencil by Weston.

113. *The Letters of D. H. Lawrence,* ed. K. Sagar and J. T. Boulton, Cambridge: Cambridge University Press, 1993, 7: 618.

114. Ibid., 7: 206; *The Letters of D. H. Lawrence,* ed. J. T. and M. H. Boulton with G. M. Lacy, Cambridge: Cambridge University Press, 1991, 6: 390, 639.

Adams to David McAlpin, 3 February 1941, *Letters,* 127.

115. See Edward Weston to Willard Van Dyke, 18 April 1938, in Leslie Calmes, *The Letters Between Edward Weston and Willard Van Dyke,* Tucson: Center for Creative Photography, 1992, 34. Weston copied this letter to Adams.

CHAPTER 2 *The High Mountain Experience.*

1. The term "High Sierra" was coined by Josiah Whitney, California State Geologist in the 1860s, to refer to the region above Yosemite, mostly exceeding the timber line.

2. Helen M. LeConte, *Reminiscences of LeConte Family Outings, Sierra Club, and Ansel Adams,* typescript of an interview conducted by Ruth Teiser, Sierra Club Oral History Committee Series, San Francisco: Sierra Club, c. 1977, 44, 46.

3. Ansel Adams, preface to Joseph N. LeConte, *A Summer of Travel in the High Sierra,* Ashland, Oregon: Lewis Osborne, 1972 [published posthumously], 9. LeConte had given Adams a copy of the 145-page manuscript, which he completed in 1890, in the 1940s. Private collection.

4. Ansel Adams, "The Photography of Joseph N. LeConte," *Sierra Club Bulletin* 29:5 (October 1944), 46. Later in life, Adams was less inclined to regard LeConte's work as artistically expressive. In the mid-1970s, Adams distinguished between his own photographs, which he believed expressed his feelings, and LeConte's, which he regarded in hindsight as showing "factual, scientific, topographic features." *Conversations,* 249. However, when he heard from Cedric Wright that LeConte was ill, he reaffirmed that LeConte had "lived the things we believe in." Ansel Adams to Cedric Wright, c. 1950, AAA CCP.

5. Robert Curry to Dr. John Barr Tompkins (Librarian, Bancroft Library), 8 May 1968, Yosemite Research Library, Yosemite National Park, California. Sets of the albums are held by both the Yosemite

Museum and the Bancroft Library, University of California, Berkeley. For a list of titles, see <http://www.oac.cdlib.org/cgi-bin/oac/berkeley/bancroft/lecontjn>.

6. *Conversations,* 249; the first issue of the journal of the American Alpine Club, *Alpina Americana* (1907), included an article by J. N. LeConte, "The High Sierra of California," illustrated with his photographs and maps. This was in Adams's library, private collection.

7. One of these images was a photograph Adams had included in *Parmelian Prints of the High Sierras: The Sentinel* (plate 22). F. E. Matthes, *The Incomparable Valley: A Geologic Interpretation of the Yosemite,* ed. F. Fryxell (1950; reprint, Berkeley and Los Angeles: University of California Press, 1956). Matthes also owned a number of Adams's prints of High Sierra subjects, now held in the F. E. Matthes Collection, Yosemite Museum, Yosemite National Park, California. Adams later offered five photographs as illustrations to Fritiof Fryxell, ed., *François Matthes and the Marks of Time: Yosemite and the High Sierra,* San Francisco: Sierra Club, 1962.

8. Fryxell, *François Matthes,* 31.

9. François E. Matthes, *Geologic History of the Yosemite Valley,* Professional Paper 160, Washington: U.S. Government Printing Office (U.S. Dept. of the Interior / Geological Survey) 1930. Leaders of the Sierra Club in the 1960s carried a copy in their backpacks, even when weight was at a premium. Fryxell, preface to *François Matthes.* Matthes had personally inscribed a copy to Adams and his wife: "To Ansel and Virginia Adams who love the Yosemite as I do." Private collection.

10. Loren Eiseley, *Darwin's Century: Evolution and the Men Who Discovered It,* New York: Doubleday, 1958, 114.

11. Howard W. Fulweiler, "Tennyson's *In Memoriam* and the Scientific Imagination," *Thought* 59:234 (September 1984), 313–34.

12. Alfred Tennyson, "There Rolls the Deep," in *In Memoriam* (section 122), *Poems of Tennyson,* London: Oxford University Press, Henry Frowde, 1912, 395.

13. Edward Carpenter, "The Songs of the Birds, Who Hears," in *Towards Democracy,* London: Swan Sonnenschein, 1905, 409.

14. Joseph LeConte, *Elements of Geology,* New York: D. Appleton, 1889, 43; Joseph LeConte, *Journal of Ramblings through the High Sierras of California,* San Francisco: Francis and Valentine, 1875, 36. This was among the books offered for sale at Best's Studio in 1938. Lawrence C. Merriam (Yosemite National Park Superintendent) to Virginia Adams, 19 May 1938, private collection. The elder LeConte's historical significance was recognized by Adams's circle well into the 1930s: at a costume party in 1938, to which Adams came as P. T. Barnum and Virginia as Jenny Lind, Monroe E. Deutsch (vice president of the University of California at Berkeley) came as LeConte. Keepsake leaflet, "A Birthday Party for Albert M. Bender Given Him by his Friends at 'Fair Oaks,' Atherton, California on June 18th, 1938, as if it were in 1888," Albert Bender Papers, F. W. Olin Library, Mills College, Oakland.

15. Lester D. Stephens, *Joseph LeConte: Gentle Prophet of Evolution,* Baton Rouge and London: Louisiana State University Press, 1982, 127; Joseph LeConte, "On Some of the Ancient Glaciers of the Sierras," *American Journal of Science and Arts,* 3d ser., 5 (May 1873), 325–42.

16. Michael Cohen, *The Pathless Way: John Muir and American Wilderness,* Madison: University of Wisconsin Press, 1984, 91.

17. John Muir, "Studies in the Sierra, No.2," *Overland Monthly* (June 1874), reprinted in *South of Yosemite: Selected Writings of John Muir,* ed. Fred Gunsky, Garden City, New York: The Natural History Press, 1968, 139.

18. F. E. Matthes, *Geologic History,* 110.

19. François E. Matthes, *Sequoia National Park: A Geological Album,* ed. Fritiof Fryxell, Berkeley and Los Angeles: University of California Press, 1950, vi.

20. Adams to David McAlpin, 2 July 1938, AAA CCP.

21. C. P. Russell, "High Sierra Camps for Hikers," *Hikers' Camps of Yosemite National Park,* Bulletin 1, Yosemite: Yosemite Natural History Association, [1925], n.p.

22. John Tyndall, *The Glaciers of the Alps and Mountaineering in 1861,* London: J. M. Dent; New York: E. P. Dutton, [1906], 9, 187. During Adams's tenure as custodian of LeConte Lodge, this book was added to the library. Ansel E. Adams, "LeConte Memorial Lodge—Season 1921," *Sierra Club Bulletin* 11:3 (1922), 309.

23. Simon Schama, *Landscape and Memory,* London: Fontana Press, 1996, 504.

24. Ansel Adams, "Anthology of Alpine Literature," *Sierra Club Bulletin* 13:1 (1928), 98–99. The following year he reviewed the English mountain writer Geoffrey Winthrop Young's *On High Hills: Memories of the Alps* (1927), which showed an "intense emotional response to situations of the beautiful and heroic." Ansel Adams, "On High Hills," *Sierra Club Bulletin* 14:1 (February 1929), 99. Adams's wide interest in alpine literature is further shown by his review of *First Over Everest* (1933), which he judged a failure compared with "the most excellent book relating to the second climbing attempt on Kangchenjunga, Paul Bauer's 'Um dem Kantsch'." Ansel Adams, "Mount Everest from the Air," *Sierra Club Bulletin* 193 (June 1934), 107.

25. William E. Colby to Edward Whymper, 23 June 1906, Sierra Club Members Papers, Bancroft Library, University of California, Berkeley.

Francis P. Farquhar, "The Sierra Nevada of California," *Alpine Club Journal* 46 (May 1934), 88–102. Adams's photographs included *Cockscomb, Yosemite National Park; Half Dome, Yosemite Valley and Tenaya Canyon; Granite Cliffs of the Kaweah;* and *Mount Winchell, Palisade Region,* which Adams later reproduced as plate 28 in *Sierra Nevada: The John Muir Trail.* Farquhar was a member of the Sierra Club board of directors and had served as president from 1931 to 1933.

26. Tipped-in letter, Ansel Adams to the Alpine Club, in a presentation copy of *Sierra Nevada: The John Muir Trail,* Alpine Club Library, London.

27. Thomas Starr King, "A Vacation Among the Sierras," *Boston Evening Transcript* (26 January 1861), 1, quoted in Alfred Runte, *Yosemite: The Embattled Wilderness,* Lincoln, Nebraska, and London: University of Nebraska Press, 1979, 14.

David Starr-Jordan, *California and Californians, and The Alps of the King-Kern Divide,* San Francisco: Whitaker-Ray, 1903, 45.

28. Videotape of a silent film by Virginia Best, "The Range of Light: Highlights on the Sierra Club Outing of 1927," private collection.

29. Vittorio Sella Photographs, Frederick H. Morley Memorial Sierra Club Collection, Bancroft Library, University of California, Berkeley. A large number of photographs by Sella were also reproduced in gravure in Luis Trenter, *Meine Berge* (Berlin: Knaur, 1927), a mountaineering classic that may have been in the Sierra Club's library.

30. Interview with David Brower, 23 April 1996. "Sierras," in the title of Adams's portfolio, was in common use in California, but later repudiated by him on the grounds that the original Spanish "Sierra" already implies the plural.

31. Ansel Adams, "Vittorio Sella: His Photography," *Sierra Club Bulletin* 31:7 (December 1946), 17.

32. Nancy Newhall, *Ansel Adams: The Eloquent Light* (1963; reprint, Millerton, New York: Aperture, 1980), 34. Zorach made a cartoon drawing of the incident, now in the Yosemite Museum, Yosemite National Park.

33. Adams to Charles Adams, 8 June 1920, *Letters,* 7–8; Adams to Virginia Best, 5 September 1921, *Letters,* 9; typescript, c. 1949, for jacket text of *My Camera in the National Parks,* Houghton Mifflin Archive, Houghton Library, Harvard.

34. Hervey Voge, ed., *A Climber's Guide to the High Sierra,* San Francisco: Sierra Club, 1954, 82. On 13 July 1934 Adams and a group of fifteen climbers, including Virginia Adams, Francis P. Farquhar, and Helen LeConte, ascended Mount Ansel Adams again for a light-hearted dedication ceremony. Glen Dawson, "Mountaineering Notes," *Sierra Club Bulletin* 20:1 (February 1935), 104–5. The peak was officially named for him on 22 April 1985, the year after his death.

35. Ansel E. Adams, "Lyell Fork of the Merced," *Sierra Club Bulletin* 11:3 (1922), 315–16; "LeConte Memorial Lodge—Season of 1922," *Sierra Club Bulletin* 11:4 (1923), 435–36; "LeConte Memorial Lodge—Season of 1923," *Sierra Club Bulletin* (1924), 83.

36. James S. Hutchinson, "Colby Pass and the Black Kaweah," *Sierra Club Bulletin* 11:2 (January 1921), 120.

37. J. N. LeConte, "Parmelian Prints of the High Sierra," *Sierra Club Bulletin* 13:1 (1928), 96.

38. Ansel Adams albums for 1925 and 1927, SCPC UCB.

39. F. E. Matthes, *Sketch of Yosemite National Park and An Account of the Origin of the Yosemite and Hetch Hetchy Valleys,* Washington: U.S. Government Printing Office, 1928, 45.

40. *Examples,* 4; *Autobiography,* 75. I thank Jim Snyder, Archivist, Yosemite Research Museum, for bringing this to my attention.

41. Sara Bard Field to Adams, 22 June 1927, AAA CCP.

42. The first ascent of the northwest face of Half Dome was finally achieved with modern techniques in 1957 by Jerry Gallwas, Mike Sherrick, and Royal Robbins, who later likened it in difficulty and awesomeness to the Eiger. Ronald W. Clark, *Men, Myths and Mountains,* London: Weidenfeld and Nicolson, 1976, 246. Adams saw mountain consciousness in terms of centuries of spiritual and aesthetic evolution. Perhaps this is why the overtly technical approach to mountain climbing that developed later in Yosemite Valley failed to impress him. When the mountains were valued mainly as an opportunity for human beings to exercise their wills, so that dependence on artificial supports became paramount, what transformation of the psyche by mountain experience was left? See *Autobiography,* 57.

43. C. E. Palmer, "Mountain-Tops as Pictorial Subjects," *Photo-Era* 62:1 (January 1929), 23; Theodore M. Wurts, "Photographing the Spirit of the Mountains," *Photo-Era* 63, 3 (September 1929), 119.

44. Arthur Gardner, *The Art and Sport of Alpine Photography* (London: H. F. and G. Witherby, 1927), 163; ibid., 45, 91, 170.

45. Adams to Nancy Newhall, n.d. [fragment], AAA CCP. Frank S. Smythe, *Adventures of a Mountaineer,* London: J. M. Dent, 1940, 217.

Frank S. Smythe, *Climbs and Ski Runs,* Edinburgh and London: W. Blackwood and Sons, 1929, 307.

46. Frank S. Smythe, *The Mountain Scene,* London: Adam and Charles Black, 1937, 25. Books by Smythe in Adams's library included *My Alpine Album* (1940), *A Camera in the Hills* (1946), and *Swiss Winter* (1948). Private collection.

47. Francis P. Farquhar, *History of the Sierra Nevada,* Berkeley and Los Angeles: University of California Press in collaboration with the Sierra Club, 1966, 220.

48. John W. Bingaman, *Pathways: A Story of Trails and Men,* Lodi, California: End-kian Publishing, 1968, 28.

49. Herbert W. Gleason, "The John Muir Trail," *Appalachia* 15 (1920), 36. Gleason's six documentary photographs included an image of Mt. Ritter and Banner Peak taken from Iceberg Lake.

50. William A. Magee, "Personal Recollections of John Muir," *Sierra Club Bulletin* 21:1 (February 1936), 35–9. Adams's photographs printed along with it (Plates 11–17) included: *Upper Canyon of the Middle Fork of Kings River from Windy Point, The Palisade Group from Windy Point, Scouting White Pass, Crossing White Pass on the way to Marion Lake, Sierra Club Camp Below Woods Lake, Mount Clarence King* (later reproduced in the book *Sierra Nevada: The John Muir Trail*), and *Rae Lake and the Colored Lady.*

51. Ansel Easton Adams, "Retrospect: Nineteen-Thirty-One," *Sierra Club Bulletin* 17:1 (February 1932), 1–11.

52. Adams's early personal albums of mountain photographs were made in the Sierra Nevada in 1920 and 1923, and his albums of Sierra Club outings were made for the years 1925, 1927–36, and 1945, SCPC UCB.

53. Cohen, *The Pathless Way,* 68, 74.

54. The photographs were made by Herbert P. Rankin, Philip S. Carlton, Walter L. Huber, Elsie Zeile, Cedric Wright, Rodney L. Glisan, Nathan Clark, and Adams. Prints from the album could be ordered individually but Adams also offered to produce on request, for thirty dollars, a portfolio of twenty-five prints with binding by Hazel Dreis and typography by Johnck and Seeger.

55. *Autobiography,* 142.

56. Adams, "Photographs of Sierra Club Outing 1929," especially numbers 87 and 88. Adams included six photographs of this subject.

57. Plate 9, *Sierra Club Bulletin* 15:1 (February 1930); "Photographs of Sierra Club 1929 Outing," *Bear Creek Spire,* number 65.

58. Francis P. Farquhar, foreword to Walter A. Starr Jr., *Guide to the John Muir Trail and the High Sierra Region,* San Francisco: Sierra Club, 1934.

59. Adams to David McAlpin, 2 July 1938, AAA CCP.

60. *Conversations,* 268.

61. Vincent Butler, introduction to Walter A. Starr Jr., *Guide to the John Muir Trail and the High Sierra Region,* San Francisco: Sierra Club, 1934, ix. The last photograph taken by Peter Starr, made from the film found in his camera at his last encampment, was given to Adams by Walter. The subject of the photograph was the Minarets. Handwritten note, signed by Walter A. Starr, private collection.

62. When a Californian, Newton B. Drury, a member of the Yosemite Advisory Board, replaced Cammerer in 1940, Adams's hopes for financial support from the government for his photographic work

seemed even more certain; American Planning and Civic Association and National Conference on State Parks, *Conference on the National Park Service,* [programme] Washington, D.C., 22–24 January 1936.

63. Adams to Col. C. G. Thomson, 10 March 1937, and Thomson to Adams, 16 March 1937, Yosemite Research Library, Yosemite National Park, California; Adams to Cammerer, 11 April 1937, Yosemite Research Library, Yosemite National Park, California.

64. He also knew him through a book designed and published by Bentley in 1937 by the Japanese artist Chiura Obata, whose works Adams and his wife sold in Yosemite from Best's Studio; *From the Sierra to the Sea,* Berkeley: The Archetype Press, 1937. Adams to Wilder Bentley, 25 May 1937, Wilder Bentley Papers, San Francisco Public Library, San Francisco, California.

65. Wilder Bentley, "Photography and the Fine Book," *U.S. Camera* 14 (Spring 1941), 72; Adams to Bentley, 4 June 1938, Wilder Bentley Papers, San Francisco Public Library, San Francisco, California.

66. The first set of proofs had to be reengraved, delaying production. Adams to Bentley, 7 November 1937, Wilder Bentley Papers, San Francisco Public Library, San Francisco, California. Adams knew of W. A. Kittredge, the director of Lakeside Press, through the Roxburghe Club, of which Kittredge was a nonresident member.

67. David Brower, *For Earth's Sake: The Life and Times of David Brower,* Salt Lake City: Gibbs Smith, 1990, 188; Adams to Bentley, n.d. [1938], Wilder Bentley Papers, San Francisco Public Library, San Francisco, California.

68. The book was announced in mid-1938 at fifteen dollars, but even at that price Adams and Bentley both lost money on it; Adams to Bentley, 30 October 1937 and 3 May 1938, Wilder Bentley Papers, San Francisco Public Library, San Francisco, California.

69. Bentley, "Photography and the Fine Book," 67.

70. Jonathan Spaulding, *Ansel Adams and the American Landscape,* Berkeley, Los Angeles, and London: University of California Press, 1995), 168; Adams to Walter Starr Sr., 10 March 1940, AAA CCP.

71. Adams to David McAlpin, 4 November 1938, *Letters,* 109.

72. John Muir, *The Mountains of California,* London: T. Fisher Unwin, 1894, 103.

73. Ansel Easton Adams, "Sierra Club Outing 1932," album, photographs 155–61, SCPC UCB. One of the versions printed for this album, number 160, resembles the first of the five variants reproduced in John Szarkowski, "Kaweah Gap and Its Variants," *Ansel Adams 1902–1984,* Carmel: The Friends of Photography, 1984, 13–15.

74. *Conversations,* 272.

75. See Weston Naef, *Era of Exploration: The Rise of Landscape Photography in the American West, 1860–1885,* Buffalo: Albright-Knox Art Gallery; New York: Metropolitan Museum of Art, 1975, plate 6, plate 10.

76. Carpenter, "Lake of Beauty," *Towards Democracy,* 373.

77. Adams to Alfred Stieglitz, 21 December 1938, Beinecke Rare Book and Manuscript Library, Yale University, New Haven, Connecticut. Copy in AAA CCP.

Alfred Stieglitz to Adams, 21 December 1938, *Letters,* 111.

78. Adams to McAlpin, 4 November 1938, *Letters,* 109.

79. Leslie Stephen, *The Playground of Europe,* Oxford: Basil Blackwell, 1936, 108.

80. Richard G. Mitchell Jr., *Mountain Experience: The Psychology and Sociology of Adventure,* Chicago and London: University of Chicago Press, 1983, viii.

81. Mihaly Csikszentmihalyi, *Flow: Studies in Enjoyment,* PHS Grant Report N.RO1HM 22883–02, 1974, 58, quoted in Mitchell, *Mountain Experience,* 153.

Cedric Wright, "Trail Song: Giant Forest and Vicinity: 1927," *Sierra Club Bulletin* 13:1 (February 1928), 20–3.

82. Adams, "Ski-Experience," *Sierra Club Bulletin* 16:1 (February 1931), 45.

83. Muir, *Mountains of California,* 128.

84. Adams, undated fragment, quoted in Newhall, *Eloquent Light,* 36.

85. M. M. Strumia, "Moods of Mountains and Climbers," *American Alpine Journal* 1:1 (1929), 31–9.

86. Adams to Virginia Best, 8 November 1923, private collection. As a member of the California Himalaya Committee, Adams was designated the photographer for an expedition proposed in 1952 (but never undertaken) that would have tackled one of three peaks over 26,000 feet in the Himalayan range: Manaslu, Dhaulagiri, or Cho Oyu, 25 miles west of Everest. He retained the right to devote most of his

time to "interpretive photography," to be later used "for production of creative prints for albums"; typed newsletter, "California Himalayan Expedition 1953," Berkeley: Californian Himalayan Committee, 10 March 1952, AAA CCP.

Ansel Adams, "Everest 1933," *Sierra Club Bulletin* 20:1 (February 1935), 114–15.

87. Patrick French, *Younghusband: The Last Great Imperial Adventurer,* London: Harper Collins, 1995, 313.

88. Helen LeConte, "The Heart of Nature," *Sierra Club Bulletin,* 11:4 (1923), 458; Sir Francis Younghusband, *The Heart of Nature; or The Quest for Natural Beauty,* London: John Murray, 1921, 83.

89. Younghusband, *Heart of Nature,* xvii, 160.

90. Adams to Virginia Best, 26 March 1923, private collection.

91. Manly P. Hall (1901–1990) founded the Philosophical Research Society in Los Angeles in 1934. Many of his early writings were printed in the *Overland Monthly,* which also published a photograph by Adams of the High Sierra in its June 1927 issue.

92. *Conversations,* 245. King's *Mountaineering in the Sierra Nevada* was first on the list of books Adams recommended to David McAlpin as preparation for their planned trip into the High Sierra in 1938. Adams owned five copies of King's book, including one first edition.

93. [Leslie Stephen], "Mountaineering in the Sierra Nevada," *Alpine Journal* 5 (1872), 389–96; Stephen, *The Playground of Europe,* 187; Clarence King, *Mountaineering in the Sierra Nevada,* London: Sampson, Low, Marston Low, and Searle, 1872, 126.

94. Roger B. Stein, *John Ruskin and Aesthetic Thought in America 1840–1900,* Cambridge: Harvard University Press, 1967, 184.

95. Ansel Adams, "Anthology of Alpine Literature," *Sierra Club Bulletin* 13:1 (1928), 99.

96. Stephen, *The Playground of Europe,* 192; ibid., 193.

97. Younghusband, *Heart of Nature,* 173.

98. During a trip into the High Sierra in 1937, Adams was accompanied by Edward Weston, Charis Wilson, Virginia, Morgan Harris, and David Brower. It was on this occasion that Adams made the photograph of Harris and Brower on the Minarets that was used as the frontispiece for the book. Brower, *For Earth's Sake,* 188.

99. Adams also had in his possession two major books by D. H. Lawrence, a committed Nietzschean: *Apocalypse* (1932), and the posthumous *Phoenix* (1936); Friedrich Nietzsche, *"The Birth of Tragedy" and "The Case of Wagner,"* trans. Walter Kaufmann, New York: Vintage, 1967, 67.

100. *Shadows on the Lake—Stieglitz and [Abraham] Walkowitz,* 1916, National Gallery of Art, Washington, D.C., in John Szarkowski, *Alfred Stieglitz at Lake George,* New York: Museum of Modern Art, New York, 1995, 39.

CHAPTER 3. *Objective Photography.*

1. He wrote to the museum that studying these photographs had taken him back to his youth. Adams to Charles Albert "Bert" Harwell, Naturalist, Yosemite Museum, 25 February 1940, Yosemite Research Library, Yosemite.

2. J. M. Hutchings, *In the Heart of the Sierras,* Yosemite Valley: The Old Cabin; Oakland: Pacific Press Publishing House, 1886. With photographs by George Fiske, I. W. Taber, S. C. Walker, C. Wagoner, J. C. Scripture, C. L. Weed, and C. Roach, many reproduced by "Phototypo"(collotype) and others as halftones, or wood-engravings after photographs. Hutchings's book, a classic in Yosemite literature, was listed among the "strictly photographic" volumes offered for sale at Best's Studio in 1938, two years after Virginia and Ansel took over its operation. Lawrence C. Merriam, Yosemite National Park Superintendent, to Virginia Adams, 19 May 1938, private collection.

3. Thomas Curran, *Fiske the Cloud Chaser,* Oakland: Oakland Museum, 1989, 2.

4. Ruskin praised "the beautiful photographs" and thanked Fiske for adding to his appreciation of mountain landscapes. John Ruskin to George Fiske, 28 April 1884. Quoted in Paul Hickman and Terence Pitts, *George Fiske: Yosemite Photographer,* Flagstaff: Northland Press; Tucson: Center for Creative Photography, 1980, 17.

5. Although the subjects of the photographs Fiske sent to Ruskin have not been established, such images as *Ice Below Nevada Fall* (no.236), *Diamond Cave, Bridalveil Creek* (no.207), and *Ice at the Foot of*

Bridalveil Fall (no.203), all c. 1874, would have been considered by Fiske at that time as among his best. Yosemite Museum, Yosemite National Park, California.

The destruction of Fiske's remaining glass plates in another fire around 1943 prevented his talent "as a top interpretive photographer," as Adams judged it, from being recognized for decades. Adams, quoted in Paul A. Hickman, "The Life and Photographic Works of George Fiske, 1835–1918," master's thesis, Arizona State University, 1979, 52. In the late 1970s, a collection of more than three hundred original prints by Fiske was given to the Center for Creative Photography in Tucson, Arizona, by Virginia Adams.

6. *Conversations*, 8–9. Adams and Dassonville met at the California Camera Club in San Francisco around 1926 and formed a close friendship; in 1928, Adams sent him a photograph, *Mt. Robson from Mt. Resplendent*, made on his recent trip as Sierra Club official photographer to the Canadian Rockies, the print made on Dassonville paper and dedicated with appreciation to "my friend W. E. Dassonville." *Pictorialism in California: Photographs 1900–1940*, with essays by Michael G. Wilson and Dennis Reed, Malibu, Calif.: The J. Paul Getty Museum; San Marino: The Henry E. Huntington Library and Art Gallery, 1994, 18. Dassonville's work was featured in the photography display at the 1915 Panama-Pacific International Exposition, which Adams attended daily. Christian A. Peterson, *After the Photo-Secession: American Pictorial Photography, 1910–1955*, New York: Minneapolis Institute of Arts in association with W. W. Norton, 1997, 181.

The cloth-bound portfolio album of twelve photographs was dedicated to "Mr. E. P. and Mrs. G. Washburn." Yosemite Museum, Yosemite National Park, California.

7. Coburn had photographed Edward Carpenter in England in 1905 and was devoted to his *Art of Creation* (1904). See Mike Weaver, *Alvin Langdon Coburn: Symbolist Photographer*, New York: Aperture, 1986, 23–24. Dassonville photographed Coburn in 1904. Susan Herzig and Paul Hertzmann, eds., *Dassonville*, Nevada City: Carl Mautz, 1999, plate 4. In 1964 Coburn sent Adams a letter of congratulation on *The Eloquent Light*, affirming his own commitment to mysticism and the spiritual. Adams wrote back that he approved of Coburn's "brand of mysticism" and felt they had much in common. Adams to Alvin Langdon Coburn, 18 May 1964, *Letters*, 291.

Thurman Wilkins, *Thomas Moran: Artist of the Mountains*, Norman, Oklahoma: University of Oklahoma Press, 1998, 40–45. Adams photographed Moran on a visit to Yosemite in the early 1920s. Center for Creative Photography, University of Arizona, Tucson.

8. Fifty California photographs by Coburn, including eight of Yosemite subjects, were exhibited at the Blanchard Gallery, Los Angeles, 29 January–10 February 1912. Percy Bysshe Shelley, *The Cloud* (with six original platinum prints by Alvin Langdon Coburn), Los Angeles: C. C. Parker, 1912.

9. *The Complete Works of John Ruskin*, ed. E. T. Cook and Alexander Wedderburn, London: George Allen; New York: Longmans, Green, 1906, 12:359–60.

10. The album was a gift in 1932 from his Sierra Club friend Francis P. Farquhar. (*Conversations*, 390.) In 1941, Adams donated the album to the Museum of Modern Art, New York, in memory of Albert Bender. He later acquired a second copy: Timothy O'Sullivan and William Bell, "Photographs Showing Landscapes, Geological and Other Features, of Portions of the Western Territory of the United States. Obtained in Connection with Geographic and Geological Explorations and Surveys West of the 100th Meridian, Seasons of 1871, 1872 and 1873. First Lieutenant Geo. M. Wheeler, Corps of Engineers, in Charge," Washington: War Department, Corps of Engineers, U.S. Army [c. 1874]. Album of twenty-five albumen prints in three sections. Ansel and Virginia Adams Collection, Center for Creative Photography, Tucson. Adams and Farquhar (a collector of western photographs) were friends in the Sierra Club since the early 1920s, and in 1928 both became charter members of the Roxburghe Club in San Francisco.

11. Beaumont Newhall and Ansel Adams, 1979, telephone conversation/tape recording, Beaumont and Nancy Newhall Papers, Special Collections, Getty Research Institute for the History of Art and the Humanities, Los Angeles.

12. *Conversations*, 306. In August 1942 Adams had written to Henry Allen Moe of the Guggenheim Foundation about the possibility of a fellowship to compile a book on W. H. Jackson, who had died that summer. Moe took advice from Tom Maloney, publisher of *U.S. Camera*, who favored the idea. Adams withdrew his request, however, when it appeared that he would have to give up his full-time employment. He suggested that Nancy Newhall should do the book, promising to assist her by making prints from Jackson's negatives if required. Adams to Henry Allen Moe, 28 September 1942, John Simon Guggenheim Memorial Foundation, New York.

13. Adams to Alfred Stieglitz, 7 July 1942, Beinecke Rare Book and Manuscript Library, Yale University, New Haven. Copy in AAA CCP.

Nancy Newhall to Adams, 13 July 1951, AAA CCP.

14. Joseph LeConte, *Sight: An Exposition of the Principles of Monocular and Binocular Vision,* London: C. Kegan Paul, 1881, 142–43; Douglas R. Nickel, "An Art of Perception," *Carleton Watkins: The Art of Perception,* San Francisco: San Francisco Museum of Modern Art, 1999, 27.

15. The spatial illusion of the stereoscope depended on pictorial elements projecting into the frame. Photographers were careful to include some object within eight feet of the lenses so that the stereoscope would accommodate the eye's short-range focusing power in full relief. After that, the stereoscopic effect would gradually decrease, and judging depth and distance would depend entirely on mathematical and aerial perspective. In 1944 a feature article in Willard D. Morgan's *Encyclopedia of Photography,* to which Adams himself had contributed six articles, described the compositional formulae of the stereo landscape view, recommending that the photographer add "some object, even if it is only a tuft of grass, within eight feet." Richard T. Kriebel, "Stereoscopic Photography," in Willard D. Morgan, ed. *Encyclopedia of Photography,* New York: Greystone Press, 1944, 19:3530–31.

Proceedings at the Annual Dinner of the Chit-Chat Club, November 1877, Joseph LeConte Miscellaneous Writings, Bancroft Library, University of California, Berkeley, quoted in Lester B. Stephens, *Joseph LeConte: Gentle Prophet of Evolution,* Baton Rouge and London: Louisiana State University Press, 1982, 165–66. Joseph LeConte, *Evolution and Its Relation to Religious Thought,* London: Chapman and Hall, 1888, 273.

16. In 1948 Virginia donated forty-two photographs by Watkins to George Eastman House. Handwritten list of photographs in the collection of Virginia Adams to be donated to the Eastman House Historical Collection, 1948, Beaumont and Nancy Newhall Papers, Special Collections, Getty Research Institute for the History of Art and the Humanities, Los Angeles. Adams would also have known Watkins's work from a series of mammoth prints that hung on the walls of the Wawona Hotel near Yosemite throughout the 1920s. Conversation with Barbara Beroza, Curator of Photographs, November, 1997, Yosemite Museum, Yosemite National Park, California. He clearly remembered "quite a collection of Watkinses in Yosemite . . . big 20-by-24 prints." "Ansel Adams," interview by Milton Esterow, *Art News* 83:6 (summer 1984), 85.

17. In 1927, three months before Adams arrived in Yosemite for his winter holidays, fourteen mammoth-plate photographs by Muybridge were presented to the Yosemite Museum, and three years later the museum acquired a further twenty-eight Muybridge mammoth prints published by Bradley and Rulofson. Adams to Virginia Best, 21 December 1927, *Letters,* 34. Yosemite Superindendent's Report, 6 October 1927, and Acquisition Files, Yosemite Research Library, Yosemite National Park, California. In 1948 Virginia Adams donated some prints from this series from her own collection to George Eastman House, together with the Watkins prints. These included "Tenaya Canyon" (no. 35), "Loya" (no. 14), "Tutokanula" (no. 9), "Glacier Rock" (no. 27), "Tokoya and Hunto" (no. 24), and "The High Sierra" (no. 38). Handwritten list of photographs in the collection of Virginia Adams to be donated to the Eastman House Historical Collection, 1948, Beaumont and Nancy Newhall Papers, Special Collections, Getty Research Institute for the History of Art and the Humanities, Los Angeles.

18. Muybridge's *Yosemite Cliff at the Summit of the Fall* was donated to the Yosemite Museum in 1931. Electronic mail message to author from Barbara Beroza, Curator of Yosemite Museum, 19 July 1999, Yosemite National Park, California.

Helen Hunt Jackson, *Bits of Travel at Home,* Boston: Roberts Brothers, 1878, 85–86.

19. "Taken at an acute angle into the sun, the basic constrasts of the image were very great. The K2 filter was used to partially clarify the haze, but no filter could completely remove it. Even infra-red photography would show considerable haze between the distant ridges. Without any filter the nearer hills would have appeared too flat. Hence, the basic constrasts of the scene were controlled by exposure and the filter used, but the intense values of the near rock were balanced by a rather soft development." Ansel Adams, *Yosemite and the Sierra Nevada,* Boston: Houghton Mifflin, 1948, 130.

20. Ansel Adams (with Robert Baker), *The Camera,* Boston: Little Brown, 1980, 73; Ansel Adams, "An Essay on Mountain Photography," *My Camera in Yosemite Valley,* Boston: Houghton Mifflin; Yosemite: Virginia Adams, 1949, 58, 61, 57.

21. Adams's characteristic italic lower case "f," scrolled at both ends, was similar in shape to the design

on the bridge of a violin, and may have been suggested by his musical background. Willard Van Dyke, film interview, *Photoprofiles: Willard Van Dyke,* produced by Thomas R. Schiff, Images Productions, Cincinnati, Ohio, 1983.

22. *Conversations,* 102; Weston's work was included in a group exhibition at the University of California, Berkeley, which opened 18 July 1927; in a show with son Brett at the East-West Gallery in San Francisco in June–July 1928; and in the Salon of the Pictorial Photographic Society of San Francisco at the Palace of the Legion of Honor, which opened 16 September 1928. See Amy Conger, *Edward Weston: Photographs (from the Collection of the Center for Creative Photography),* Tucson: Center for Creative Photography, University of Arizona, 1992, Appendix C, 60.

23. Edward Weston, "From My Daybook," *Creative Art* 3:2 (August 1928), xxix–xxxvi. Reprinted in *Edward Weston on Photography,* ed. Peter C. Bunnell, Salt Lake City: Peregrine Smith, 1983, 48–52. Seven photographs by Weston were reproduced: *Mojave Desert* (1928); *Maguey* (1926); *Ollas de Oaxaca* (1926); *Study* [nude] (1927); *Sea Shell* (1927); *Chard* (1927); and *Study* [nude] (1925).

24. Tom Cooper and Paul Hill, "Interview: Ansel Adams," *Camera* 55:1 (January 1976), 21.

25. *Conversations,* 102.

26. José Rodriguez, "The Art of Edward Weston," *California Arts and Architecture* 26 (November 1930), 36–8. Reprinted in *Edward Weston Omnibus: A Critical Anthology,* eds. Beaumont Newhall and Amy Conger, Salt Lake City: Peregrine Smith, 1984, 36–39.

Frances D. McMullen, "Lowly Things That Yield Strange, Dark Beauty," *New York Times Magazine* (16 November 1930), 7, 20. Reprinted in *Edward Weston Omnibus,* 40–44.

Edward Weston, quoted in McMullen, "Lowly Things," 43.

27. Peterson, *After the Photo-Secession,* 134.

28. Ansel Adams, interviewed by Paul Hickman, 15 March 1978, audio tape, side 1, courtesy of Paul Hickman. Adams to Albert Bender, [postdated by Adams, July 1930], AAA CCP.

29. Adams to Alfred Stieglitz, 6 July 1933, Alfred Stieglitz Collection, Beinecke Rare Book and Manuscript Library, Yale University, New Haven. Copy in AAA CCP.

30. Edward Weston, "Photography—Not Pictorial," *Camera Craft* 37:7 (July 1930), 313–20. Reprinted in *Edward Weston on Photography,* ed. Peter C. Bunnell, Salt Lake City: Peregrine Smith, 1983, 57–60.

31. Ansel Adams, "Photography," *The Fortnightly* (18 December 1931), 21–22. Reprinted in *Edward Weston Omnibus,* 45–47. *The Fortnightly* was published from 11 September 1931 through 6 May 1932 (vol. 2, no. 18).

32. Weston to Adams, *Letters,* 48–50. The letter can now be seen as an important statement of artistic intent. Weston's having transcribed most of it into his daybook suggests that he recognized this.

33. Weston to Adams, *Letters,* 49. This expression was used immediately thereafter by Weston in a statement for his one-man show at the Delphic Studios in New York, 29 February–13 March 1932. See *Edward Weston on Photography,* 70.

34. Francis Farquhar, "Mountain Studies in the Sierra: Photographs by Ansel Easton Adams," *Touring Topics* (February 1931), n.p.

35. H. S. Bryant to A. J. Olmsted, 19 November 1930, A. J. Olmsted Papers, Smithsonian Institution Archives, Washington, D.C. Two photographs by F. Russell Bichowsky made in the Sierra Nevada were reproduced in John H. Williams, *Yosemite and Its High Sierra,* John H. Williams: Tacoma and San Francisco, 1914: *Triple Divide Peak* (p. 93) and *Summit of Mt. Conness* (p. 106).

Ada Rainey, "Pictorial Photographer Show," *Washington Post* (11 January 1931), clipping, AAA CCP. Four photographs from the exhibition were reproduced in *The Camera* 43 (July 1931): "At Glacier Point, Yosemite National Park"; "Skiing on Mt. Watkins"; "The Bennington Glacier"; and "Cockscomb Crest — Yosemite Sierra."

36. Adams to Mary Austin, 10 August 1931, 4 May 1932, Mary Austin Collection, Huntington Library, San Marino, California.

37. *Conversations,* 110.

38. Mary Alinder, *Ansel Adams: A Biography,* New York: Henry Holt 1996, 91. It should be noted that there is no connection between Edward Weston and the Weston Meter, developed by the Weston Electric Instruments Company. The Weston Meter was unusual in being calibrated in candles per square foot, which enabled the photographer to directly apply a formula to his or her meter reading, thus making possible a quick mental calculation of the exposure. Ansel Adams, *The Negative,* The New Ansel Adams Photography Series, Book 2, Boston: Little, Brown, 1981, 66.

39. *The Daybooks of Edward Weston,* ed. Nancy Newhall, vol. 2 (1961; reprint, Millerton, New York: Aperture, 1973), 80.

40. Kenneth Rexroth, "The Objectivism of Edward Weston: An Attempt at a Functional Definition of the Art of the Camera," [1931], typescript, Edward Weston Archive, Center for Creative Photography, University of Arizona, Tucson. This essay is reproduced in full in *History of Photography* 22:2 (Summer 1998), 179–82.

Lincoln Kirstein to Kenneth Rexroth, 2 May 1932, *Hound and Horn* correspondence, file za 222, Beinecke Rare Book and Manuscript Library, Yale University, New Haven.

41. Weston to Adams, 28 January 1932, *Letters,* 50. "Let the eyes work from inside out—do not imitate 'photographic painting,' in a desire to be photographic! (this latter is not an original thought with me. More, in detail, later)." This thought had been contributed by Rexroth; see *The Daybooks of Edward Weston* 2:240. Willard Van Dyke, Weston's close friend and student since 1928, and a friend of Adams's, also read the Rexroth essay. Willard Van Dyke to Edward Weston, 5 January 1932, reprinted in Leslie Squyres Calmes, *The Letters Between Edward Weston and Willard Van Dyke (The Archive* 30), Tucson: Center for Creative Photography, 1992, 1, 53. The envelope in which Van Dyke returned it is postmarked 13 June 1932.

42. Alfred North Whitehead, *Science and the Modern World,* Lowell Lectures 1925, Cambridge: Cambridge University Press, 1926, 125. The book had been published in New York by Macmillan in 1925, and was later reprinted by Pelican Mentor Books, New York, in 1948.

Edward Weston, "From My Daybook," *Creative Art,* 3:2 (August 1928), xxix–xxxvi, and "Amerika und Fotographie," in Gustaf Stotz, ed., *Internationale Ausstellung des Deutschen Werkbunds Film und Foto,* Stuttgart: Des Deutschen Werkbunds, 1929, 13–14. Both reprinted in *Edward Weston on Photography,* 55, 51.

43. William Carlos Williams, "Charles Sheeler—Paintings—Drawings—Photographs" (1939), in *Selected Essays of William Carlos Williams,* New York: Random House 1954, 233. Mike Weaver, *William Carlos Williams: The American Background,* Cambridge: Cambridge University Press, 1971, 53–64.

44. Kenneth Rexroth, "Prolegomena to a Theodicy" (53–78, 189–92), "Fundamental Disagreement with Two Contemporaries" (79–86), and "The Place for Ivor Winters" (165–68), in Louis Zukofsky, *An "Objectivists" Anthology,* Le Beausset, Var, France: TO 1932; Linda Hamalian, *A Life of Kenneth Rexroth,* New York and London: W. W. Norton, 1991, 71.

45. *The Daybooks of Edward Weston,* 2:221; Louis Zukofsky, "An Objective" (1931), in *Prepositions: The Collected Critical Essays of Louis Zukofsky,* London: Rapp and Carroll, 1967, 20, 25.

46. Rexroth apologized in advance for his use of this "Teutonism" and adopted the *Neue Sachlichkeit* spelling of "foto," possibly to associate it by an analogy, probably Marxist, with *Realpolitik.*

47. Weston received *The Little Review* while he was in Mexico, which in the spring 1926 issue reproduced photographs by László Moholy-Nagy and Charles Sheeler; he also saw the work of Man Ray in a German periodical. *The Daybooks of Edward Weston,* 1:190, 191.

Jean-Claude Gautrand [interview], "Ansel Adams," *Photo-Revue* (Janvier 1975), 24. Adams admired Renger-Patzsch's work and had tried to borrow some of his photographs for "The Pageant of Photography" exhibition in 1940, but, unable to get them from Germany, exhibited instead studies of nature in close-up by Andreas Feininger, the next generation in the Neue Sachlichkeit tradition. *Conversations,* 398.

48. Albert Jourdan, "Sidelight no.16, The Impurities of Purism," *American Photography* 29 (June 1935), 348–56. Reprinted in *Seeing Straight: The f.64 Revolution in Photography,* ed. Therese Thau Heyman, Oakland: Oakland Museum, 1992, 62.

49. Rexroth was a self-proclaimed Communist, but in the depth of the Depression any expression in the arts that suggested a commitment to documentary projects was automatically viewed as socialist. Weston himself was in the early thirties accused of leftist sympathies. Adams to Edward Weston, 4 September 1935, Edward Weston Archives, Center for Creative Photography, University of Arizona, Tucson.

Weston to Adams, 28 January 1932, *Letters,* 50.

50. Alfred North Whitehead, *Process and Reality: An Essay in Cosmology,* London: Cambridge University Press, 1929, 30.

51. Rexroth, "The Objectivism of Edward Weston," 1.

52. Edward Weston to Ansel Adams, 28 January 1932, *Letters,* 48. Weston copied most of this letter into his daybook entry for 1 February 1932. See *The Daybooks of Edward Weston,* 2:240.

53. *Edward Weston on Photography,* 62; Adams, "An Exposition of My Photographic Technique," *Camera Craft* 41 (January 1934), 20.

54. Adams, *My Camera in Yosemite Valley,* plate 2.

55. *Brancusi's Photographs,* exhibition catalogue, London: Arts Council of Great Britain, 1981; Rexroth, "The Objectivism of Edward Weston," typescript, 5.

56. *The Daybooks of Edward Weston,* 2:151. Weston had been an admirer of Brancusi's sculpture for many years. He subscribed to *The Little Review,* a literary journal, and probably saw a special number in 1921 devoted to the work of Brancusi and illustrated with twenty-four of the sculptor's photographs of his own work. In an accompanying essay by Ezra Pound, Brancusi is presented as in revolt against nineteenth-century rhetoric and monumentalism, producing instead sculptures of extreme simplification in "an approach to the infinite *by form,* by precisely the highest possible degree of formal perfection." Ezra Pound, "Brancusi," *The Little Review* (Autumn 1921), 6.

57. Rexroth asserted that Weston's camera art was truly comparable only with the work of Brancusi, the formal integrity of which culminated in a sense of mystery verging on Rudolf Otto's idea of "the holy." The translation into English of Otto's *Idea of the Holy* had been published in more than half a dozen printings from 1923 to 1931.
Rexroth, "The Objectivism of Edward Weston," typescript, 8, 7.

58. Edward Weston, [Statement, in conjunction with Delphic Studios exhibition, 1930], *The San Franciscan* 5:2 (December 1930), 23.

59. Edward Weston, [Statement], *Exhibition of Photographs / Edward Weston,* New York: Delphic Studios, 1932. Reprinted in *Edward Weston on Photography,* 70.

60. R. H. Wilenski, *The Modern Movement in Art,* London: Faber and Gwyer, 1927, quoted in Ansel Adams, "The New Photography," *Modern Photography 1934–35,* London: The Studio; New York: Studio Publications, 1935, 10.
Karl Blossfeldt, *Urformen der Kunst,* Berlin: Verlag Ernst Wasmuth, 1928. English title: *Art Forms in Nature,* New York: Weyhe, 1929, 1932, 1935. In 1938 the books offered for sale at Best's Studio in Yosemite, run by Virginia and Ansel Adams, included both *Making a Photograph* and Blossfeldt's *Art Forms in Nature.* Laurence C. Merriam, Yosemite National Park Superintendent, to Virginia Adams, 19 May 1938, private collection.

61. R. H. Wilenski, *The Meaning of Modern Sculpture,* London: Faber and Faber, 1932, 158.

62. Ansel Adams, interviewed by Anita Silvers, "Editorial," *Journal of Aesthetics and Art Criticism* 39:2 (Spring 1981), 244.

63. Amédée Ozenfant, *Foundations of Modern Art,* London: John Rodker, 1931, 196; Amédée Ozenfant and Charles-Edouard Jeanneret, "Le Purisme," in *Ozenfant and Purism: The Evolution of a Style,* trans. and ed. Susan L. Ball, Ann Arbor: UMI Research Press, 1981, 36.

64. Ansel Adams, "An Exposition of My Photographic Technique," *Camera Craft* 41 (January 1934), 19–25. Three further articles in the series followed with subheadings: "Landscape" (February 1934), 72–78; "Portraiture" (March 1934), 114–22; and "Advertising and Illustrative Photography; Montage and Superimposition; Architectural Photography; Documentary Photography; and the Photo-Document" (April 1934), 172–83.
William Mortensen, "Venus and Vulcan: An Essay on Creative Pictorialism. 5. A Manifesto and a Prophesy," *Camera Craft* 41 (July 1934), 310.

65. Quoted in *Autobiography,* 114.

66. D. W. Prall, *Aesthetic Judgement,* New York: Thomas Y. Crowell, 1929, 199, 226. The book, completed in the fall of 1927, included Cunningham's photograph of *Two Lilies* (facing p. 57); three studies of a violin (facing pp. 76, 82, 88); and three studies of a portrait bronze by Jacob Epstein (facing pp. 219, 244, 254); as well as one photograph by Francis Bruguière and one by Edward Steichen; and three landscape etchings by Cunningham's husband, Roi Partridge.

67. Adams, "The New Photography," 16. He also used this expression in "An Exposition of My Photographic Technique," *Camera Craft* 41 (January 1934), 20.
Walter Gutman [interview with Adams], "News and Gossip," *Creative Art* (May 1933), 331.

68. Adams, "The New Photography," 16.

69. Adams, "Exposition of My Photographic Technique," 23.

70. G. H. Saxon Mills, "Modern Photography: Its Development, Scope and Possibilities," in *Modern Photography* (*The Studio* Special Number), London: The Studio; New York: William Edwin Rudge, 1931, 12.

Adams to Willard Van Dyke, "early 1933" [Van Dyke estimated the date on a copy transcribed by Nancy Newhall], Willard Van Dyke Papers, Center for Creative Photography, University of Arizona, Tucson.

71. His view had changed since 1931 when he had proposed to Mary Austin that a popular edition of *Taos Pueblo* could be reproduced by photogravure. Adams to Mary Austin, 9 January 1931, Mary Austin Collection, Huntington Library, San Marino, California.

72. Adams to C. G. Holme, February 1934, quoted in Newhall, *Eloquent Light,* 108.

73. Adams to C. G. Holme, May 1934, quoted in Newhall, *Eloquent Light,* 108–9; Ansel Adams, "Exposition of My Photographic Technique," 175.

74. Bryan Holme, the editor of The Studio's New York office, recalled: "Both aesthetically and commercially, this experiment worked beautifully. Ansel Adams . . . was so thrilled with this varnishing technique that he—and many other top photographers—copied the idea ever after." Bryan Holme, introduction to *The Studio: A Bibliography, The First Forty Years 1893–1943,* London: Sims and Reed, 1978, 4. Beaumont Newhall remarked on the likeness of reproduction to original in his review of *Making a Photograph,* in *American Magazine of Art* 28 (August 1935), 508, 512. The editor of *Camera Craft,* Sigismund Blumann, also drew attention to the unconventionally handcrafted treatment of the reproductions "of such excellent quality that many will believe that they are actual photographs." "Our Book Shelves: Making a Photograph, by Ansel Adams," *Camera Craft* 42 (May 1935), 259.

75. A slightly revised edition, with different typography and jacket illustration, some changes to chemical recommendations, and added notes on the miniature camera and on color, was printed in 1939. The book was a great success with amateurs, and highly praised in national photographic magazines. *American Photography* wrote: "We cannot too strongly recommend it." Sales catalogue, The Studio, June 1939, John Johnson Collection, Bodleian Library, Oxford. By the 1940s the book was selling about 350 copies a year. A new edition appeared in 1948, set with yet a different typography, which contained an extra frontispiece in four-color engraving, *Azalea Shrubs, Autumn, Yosemite Valley, California.*

76. Ansel Adams, introduction to *Making a Photograph,* 13–15; One photograph by Dorothea Lange, *Bread-line* (1933, p. 93), the only one not by Adams, illustrated a discussion of the photo-document. Lange's copy of the book is inscribed by Adams: "For Dorothea Lange—swell human being, who helps make this book human! From Ansel Adams, April 1935." Dorothea Lange Papers, Oakland Museum.

77. *Conversations,* 334.

78. F. C. Tilney, *Principles of Photographic Pictorialism,* London: Chapman and Hall, 1930, 103.

79. Paul L. Anderson, *Pictorial Photography: Its Principles and Practice* (1917), London and Philadelphia: J. B. Lippincott, 1923, 37. Anderson's straightforwardly written basic manual, containing not only detailed technical discussions and illustrations of equipment but also reproductions of the work of such photographic artists as D. O. Hill, Clarence White, Karl Struss, and Anne Brigman, was an excellent model for Adams's *Making a Photograph.* A later edition of Anderson's book, under the title *The Technique of Pictorial Photography,* was listed as recommended further reading by Adams in an article in *U.S. Camera* 1:7 (December 1939).

80. Ansel Adams, untitled photograph, c. 1920, Center for Creative Photography, University of Arizona, Tucson; Willard Van Dyke, "Group f/64," *Scriber's Magazine* 103:3 (March 1938), 55.

81. Diana Emery Hulick, "Continuity and Revelation: The Work of Ansel Adams and Edward Weston," in *Through Their Own Eyes: The Personal Portfolios of Edward Weston and Ansel Adams,* exhibition catalogue, Seattle: Henry Art Gallery, University of Washington, Seattle, 1991, 25.

82. Alex D. Leipper, "Picture-Making is Easier with Panchromatic Film," *Photo-Era* 65:1 (July 1930), 21.

83. Ansel Adams, "Exposition of My Photographic Technique," 182.

84. Ansel Adams, *Making a Photograph,* 61; C. E. Kenneth Mees, *Photography,* London: G. Bell and Sons, 1936, 92–3.

85. Dr. Mike Ware, professor of chemistry, author, and photographer, in conversation with the author, 2 July 1996.

86. Hurter and Driffield's "D-log-E Curve," a graph of the relationship between exposure, development, and film density, became known, by its sine-wave shaped line, as the "characteristic curve" of a given emul-

sion. A detailed description of the characteristic curve was given by Adams in *Making a Photograph* in practical photographic terms (p. 45). The idea of an exposure system based on sensitometric principles was first suggested in a two-part article by John L. Davenport, "Constant Quality Prints," *U.S. Camera* 12–13 (1940). In 1952, in a letter to the reviewer Jacob Deschin, Adams explained that his Zone System was "simply a way of thinking about values, and controlling them." He added, "It is nothing I could discover; it was all there since H & D." Ansel Adams, "Letter from Ansel Adams," *The Photo Reporter* 2:9 (September 1972), 10.

87. Adams, *Making a Photograph,* 60.

88. Although specific spot-area measurements would not be possible until the invention of the Salford Electrical Instruments (S.E.I.) meter in the 1940s, basic photoelectric exposure meters of the selenium-cell type, introduced in the 1920s, did provide much greater accuracy than earlier meters by measuring light reflected from the subject rather than overall incident light. "Ansel Adams," interview by Victoria and David Sheff, *Playboy* 30:5 (May 1983), 73.

89. Ansel Adams, with Robert Baker, *The Negative,* Boston: Little Brown, 1981, 66.

90. Tilney, *Principles of Photographic Pictorialism,* 162.

91. Adams, *Making a Photograph,* 68.

92. Van Dyke, "Group f/64," 55.

93. Edward Weston, "Photography," in Carl Thurston, ed., *Enjoy Your Museum,* Pasadena: Esto Publishing Company, 1934. Reprinted in *Edward Weston on Photography,* 72–77. It is not known who cut Weston's original text of more than two thousand words to about four hundred words for the one-page foreword in *Making a Photograph.* Because of the amount of rewriting and reordering of paragraphs, it is unlikely that this was done by the editor of The Studio. Weston, approached by Adams to contribute a foreword to the book, may have handed over the recently published longer article and invited Adams to take from it whatever he wished to use. But it is equally possible that Weston edited it himself and realized that, in condensing the article, he could not permit an apparent contradiction.

Adams, "The New Photography," 14; Adams's emphasis.

94. "Photographs by Ansel Adams," 29 January–1 March 1933, Mills College Art Gallery. Roi Partridge, Imogen Cunningham's husband, was the gallery director.

These exhibitions included a show in November 1933 at the Delphic Studios where two previous exhibitions of Weston's work had been held, one at the Albright Art Gallery in Buffalo in February 1934, and one at Yale University Art Gallery in the winter of 1934.

95. Albert Bender to Adams, 4 April 1933, Albert Bender Papers, F. W. Olin Library, Mills College, Oakland, California.

96. Van Dyke, "Group f64," 55; Alfred Stieglitz to Adams, 13 May 1935, *Letters,* 77; Adams to Willard Van Dyke, "early 1933," [Van Dyke's estimation, noted on a copy transcribed by Nancy Newhall], Willard Van Dyke Papers, Center for Creative Photography, University of Arizona, Tucson.

97. Ansel Adams, "Exhibition of Photographs," An American Place, 27 October–25 November 1936, checklist. Reprinted in Andrea Gray, *Ansel Adams: An American Place, 1936,* (supplement to *The Archive*), Tucson: Center for Creative Photography, 1982, 38.

98. *Edward Weston on Photography,* 37.

99. Ansel Adams, "Sierra Club Outing 1932—Ansel Easton Adams," album of photographs, no. 138, SCPC UCB.

CHAPTER 4 *Expression as Equivalent.*

1. Adams to Paul Strand, 12 September 1933, *Letters,* 56–7.

2. Alfred Stieglitz, inscription to Adams, 25 April 1933, in *Camera Work* 36 (1911), AAA CCP.

3. F. S. C. Northrop, *The Meeting of East and West,* New York: Macmillan, 1946, 162. On page 163 Northrop describes Stieglitz's interpretation of another of O'Keeffe's paintings, *The Two Blue Lines,* in which "one blue line represents the female aesthetic component; the other, the male scientific component in things."

4. Arthur Dove, text for exhibition catalogue, New York: The Intimate Gallery, 1929. Quoted in Dorothy Norman, *Alfred Stieglitz: An American Seer,* Millerton, New York: Aperture, 1973, 102.

Examples, 11. In an interview Adams was quoted as saying, "Representation means recognition. People in the east and midwest who have never seen a western landscape see a Point Lobos rock as an ab-

straction. We call it an 'extraction' in photography." Interview by Anita Silvers, "Editorial," *Journal of Aesthetics and Art Criticism,* 34:2 (Spring 1981), 244.

5. F. S. C. Northrop, "The Functions and Future of Poetry," in *Logic of the Sciences and Humanities,* Westport, Conn.: Greenwood Press, 1947. First printed in *Furioso* 1:4 (1941), 186.

6. Strand's copy was in his library, now in the collection of Bard College, Annandale-on-Hudson, New York.

Benedetto Croce, "Art as Intuition," in Croce, *Aesthetic,* trans. Douglas Ainslie, New York: Macmillan, 1909. Reprinted in Eliseo Vivas and Murray Krieger, eds., *The Problems of Aesthetics,* New York and Toronto: Rinehart, 1953, 80. This latter volume is in Minor White's library, Minor White Archive, The Art Museum, Princeton University.

7. M. E. Moss, *Benedetto Croce Reconsidered,* Hanover and London: University Press of New England, 1987, 24, 43.

8. Croce, in Vivas and Krieger, *Problems of Aesthetics,* 75.

9. R. G. Collingwood, *The Principles of Art,* Oxford: Clarendon Press, 1931, 117; quoted in Dorothy Norman, "An American Place," in Waldo Frank, Lewis Mumford, Dorothy Norman, Paul Rosenfeld, and Harold Rugg, eds., *America and Alfred Stieglitz: A Collective Portrait,* New York: The Literary Guild, 1934, 134; Collingwood, *Principles of Art,* 118.

10. Adams to Alfred Stieglitz, 20 May 1934, 16 May 1935, 30 July 1936; *Letters,* 69, 78, 83.

11. Adams to Alfred Stieglitz, 12 August 1936, Beinecke Rare Book and Manuscript Library, Yale University, New Haven. Copy in AAA CCP.

12. Adams to Virginia Adams, 16 November 1936, *Letters,* 85.

13. "Ansel Adams: Exhibition of Photographs," New York: An American Place (27 October–25 November 1936), a single folded page with introductory text by Adams. Reprinted in Andrea Gray, *Ansel Adams: An American Place, 1936,* Tucson: Center for Creative Photography, 1982, 38.

14. D. H. Lawrence, "New Mexico," in D. H. Lawrence, *Phoenix,* London: William Heinemann, 1936, 147.

Lawrence, "Pan in America," in *Phoenix,* 27. Adams knew of Lawrence's works through Mabel Dodge Luhan, Mary Austin, and Stieglitz; this book is in Adams's library, private collection.

15. Adams to Patricia English, 13 November 1936, AAA CCP.

16. Adams admitted to Willard Van Dyke in early 1933 (possibly just after his visit to Stieglitz) that many of the photographs he had made in his Group f/64 enthusiasm were "little more than technical exercises" and that he was now striving for more than mere technical perfection. Adams to Van Dyke, "early 1933," [Van Dyke's estimation], AAA CCP.

17. Ansel Adams, "Change Relates (Presumably) to Progress," *Untitled* 7–8 (1974), 26.

18. In Stieglitz's words, affirming "A Yes to one's Yes." Dorothy Norman, "An American Place," in *America and Alfred Stieglitz,* 130.

19. Maurice Denis, *Théories 1890–1910,* Paris: Bibliothèque de "L'Occident," 1912, 267. Quoted in translation by H. R. Rookmaaker, *Gauguin and Nineteenth Century Art Theory,* Amsterdam: Swets and Zeitlinger, 1972, 208.

20. Adams, "Change Relates (Presumably) to Progress," 27.

21. Wassily Kandinsky, "Extracts from 'The Spiritual in Art'," *Camera Work* 39 (July 1912), 34. Bruce F. Campbell, *Ancient Wisdom Revived: A History of the Theosophical Movement,* Berkeley, Los Angeles, London: University of California Press, 1980, 169.

22. Wassily Kandinsky, *Concerning the Spiritual in Art,* translated and with an introduction by M. T. H. Sadler, New York: Dover, 1977, 2. (Reprint of W. Kandinsky, *The Art of Spiritual Harmony,* London: Constable, 1914.) One of the artists he clearly felt had expressed this inner spirit was the composer Scriabin, a Theosophist whose music Adams greatly admired.

23. A copy of the book was lent to him by his friend the painter Henrietta Shore on 9 August 1927. *The Daybooks of Edward Weston,* ed. Nancy Newhall, Millerton, N.Y.: Aperture, 1973, 2:34, 151.

24. Friedrich Nietzsche, *Thus Spake Zarathustra,* trans. Thomas Common, Ware, Hertfordshire: Wordsworth, 1997, 83; A. R. Orage, *Nietzsche in Outline and Aphorism,* London and Edinburgh: T. N. Foulis, 1907, 9.

25. Friedrich Nietzsche, *Human, All Too Human,* trans. R. J. Hollingdale, Cambridge: Cambridge University Press, 1986, 152.

26. Adams wrote to her from New York, thanking her for her help with the preparations for the show and added, "Your print, the White Tombstone, was sold for $100." Adams to Patricia English, 18 November 1936, AAA CCP.

Years later Adams remembered that "Stieglitz liked the White Tombstone best of all." Adams to Dorothy Norman, 7 July 1951, Dorothy Norman Papers, Beinecke Rare Book and Manuscript Library, Yale University, New Haven. Stieglitz pressured David McAlpin into buying this print (the only one Stieglitz had priced at one hundred dollars, far above the average of twenty-five or thirty dollars), by offering to include a number of other images with it. *Conversations*, 317. Stieglitz told Beaumont Newhall at an exhibition in December 1940, "I still think that's the best our friend has done: magnificent." Beaumont Newhall to Adams, 1 January 1941, *Letters*, 123. When the cemetery where the gravestone in the photograph stood was being excavated for redevelopment, Adams returned to salvage the portion of the stone representing the grieving woman and urn.

27. One critic referred to Herbert Read's discussion in *Art Now* (1933) of Cézanne's objective conception that the artist's "real vision" was obtained directly from sense data, independent of intellect and prior to emotion, but another believed that it was only through the subjective translation of such data into qualities of energy and feeling within the artist that the work of art came into being. Stieglitz, for example, found release for his own torments only by photographing O'Keeffe recreating the emotional states objectified in her own paintings. Herbert J. Seligmann, "291: A Vision Through Photography," in *America & Alfred Stieglitz*, 114. Ralph Flint, "Post-Impressionism," in *America & Alfred Stieglitz*, 160.

28. Paul Rosenfeld, "The Boy in the Darkrooom," in *America & Alfred Stieglitz*, 87, 70.

29. Ibid., 87; 85–86.

30. Kandinsky, *Concerning the Spiritual in Art*, 17, 56–57.

31. In *Landschaftlicher Formenrhythmus* (1909) the three horizontal bands are wavelets at the lake's edge, a line of distant snowcapped mountains casting a thin shadow on the lake, and the dotted and curled cloud shapes; and in *Eiger, Mönch und Jungfrau im Mondschein* (c. 1908) three cloud forms correspond to three mountain peaks. Stephen F. Eisenman and Oskar Bätschmann, *Ferdinand Hodler: Landscapes*, trans. Danielle Nathanson, Zürich: Verlagshaus Zürich, 1987, 36, 40.

32. By contrast, the sea with its endless ebb and flow was a life symbol. Referring to Wilhelm Worringer, Simmel associated the sea with empathy and the mountains with abstraction. Mountain transcendence depended on an unclouded sky; clouds above the Alps brought the mountains down to earth.

Georg Simmel, "Die Alpen," in *Philosophische Kultur* (1923; reprint, Berlin: Verlag Klaus Wangenbach, 1986), 125–30. My thanks to Berndt Ostendorf for help with translation.

33. Marsden Hartley, "On the Subject of the Mountains: Letter to Messieurs Segantini and Hodler" (1932). Reprinted in Jeanne Hokin, *Pinnacles and Pyramids: The Art of Marsden Hartley*, Albuquerque: University of New Mexico Press, 1993, 135–37.

34. *Conversations*, 330. Somewhat surprisingly, Adams frequently mentions O'Keeffe and Marin, and often Dove, in his writings and correspondence, but not Hartley. Part of the reason may have been that Hartley was not fully accepted by Stieglitz's inner circle in the later period.

35. Hartley to Adelaide Kuntz, 1933, quoted in Townsend Ludington, *Seeking the Spiritual: The Paintings of Marsden Hartley*, Ithaca, New York; London: Cornell University Press, 1998, 60.

36. Adams to Paul Strand, 12 September 1933, *Letters*, 56.

Marin, also a pianist, preferred Bach to all other composers and sought to emulate Bach's musical structure in his painting. Duncan Phillips, in *John Marin* [tributes by William Carlos Williams et al.], Berkeley and Los Angeles: University of California Press, 1956, n.p. When Adams played Bach for him during their time in New Mexico, an interesting debate ensued. Adams maintained that the tone of a note depended on its relationship to other notes in a melodic sequence, and Marin insisted that each note was unique and independent. Marin, whose earliest work had been realist to the point of microscopic accuracy, spent many hours discussing Adams's photographs with him. *Autobiography*, 211, 309.

Herbert J. Seligmann, *Alfred Stieglitz Talking*, New Haven: Yale University Library, 1966, 7.

37. Ruth E. Fine, *John Marin*, Washington: National Gallery of Art; New York: Abbeville, 1990, 90, 102, 96, 8. Marin spent time in Kufstein in the Austrian Tyrol, Munich, Nuremberg, and Strasbourg in 1910. Fine, *John Marin*, 290.

38. Charles Caffin, "Charles Caffin in the *New York American*," *Camera Work* 48 (October 1916), 14. Stieglitz had remarked to Seligmann in 1926 that Marin had made the medium of watercolor into an

equivalent of music, and that Marin was always "essentially a musician." Seligmann, *Alfred Stieglitz Talking,* 88.

39. This painting by Marin was reproduced as the frontispiece to *John Marin,* New York: Museum of Modern Art, 1936, the catalogue for his one-man show, a copy of which was inscribed by Stieglitz to Adams. Private collection.

40. Ansel Adams, "Geometrical Approach to Composition," in *The Complete Photographer* 30:5 (10 July 1942), 1918–24. Reprinted in *The Encyclopedia of Photography* (The Complete Photographer: The Comprehensive Guide and Reference for All Photographers), vol. 9, New York: Greystone Press, 1943, p. 1921. Adams's use of the word "sector," with its inference of intersecting lines, is indicative of an objectivist-scientific approach to composition. See also Adams, *Making a Photograph,* 62.

41. Hartley knew Segantini's work even before he met Stieglitz in 1909, having seen it reproduced in the January 1903 issue of *Jugend,* which was devoted entirely to Segantini. Segantini died in 1899, and retrospectives of his work had been mounted in most of the major cities of Europe.

42. Adams, *Examples,* 41–43.

43. Carpenter, *Towards Democracy,* 519.

44. Ansel Adams, "A Personal Credo, 1943," *The American Annual of Photography* 48 (1944), 7–16, 14; Ansel Adams, "Letter from Ansel Adams," *The Photo Reporter* 2:9 (September 1972), 10.

45. Mary Street Alinder, *Ansel Adams: A Biography,* New York: Henry Holt, 1996, 193.

46. Newhall, *Eloquent Light,* 42. The moon carried romantic associations of love and death and profound theosophical significance for the soul's evolution. For instance, *Yosemite Valley, Moonrise* and *Autumn Moon, the High Sierra from Glacier Point,* in Ansel Adams, *Yosemite Valley,* ed. Nancy Newhall, San Francisco: Five Associates, 1959, plate 4, plate 45; *High Country Crags and Moon, Sunrise, Kings Canyon National Park* (c. 1935,) and *Moon and Half Dome, Yosemite* (1960), in Ansel Adams, *Yosemite and the Range of Light,* Boston: Little Brown, 1979, plate 84, plate 115.

47. Ira H. Latour, "Ansel Adams, the Zone System, and the California School of Fine Arts," *History of Photography* 22:2 (Summer 1998), 148.

48. Minor White, "Photography is an Art," *Design* 49 (December 1947), 20.

49. Minor White, "Are Your Prints Transparent?," *American Photography* 45 (November 1951), 675.

50. Dorothy Norman, "Alfred Stieglitz—Seer," *Aperture* 3:4 (1955), 3–24. This was followed by the issue-long "Alfred Stieglitz: Introduction to an American Seer," *Aperture* 8:1 (1960), 3–65; and the book, *Alfred Stieglitz: An American Seer,* New York: Duell, Sloan, and Pearce, 1960.

51. Evelyn Howard, "The Significance of Stieglitz for the Philosophy of Science," in *America & Alfred Stieglitz,* 205–6.

52. Minor White, "A Unique Experience in Teaching Photography," *Aperture* 4:4 (1956), 156.

53. Minor White, foreword to "The Way Through Camera Work," *Aperture* 7:2 (1959).

54. Adams to Minor White, 11 February 1962, Minor White Archive, The Art Museum, Princeton University. Lawrence had written to Dorothy Brett in Taos in 1929, "All that talk is no good, *none at all*—whether it's Leo Stein or Orage or Gurdjieff....If there could be a little nice friendly *living* and less unfriendly talking we'd be all right." D. H. Lawrence to Dorothy Brett, 2 March 1929, *The Letters of D. H. Lawrence,* ed. K. Sagar and J. T. Boulton, Cambridge: Cambridge University Press, 1993, 7:206.

55. Adams to Minor White, 25 March 1956, Minor White Archive, The Art Museum, Princeton University; Minor White to Adams, 8 March 1947, in Peter C. Bunnell, *Minor White, The Eye That Shapes,* Princeton: The Art Museum, Princeton University, 1989, 25.

56. Minor White, "Things for What Else They Are," *Mirrors, Messages and Manifestations,* Millerton, N.Y.: Aperture, 1969, 106.

Minor White and Walter Chappell, "Some Methods for Reading Photographs," *Aperture* 5:4 (1957), 156–71, 159. White had made this criticism as early as 1953–54 in "Fundamentals of Style in Photography and the Elements of Reading Photographs," unpublished typescript, Minor White Archive, The Art Museum, Princeton University. Copyright © by the Trustees of Princeton University.

57. Minor White to Adams, 25 January 1949, Minor White Archive, The Art Museum, Princeton University. Copyright © by the Trustees of Princeton University.

58. The trips were made during the last week of July and again in late August and early September, 1937. Amy Conger, *Edward Weston: Photographs,* Tucson: Center for Creative Photography, 1992, 82.

The two surviving prints of the series are reproduced as fig. 1070 and fig. F.4. Weston may well have

discussed this series of surf images with Adams, who could have seen one of them reproduced in Edward Weston, "What is Photographic Beauty?" *Camera Craft* 46 (June 1939), 250. In a letter to Adams, Weston mentioned that his new compound shutter "stops waves beautifully." Edward Weston to Adams, [c. Nov. 1938], Beaumont and Nancy Newhall Papers, Special Collections, Getty Research Institute for the History of Art and the Humanities, Los Angeles.

59. Beaumont Newhall, *In Focus: Memoirs of a Life in Photography,* Boston: Little Brown, 1993, 59–63; *Autobiography,* 200.

60. Newhall, "Enduring Moment," n.p., AAA CCP. Although Newhall placed this event at Bolinas, Adams himself remembered these images as having been taken on the San Mateo County coast, south of San Francisco. *Examples,* 23. All five frames are reproduced in *Examples,* 24–25 and *Classic Images* (1986), plates 26–30. A magnificent reproduction of them, printed by David Gardner, is in *An Eclectic Focus, Photographs from the Vernon Collection,* Santa Barbara: Santa Barbara Museum of Art, 1999, 74–79.

Edward Carpenter, *The Art of Creation,* London: George Allen, 1907, 73.

61. Dove described his evolution from impressionist to expressionist in A. J. Eddy's *Cubists and Post-Impressionism* (1913), a book Edward Weston was recommending to photographers in 1922. Edward Weston, "Random Notes on Photography," lecture delivered before the Southern California Camera Club, Los Angeles, June 1922, reprinted in Peter C. Bunnell, ed., *Edward Weston on Photography,* Salt Lake City: Peregrine Smith, 1983, 28.

62. First illustrated in Samuel Kootz, *Modern American Painters,* New York: Brewer and Warren, 1930, plate 17, dated 1924. The illustration in *America & Alfred Stieglitz,* plate 10, is reproduced in a vertical, rather than its correct horizontal, orientation.

63. *Examples,* 24–26.

64. John Varian, "The Wave," *Dune Forum* 1:2 (15 February 1934), 48. This issue of *Dune Forum* was owned by Adams. Private collection.

Vaughn Cornish, *Waves of Sand and Snow,* London: T. Fisher Unwin, 1914, 11.

65. Ansel Adams, untitled poem, n.d., Beaumont and Nancy Newhall Papers, Special Collections, Getty Research Institute for the History of Art and the Humanities, Los Angeles.

66. Minor White, "On the Strength of a Mirage," *Art in America* 46 (Spring 1958), 55; Adams to Alfred Stieglitz, 4 May 1941, *Letters,* 130.

67. White, "Fundamentals of Style in Photography," 190–91, 212–13.

68. Ibid., 257. White was probably referring to Adams's *Mount Williamson, Sierra Nevada from Manzanar, California* (1945); see fig. 5.2.

69. Adams to Minor White, 4 September 1960, Minor White Archive, The Art Museum, Princeton University.

70. Waldo Frank, "The New World in Stieglitz," in *America & Alfred Stieglitz,* 219.

71. *Autobiography,* 134.

72. Adams to Patricia English, 10 June 1937, AAA CCP.

73. Adams to Cedric Wright, 10 June 1937, *Letters,* 95.

74. Ibid.

75. Dorothy Norman, "Art is an Equivalent," in *Dualities,* New York: Privately printed for An American Place 1933, 94.

76. Ansel Adams, *Portfolio One: Twelve Photographic Prints,* San Francisco, 1948, in *The Portfolios of Ansel Adams,* Boston: Little, Brown, 1977, n.p.

77. Quoted, from a letter, by Clarence Kennedy, "Photographs in Portfolio," *Magazine of Art* 43:2 (February 1950), 68–9.

78. Sherrye Cohn, *Arthur Dove: Nature as Symbol,* Ann Arbor, Michigan: UMI Research Press, 1985, 77–8; Adams to Beaumont Newhall, 1 February 1949, AAA CCP.

79. David E. Cooper, ed., *A Companion to Aesthetics,* Oxford: Blackwell, 1992, 350–1.

Sue Davidson Lowe, *Stieglitz: A Memoir/Biography,* London: Quartet, 1983, 211; Stieglitz's copy of Jung's *Psychology of the Unconscious* (trans. B. Hinkle, 1916) is in the library of Georgia O'Keeffe, *The Book Room: Georgia O'Keeffe's Library in Abiquiu,* [New York]: The Grolier Club and the Georgia O'Keeffe Foundation, 1997, 40.

80. Ira H. Latour to the author, 7 November 1998.

81. Adams to Minor White, 8 August 1961, Minor White Archive, The Art Museum, Princeton University.

82. Ansel Adams, [untitled tribute] in "Minor White: A Living Remembrance," *Aperture* 95 (Summer 1984), 30–31.

83. Ansel Adams, *Portfolio Four. What Majestic Word: In Memory of Russell Varian,* San Francisco: Sierra Club, 1963. The title is taken from John Varian's poem "Sand Dunes," in John O. Varian, *Doorways Inward and Other Poems,* Halcyon, Calif.: The Halcyon Temple Press, 1934, 43.

Six of the fifteen images were of Yosemite subjects, two were made in Alaska, one was of the Oceano dunes near the Varian home, and the others were taken in various parts of California, including Castle Rock, a site Varian loved. The Varian Foundation hoped that Castle Rock would be purchased for preservation as a state park with proceeds from the portfolio. Dorothy Varian, *The Inventor and the Pilot,* Palo Alto, California: Pacific Books, 1983, 56.

CHAPTER 5 *Intangible Values of the Natural Scene.*

1. The set of images from the national parks was only the first in a series of subjects originally planned to include Native American reservations, grazing, mining, fisheries, power, and irrigation. Ansel Adams, "Mural Project for the United States Department of the Interior Building, Washington, D.C.," 7 December 1941, typescript. Yosemite Research Library, Yosemite National Park, California. Adams even suggested that the photo-murals might be produced for individual park administration offices in the respective national parks. Memo, Adams to Frank Kittredge, Yosemite National Park Superintendent, 11 August 1941, Yosemite Research Library, Yosemite National Park, California. He sent a set of prints, adding several he had made in the early 1930s in Kings Canyon, to the Department of the Interior, but he kept the negatives, the Department having agreed to let him retain the right to make future prints from them. *Autobiography,* 271. Two hundred twenty-six mounted prints of these subjects are held by the National Archives, Washington. See *Ansel Adams: The National Park Service Photographs,* New York: Abbeville, 1994, for reproductions of 186 photographs. Some of the images can be viewed on the National Archives website: <http://www.nara.gov/nara/nail.html>. See also Peter Wright and John Armor, *The Mural Project,* Santa Barbara: The Reverie Press, 1989, v.

2. *Conversations,* 432.

3. Adams to Henry Allen Moe, 12 September 1944, John Simon Guggenheim Memorial Foundation, New York.

4. Ansel Adams, "Mural Project for the United States Department of the Interior Building, Washington, D.C.," 6–7.

5. Ansel Adams, "Problems of Interpretation of the Natural Scene," *Sierra Club Bulletin* 30:6 (December 1945), 48, and following 46.

6. Adams to Paul Brooks, 31 March 1945, Houghton Mifflin Archive, Houghton Library, Harvard University.

7. Ansel Adams, *Yosemite and the Sierra Nevada,* with selections from the works of John Muir edited by Charlotte Mauk, Boston: Houghton Mifflin, 1948. 8 × 10¼ inches. The book included 132 pages of text by Muir and a 128-page section comprising 64 photographs, each with a caption and an excerpt from Muir's text on the facing page. The book was so well received that Adams and Houghton Mifflin quickly decided to publish another on the same model, *The Land of Little Rain* (1950), with text by Mary Austin and photographs by Adams. See Anne Hammond, "The Land of Little Rain," in *Perpetual Mirage: Photographic Narratives of the Desert West,* organized by May Castleberry, Whitney Museum of American Art, New York, 1996, 140–45.

Adams to Paul Brooks, 22 July 1946, Houghton Mifflin Archive, Houghton Library, Harvard University.

8. Adams to Paul Brooks, 30 October 1947, Houghton Mifflin Archive, Houghton Library, Harvard University. Although he had turned over most of the textual editing to Mauk, Adams's correspondence shows he had a comprehensive knowledge of Muir's writings. Adams to Dorothy Hillyer, 2 June 1945, Houghton Mifflin Archive, Houghton Library, Harvard University. With the financial assistance of Adams's friend, David McAlpin, a Department of Photography was established at the Museum of Modern Art, New York, in September 1940, with Beaumont Newhall as curator of photography. Its exhibition program was launched with a show in December, "Sixty Photographs," curated by Newhall and Adams together. Thus began a long collaborative relationship between Adams and the Newhalls, producing such exhibitions as "The Negative and Print Show" (1942), "Manzanar" (1944), and "Ansel Adams" (1952). Adams and Nancy Newhall were coauthors of many books.

9. The arrangement was that the Adamses would bear the costs of platemaking and manufacturing, and that Houghton Mifflin would purchase half the copies printed. Paul Brooks to Lovell Thompson, 7 February 1949; Adams to Paul Brooks, 12 March 1949, Houghton Mifflin Archive, Houghton Library, Harvard University.

10. Adams to Paul Brooks, 15 February 1949 and 4 August 1949, Houghton Mifflin Archive, Houghton Library, Harvard University.

11. Adams to Nancy Newhall, 15 August 1949, Beaumont and Nancy Newhall Archive, Center for Creative Photography, University of Arizona, Tucson.

Adams to Nancy Newhall, 14 February 1950, AAA CCP. Newhall responded on 28 February that the National Park Service, from whom they had hoped to elicit support, was also unable to raise funds for the show.

12. Nancy Newhall to Adams, 21 February 1952, AAA CCP.

13. Adams to Beaumont Newhall, 2 April 1954, AAA CCP; Nancy Newhall to Adams, 28 April 1954, AAA CCP.

Conversations, 462. See also David Featherstone, "This Is the American Earth: A Collaboration by Ansel Adams and Nancy Newhall," in Robert Dawson et al., *Ansel Adams: New Light: Essays on His Legacy and Legend,* San Francisco: The Friends of Photography, 1993, 63–73.

14. Nancy Newhall, "Ansel Adams: Brilliant Recorder of Nature's Magnificence," *Modern Photography* (1969), 108. Adams later admitted that it was primarily his presence on the board of directors of the Sierra Club that pushed the exhibition forward. *Conversations,* 712.

15. The panels by Richard Reynolds and Frann Spencer Reynolds, "Land Use by Two American Cultures: Redman's Sierra Nevada and Whiteman's Sierra Nevada," and the one by Ted Spencer, "Planning in Yosemite Valley" were reproduced separately in a spiral-bound booklet, "This Is the American Earth" Exhibition, 1955, Bancroft Library, University of California, Berkeley. The panels by the Reynolds team and Ted Spencer, with detailed presentations of problems specific to Yosemite Valley, were too localized to integrate easily with the wider horizon of Newhall's and Adams's show, and they were excluded from the book. Nancy Newhall to Adams, 23 May 1955, AAA CCP.

16. Newhall already had experience working with the Smithsonian. In 1954 it circulated a show she curated, "Ansel Adams: Photographs 1933–1953," as well as retrospective exhibitions of Edward Weston and Brett Weston.

17. Adams to Edward Weston, 21 July 1956, Edward Weston Archive, Center for Creative Photography, University of Arizona, Tucson. Some of the photo-panel exhibitions created for the USIA were disassembled at the end of their tours and the photographs hung in government offices, but most were destroyed. Margaret Cogswell, formerly of Office of Educational Programs, National Museum of American Art, Smithsonian Institution, to the author, 27 January 1997.

18. "The Family of Man" had started its international tour, also with four copies, in 1955. It was an outstanding success for the USIA, eventually reaching thirty-eight countries with a cumulative audience of nearly nine million. Eric J. Sandeen, *Picturing an Exhibition: "The Family of Man" and 1950s America,* Albuquerque: University of New Mexico Press, 1995, 95. Shortly after "This Is the American Earth" was accepted for touring by the USIA, Lois Bingham, chief of the Fine Arts Branch in the Exhibits Division of the agency, was asked to produce an exhibition for the opening of the Kongresshalle, the new American cultural centre in Berlin, in September 1959. She proposed a show demonstrating America's cultural complexity, to be curated by Nancy Newhall, with five hundred photographs printed by Adams, some fifty of which were by him. It was designed by Herbert Bayer, who had also designed "The Family of Man," and it was called "Volk aus Vielen Völkern" ("Nation of Nations," a phrase from Whitman). Lois Bingham, unpublished typescript of a speech, National Collection of Fine Arts, Office of Program Support, Smithsonian Institution Archives, Washington.

19. Both Knopf, and Simon and Schuster, turned them down, but their hopes were rekindled when Horace Albright, former Director of the National Park Service, was so enthusiastic about the project, even before having seen the exhibition, that he had offered to help raise funds for a book. Newhall to Adams, 11 January 1955, AAA CCP.

20. Max McGraw was president of McGraw-Edison. David Brower later remarked that, as an "out-and-out capitalist," though deeply appreciative of beautiful scenery, McGraw probably would not have approved of the political message advocating wilderness preservation in Newhall's text, if he had known

about it in advance. David Brower in an interview with Susan Schrepfer, *David R. Brower: Environmental Activist, Publicist and Prophet,* Berkeley: Regional Oral History Office, The Bancroft Library, University of California, Berkeley, 1980, 268–69.

21. The Sierra Club published five further books within the first three years of its "Exhibit Format" series: *Words of the Earth: Cedric Wright* (1960); *This We Inherit: The Parklands of America,* photographs by Ansel Adams (1961); *In Wilderness is the Preservation of the World,* photographs by Eliot Porter and texts from Henry David Thoreau (1962); *The Place No One Knew: Glen Canyon on the Colorado,* photographs by Eliot Porter (1963); and Nancy Newhall, *Ansel Adams: The Eloquent Light* (1963).

22. Michael Cohen, *The History of the Sierra Club 1892–1970,* San Francisco: Sierra Club Books, 1988, 153, 254.

23. Ibid., 237.

24. *David R. Brower: Environmental Activist,* 40.

25. Ansel Adams and Nancy Newhall, *This Is the American Earth* (1959), San Francisco: Sierra Club, 1960. Reprinted in paperback, San Francisco: Sierra Club and Ballantine Books 1968. Reissued in hardcover, San Francisco: Sierra Club Books, 1992. The book accommodated eighty-four of the one hundred and two photographs in the exhibition; forty-three of these were by Adams. In its first three months, the book sold approximately six thousand copies at fifteen dollars each. Adams to Newhall, 4 April 1960, AAA CCP. It was originally produced in gravure by Photogravure and Color Company of New York, and Paul Strand was so impressed with the standard of production that he later asked Nancy Newhall whether she thought the Sierra Club would also consider reprinting *Time in New England.* Paul Strand to Nancy Newhall, 17 September 1965, Beaumont and Nancy Newhall Archive, Center for Creative Photography, University of Arizona, Tucson.

26. In January 1955, when Newhall was working on the text for the exhibition, she visited Norman in New York and may have been impressed by Norman's work for Steichen's show. Newhall to Adams, 11 January 1955, AAA CCP. This short excerpt style was quite different from the orations, diary entries, and whole poems that Newhall had edited for Paul Strand's *Time in New England* (1950).

27. Newhall had made a close study of many of the photoessays in *Life,* including four different versions of W. Eugene Smith's "Spanish Village." Newhall, "The Caption: The Mutual Relation of Words/Photographs," in Nancy Newhall, *From Adams to Stieglitz: Pioneers of Modern Photography,* New York: Aperture, 1989, 139–40; first printed in *Aperture* 1 (1952). Adams's exhibition "A Pageant of Photography" (1940) had included an exhibit of pictures from *Life* magazine.

Steichen's assistant, Wayne Miller, spent approximately eight months in the archives of *Life* selecting photographs for the exhibition. Sandeen, *Picturing an Exhibition,* 41.

Steichen had told Newhall about his show as early as 1950. She reported to Adams that the show would be "slightly anthropological," and then quoted from the Bible (Acts 17:26), "God . . . hath made of one blood all nations of men, for to dwell on all the face of the earth." Newhall to Adams, 9 December 1950, AAA CCP.

28. Newhall to Adams, 11 January 1955, AAA CCP.

29. Also in "The Family of Man" were Barbara Morgan's image of a young girl playing a flute (Panel 11 of the exhibition "This Is the American Earth") and Henri Cartier-Bresson's photograph of Indian women praying on a hilltop (Panel 2). William Garnett, *Snow Geese over Buena Vista Lake, California* (p. 63) was included on Panel 9.

30. Adams, *Born Free and Equal,* New York: U.S. Camera, 1944. Under political pressure from the museum, the title of the show was changed to what Nancy Newhall called "the noncommittal 'Manzanar'." Nancy Newhall, "The Photographer and Reality: Ansel Adams," unpublished typescript, 1951, Beaumont and Nancy Newhall Papers, Special Collections, Getty Research Institute, Los Angeles.

31. Sandeen, *Picturing an Exhibition,* 47. Adams's first sight of *The Family of Man* in book form, however, must have horrified him: the double-spread reproduction of *Mt. Williamson from Manzanar* was printed not across the gutter but separated into two panels by a white gutter that acted as a margin, cutting the mountain in two. Adams's preferred fine-art format was one in which the photographs were uncropped, isolated by white borders, and not run over two pages if that could be avoided. He had used this portfolio style consistently in his earlier books. After his death, when the Ansel Adams Publishing Rights Trust reissued *This Is the American Earth* in 1992, the design reflected portfolio style rather than photojournalistic practice. In the 1992 edition the photographs were surrounded by at least a ⅜-inch

margin, with layouts on many pages altered to accommodate slightly smaller images. This reduced the number of images spread across the page from eleven to three.

32. Adams and Dorothea Lange had worked together in 1943 on a project for the Office of War Information, photographing Italian Americans in San Francisco, and on a study of the living conditions of shipyard workers in Richmond, California, in 1944. It may have been Lange who instilled in Adams the importance of positive representations of the Japanese Americans, because she suggested she would do this herself in dealing with stories of successful African and Chinese Americans for the OWI. Dorothea Lange to Jess Gorkin, OWI, 13 April 1943; 10 July 1943, Dorothea Lange Papers, Oakland Museum. In 1950 Adams proposed to the Bureau of Indian Affairs a photographic project on Native Americans similar to the one on Manzanar. Dillon S. Meyer to Adams, 20 June 1950, AAA CCP. From the late 1940s through 1955 Adams was trying to find a publisher for a book on African Americans with a text by Nancy Newhall. Adams and Newhall, memo to Garfield Merner, 6 January 1955, AAA CCP.

33. Newhall to Adams, 19 May 1958, AAA CCP. Harrison Brown published, in 1954, an historical survey of the causes of the population explosion with a Malthusian warning for the future of mankind, if population growth continued unchecked. "Since 1940 the population of the Indian sub-continent has been increasing at a rate of about 5 million persons per year." Harrison Brown, *The Challenge of Man's Future*, London: Secker and Warburg, 1954, 58.

34. Newhall to Adams, 11 November 1954, AAA CCP. Newhall knew the films of Pare Lorentz: *The Plow that Broke the Plains* (Paul Strand was one of the cameramen), and *The River* (Willard Van Dyke was in the camera crew). Paul Strand and Leo Hurwitz had also produced for Frontier Films an epic documentary called *Native Land* (1942). In *This Is the American Earth*, Margaret Bourke-White's aerial photograph of farm furrows plowed in great curves, *Contour Plowing* (p. 31), echoes the practical message of Robert Flaherty's film *The Land* (1942).

35. Newhall, "The Caption," 135–44; Ansel Adams, "In the Artist's Print 'We See More Than Our Eyes...Could Command'," *The Commonwealth* 300:31 (2 August 1954), 165.

36. Newhall to Adams, 28 December 1958, AAA CCP. The text for *Yosemite Valley*, like *This Is the American Earth*, was set in short verse-style lines, although it was written by Adams and is descriptive rather than poetic. Tom Maloney compared the overture to "an editorial pictorial treatment akin to television programming," in "New Books," *U.S. Camera*, September 1960, 36. When David Brower defended the book's style, Maloney reiterated his view that the opening was pretentious, and that Brower obviously thought he was publishing grand opera. Tom Maloney to David Brower, 13 September 1960, Sierra Club Papers, Bancroft Library, University of California, Berkeley.

37. In Adams's introduction, "The Meaning of the National Parks," in *My Camera in the National Parks*, there is an almost identical phrase: "We have been given the earth to live upon and enjoy," vii.

38. Carpenter, *Towards Democracy*, 260–61.

39. See Adams's use of a similar phrase, "Solitude, so vital to the individual man, is almost nowhere," in *My Camera in the National Parks*, ix; Bernard De Voto, "The National Parks," *Fortune* 35:6 (June 1947), 120.

40. This photograph was the first image in Adams's *Portfolio Two: The National Parks and Monuments* (1950), where it followed a preface of excerpts from Whitman's poem *Starting from Paumanok*: "This then is life. . . . / Underfoot the divine soil, overhead the sun."

41. In the 1992 edition the title is *Half Dome, Blowing Snow, Yosemite National Park, California*. Many of Adams's original titles were altered or corrected in the reissued version, but the titles given here are from the first edition.

42. This photograph was also included in Adams's *Portfolio III: Yosemite Valley*, dedicated to Beaumont and Nancy Newhall, San Francisco: Sierra Club, 1960. Two other photographs published in *This Is the American Earth* were also included in *Portfolio III: Yosemite Valley*; they were *Lower Yosemite Fall*, and *Dogwood Blossoms*.

43. Adams used filtration and extended development to obtain precisely the sense of brightness and clarity in the leaves that he needed for this effect. Ansel Adams, *The Negative*, Boston: Little, Brown 1981, 219.

44. Robert Hewison, *John Ruskin: The Argument of the Eye*, London: Thames and Hudson, 1976, 58.

45. See Anne Hammond, "Ansel Adams: Natural Scene," *The Archive* 27 (1990), 22. These categories and interpretations emerged from a study of pictorial motifs in landscape art with Christopher Titter-

ington and Mike Weaver during 1985 and 1986, toward an unrealized exhibition for the Victoria and Albert Museum, London.

46. John Ruskin, *The Complete Works of John Ruskin,* ed. E. T. Cook and Alexander Wedderburn, London: George Allen; New York: Longmans, Green, 1906, 11:41.

47. John Muir, *My First Summer in the Sierra,* London: Constable; Boston: Houghton Mifflin, 1911, 135.

48. This is an abridgement from a passage also used in Paul Strand's *Time in New England,* New York: Oxford University Press, 1950 (p. 63), for which Nancy Newhall edited the texts.

49. In the 1992 edition of *This Is the American Earth,* this photograph was replaced with a much more neutrally descriptive cloud image by Adams, *Thundercloud, Lake Tahoe, California,* which does not evoke such destructive power.

50. Adams made the photograph as part of a documentary project with Dorothea Lange, recording the living conditions of shipyard workers and their families, in Richmond, California, in 1944, before the nuclear threat was known. Its caption, written by Lange's assistant, reveals that the two younger children lived in a one-room cabin with four adults, and were being looked after by a neighbor's older child while their parents were out. Dorothea Lange to Adams, 22 October 1951, AAA CCP.

51. Conducting an extended interview with Stieglitz in 1944 with the intention of writing his biography, Newhall recorded some of his own descriptions of his equivalents. Newhall, "Alfred Stieglitz: Notes for a Biography," *From Adams to Stieglitz,* 108.

52. Abstract of letter from Adams to Joseph Short, Secretary to the President, 2 January 1951, Harry S. Truman Library, Independence, Missouri; Sandeen, *Picturing an Exhibition,* 66.

53. It was especially important to Newhall to obtain the photograph of the "exploding nebula," Adams recalled in the 1970s. *Conversations,* 469.

54. The Sierra Club and the Wilderness Society, among many conservation groups, attended; as did the National Park Service, National Forest Service, and the Bureau of Reclamation, among federal agencies of land management; livestock and timber industries, among corporate business interests; and concessionaires, including wilderness guides. Cohen, *The History of the Sierra Club,* 125.

55. Susan R. Schrepfer, "Establishing Administrative 'Standing': The Sierra Club and the Forest Service, 1897–1956," *Pacific Historical Review* 58:1 (February 1989), 64.

56. Bernard De Voto, "Conservation Down and on the Way Out," *Harper's* (August 1954), 70.

57. Adams to Newhall, 25 August 1954, AAA CCP; De Voto to Nancy Newhall, 4 September 1954, Beaumont and Nancy Newhall Archive, Center for Creative Photography, University of Arizona, Tucson.

Newhall to Adams, 9 September 1954, AAA CCP. Adams's original outline had presented the National Park Service and National Forest Service side by side, depicting their historical development and focusing on their diverging purposes, but he and Newhall soon found such a comparison impossible to illustrate.

58. George Marshall to Nancy Newhall, 8 May 1954, Nancy and Beaumont Newhall Archive, Center for Creative Photography, University of Arizona, Tucson.

59. Newhall to Adams, 23 May 1955, AAA CCP.

Panel 5 of the exhibition, with its photograph of *Steamboat Rock, Echo Park* by Philip Hyde and subtitled "A Valley Once Dammed Becomes a Wasteland," had caused officials of the National Park Service to object to Adams about that part of the show. Adams to Horace Albright, 24 June 1955, Beaumont and Nancy Newhall Papers, Special Collections, Getty Research Institute for History of Art and the Humanities, Los Angeles, California. But not all dam building was to be condemned, as long as the essential spirit of the landscape was acknowledged. On Adams's return in the spring of 1954 from a photographic expedition to Shasta Dam in northern California, he exclaimed to Newhall, "It is a monument of great times and great human intention. On the dam is a small bronze plaque—BUILT FOR THE PEOPLE BY THE PEOPLE—Praise God for FDR and the surge of thought that conceived such noble things!!! The Mountain—Mt. Shasta... is the controlling spirit of the scene." (Mount Shasta was the mecca of Ella Young's theosophist Mountain Fellowship, into which she had initiated Ansel and Virginia in 1929.) Adams doubted whether his photograph *Shasta Dam, California* (p. 67) would adequately express the subject, because such an interpretation needed to embrace "hundreds of miles of human work and dreams, communities protected from disastrous floods [and] getting the lifeblood of water," although the dam's benefit to crops is evident in his *Irrigation, Salinas Valley, California* (p. 66). Adams to Newhall, 30 April 1954, AAA CCP.

60. Adams to Newhall, 16 December 1957, AAA CCP. When the dummy was shown to the Sierra Club directors, they wanted to be reassured that Newhall's combination of pictures and text would serve to promote the passage through Congress of the Wilderness Bill. Adams to Newhall, 27 March 1958, AAA CCP.

61. Cohen, *History of the Sierra Club,* 216.

62. Robert S. Yard, "The Wilderness Society Platform," *The Living Wilderness* (September 1935), 2. See Cohen, *History of the Sierra Club,* 110–12. Robert Marshall had earlier committed himself to this position in "The Problem of the Wilderness," *American Alpine Journal* (1931), 348–59, which was in Adams's library. Private collection.

63. Robert Marshall and Benton MacKaye both belonged to the Socialist Party, and Marshall in particular described himself as a Marxist. Aldo Leopold, too, voted in the 1930s and 1940s for the Socialist Party candidate, Norman Thomas. (See Franklin Rosemont, "Radical Environmentalism," in Mari Jo Buhle et al., eds., *Encyclopedia of the American Left,* 2d ed., New York and Oxford: Oxford University Press, 1998, 662.) Marshall's younger brother, George, a liberal lawyer and treasurer of the Civil Liberties Congress, was jailed for refusing to testify to the House Un-American Activities Committee. *Conversations,* 156–7. George Marshall was a close friend of Adams in the 1940s, when he edited the Wilderness Society's magazine, *Living Wilderness.* He was later nominated to the board of directors of the Sierra Club by Adams and Richard Leonard in the 1950s, serving as president in 1966–67.

Adams gave his political affiliation as "Democrat" in *Who's Who in California 1942–43,* edited by Russell Holmes Fletcher, Los Angeles: Who's Who Publications, 1941, 4. He later admitted that he had subscribed to the radical San Francisco paper, *People's World,* and had been on the mailing list of the California Labor School. Adams to Beaumont Newhall, 16 June 1954, Nancy and Beaumont Newhall Archive, Center for Creative Photography, University of Arizona, Tucson.

64. Adams to Paul Brooks, 14 December 1950, Houghton Mifflin Archives, Houghton Library, Harvard University.

65. Hermann Keyserling, *Travel Diary of a Philosopher,* vol. 1, New York: Harcourt Brace, 1925. Inscribed: "Edward, from Merle [Armitage], 1931, June." Special Collections, Getty Research Institute, Los Angeles.

Adams to Edwin Land, c. 1955, AAA CCP. See further, Anne Hammond, "Ansel Adams: Natural Scene," *The Archive* 27 (1990), 19–20.

CHAPTER 6 *Landscape as Process.*

1. Herbert Read, "Science and the Modern World," *New Criterion* 4:3 (June 1926), 581–86. Stieglitz read it during a six-month period in 1926. Stieglitz to Waldo Frank, Waldo Frank Collection, Van Pelt Library, University of Pennsylvania, Philadelphia.

2. Whitehead's work has affinities with the pragmatism of both William James and John Dewey, the emergent evolutionism of Henri Bergson, and the idealism of Samuel Alexander and F. H. Bradley. See George R. Lucas Jr., *The Genesis of Modern Process Thought: A Historical Outline with Bibliography,* Metuchen, N.J.: The American Theological Library Association; London: The Scarecrow Press 1983, 5.

3. Lucas, *Genesis of Modern Process Thought,* 79.

4. Joseph LeConte, "Correlation of Vital with Chemical and Physical Forces," quoted in H. P. Blavatsky, *Isis Unveiled: A Master-Key to the Mysteries of Ancient and Modern Science and Theology,* 2 vols., London and Benares: The Theosophical Publishing Society, 1910, 1:466–67.

5. Lucas, *Genesis of Modern Process Thought,* 39; Alfred North Whitehead, *Modes of Thought,* Cambridge: Cambridge University Press, 1938, 151.

6. See Roderick Nash, *The Rights of Nature: A History of Environmental Ethics,* Madison: University of Wisconsin, 1989, 59–60; and Susan Armstrong-Buck, "Whitehead's Metaphysical System as a Foundation for Environmental Ethics," *Environmental Ethics* 8:3 (Fall 1986), 241–59.

7. Alfred North Whitehead, *Science and the Modern World* (Lowell Lectures 1925), Cambridge: Cambridge University Press, 1926, 155.

8. Jan Christian Smuts, "The Holistic Universe," in *Process Philosophy: Basic Writings,* ed. Jack R. Sibley and Pete A. Y. Gunter, Washington, D.C.: University Press of America, 1978, 234, 241. Originally published in Jan Christian Smuts, *Holism and Evolution,* New York: Macmillan, 1926.

9. Aldo Leopold, "Wilderness Values," *Living Wilderness* 7:7 (March 1942), 24–25. The photograph by Adams was captioned "An incident in the career of Roaring River [Kings Canyon National Park]."

10. Aldo Leopold, "A Conservation Esthetic," in *A Sand County Almanac and Sketches Here and There* (1949; reprint, New York and Oxford: Oxford University Press, 1987); Adams, "The Meaning of the National Parks," *My Camera in the National Parks,* Yosemite: Virginia Adams; Boston: Houghton Mifflin, vi.

11. Joseph LeConte, "My Trip to Kings River Canyon," *Sunset* 5:6 (October 1900), 277.

12. Nancy Newhall, Notebook: 28 March 1953 to 19 February 1954, Beaumont and Nancy Newhall Papers, Special Collections, Getty Research Institute for the History of Art and the Humanities, Los Angeles.

13. With very high or very low light levels, exposure corrections are required to compensate for extreme film response. This phenomenon was commonly referred to as "reciprocity failure," but Adams preferred to describe it as a "reciprocity departure" or as a "reciprocity effect." Adams, *Yosemite and the Sierra Nevada,* 121; Ansel Adams (with Robert Baker), *The Negative,* Boston: Little Brown, 1981, 42.

14. Ansel Adams, "Exposure with the Zone System," in *The Encyclopedia of Photography,* ed. Willard D. Morgan, New York: Greystone Press, 1943, 8:1375.

15. Ansel Adams, "An Exposition of My Photographic Technique: Landscape," *Camera Craft* 41 (February 1934), 73–74.

16. *Examples,* 53.

17. Whitehead, "Immortality. The Ingersoll Lecture for 1941," in *The Philosophy of Alfred North Whitehead,* ed. Paul Arthur Schilpp, New York: Tudor, 1951, 689.

18. Newhall to Adams, 9 September 1954, AAA CCP; Adams to Virginia Best, 11 March 1927, *Letters,* 29.

19. J. C. Powys, *The Complex Vision,* New York: Dodd, Mead, 1920; see chapter 11, "The Illusion of Dead Matter," in *In Defence of Sensuality,* London: Victor Gollancz, 1930. By sensuality, Powys meant the life of sensations as well as of thoughts—what he called Life-Sensation.

20. John Cowper Powys, "Wood and Stones" (1899), *John Cowper Powys: A Selection from his Poems,* ed. Kenneth Hopkins, London: Macdonald, 1964, 33. This edition reproduces an undated frontispiece portrait by Edward Weston.

21. Adams to Weston, 29 November 1934, *Letters,* 73; Whitehead, *Science and the Modern World,* 125.

22. Whitehead, "Immortality," 693.

Adams, "The Meaning of the National Parks," viii; *Yosemite and the Sierra Nevada,* Boston: Houghton Mifflin, 1948, xv.

Edward Carpenter, *The Art of Creation,* London: George Allen, 1907, 33.

23. Adams to Edward Weston, 14 December 1951, Edward Weston Archives, Center for Creative Photography, University of Arizona, Tucson.

24. Alfred North Whitehead, *Nature and Life,* Cambridge: Cambridge University Press, 1934, 93.

25. *Dialogues of Alfred North Whitehead,* as recorded by Lucien Price, Westport, Connecticut: Greenwood Press, 1954, 228.

Whitehead, *Modes of Thought,* 60. Adams owned a copy of Shelley's poems in 1922. Adams to Virginia Best, 1 March 1922, private collection.

26. John Dewey, *Experience and Nature,* George Allen and Unwin, 1929, 266; William James, *Varieties of Religious Experience* (1902; reprint, New York and London: Longmans, Green, 1925), 494–95.

27. Carpenter, *Art of Creation,* 30, 32.

28. Henry David Thoreau, *Walden: Or Life in the Woods,* Boston: The Limited Editions Club, 1936, 166.

29. William James, *Pragmatism: A New Name for Some Old Ways of Thinking,* New York and London: Longmans, Green, 1922, 128.

30. Nancy Newhall, *Ansel Adams: The Eloquent Light* (1963, reprint, Millerton, N. Y.: Aperture, 1980), 36–7.

31. Ansel Adams, introduction to *Photographs 1951–73,* by Wynn Bullock, Monterey: Privately published, 1973, photocopy enclosed in a letter from Adams to Nancy and Beaumont Newhall, 13 February 1974, Beaumont and Nancy Newhall Papers, Special Collections, Getty Research Institute for the History of Art and the Humanities, Los Angeles.

32. Vaughn Cornish, *The Poetic Impression of Natural Scenery,* London: Sifton Praed, 1931, 42, 9.

33. Minor White, "Fundamentals of Style in Photography and the Elements of Reading Photographs," Minor White Archive, The Art Museum, Princeton University, typescript, 105.

34. "Ansel Adams Photography Course, Notes of Lectures Given at Museum of Modern Art, New York, 5 February–17 March 1945, Minor White Archive, The Art Museum, Princeton University. The author of these handwritten notes is not given, but may have been Nancy Newhall.

35. Clement Greenberg, "The Camera's Glass Eye," *The Nation* (9 March 1946), 294–96; Rudolf Arnheim, "The Splendor and Misery of the Photographer," in *New Essays on the Psychology of Art,* Berkeley: University of California Press, 1986, 118.

36. For example, *Nevada Fall, Yosemite National Park* (c. 1932), in *Letters,* 174, and *Top of Ribbon Fall* in Ansel Adams, *Yosemite Valley* (San Francisco: 5 Associates, 1959), plate 8; *Examples,* 16.

37. Edward Carpenter, *Towards Democracy,* London: Swan Sonnenschein, 1905, stanza 8, p. 11; *Examples,* 16–7.

38. Whitehead, *Nature and Life,* 60.

39. Whitehead, *Modes of Thought,* 148, 108, 164.

40. Joseph LeConte, *Evolution and Its Relation to Religious Thought,* London: Chapman and Hall, 1888, 299. See also Josiah Royce, Joseph LeConte, G. H. Howison, and Sidney Edward Mezes, *The Conception of God: A Philosophical Discussion Concerning the Nature of the Divine Idea as a Demonstrable Reality,* New York and London: Macmillan, 1897, 72.

41. William James, *The Varieties of Religious Experience* (1902; reprint, New York and London: Longmans, Green, 1925), 85.

42. Ansel Adams, "The Meaning of the National Parks," vii. Walt Whitman, *Complete Poetry and Selected Prose,* ed. James E. Miller Jr., Boston: Houghton Mifflin, 1959, 111.

43. Ansel Adams, "The Roots of Inspiration," Art Directors and Artists Club of San Francisco, University of California, typescript of a lecture, 15 September 1961, AAA CCP.

44. Adams to Alfred Stieglitz, 9 October 1933, *Letters,* 59; William James, "The Knowing of Things Together" (1895), in *Collected Essays and Reviews,* London: Longmans, Green, 1920, 374.

45. Walt Whitman, "Starting from Paumanok," in *Complete Poetry and Selected Prose,* 17.

1. Manuscript Sources

Adams, Ansel. Ansel Adams Archive. Center for Creative Photography. University of Arizona, Tucson.
———. *Conversations with Ansel Adams*. Interviews by Ruth Teiser and Catherine Harroun, 1972, 1974, and 1975. Regional Oral History Office. Bancroft Library, University of California, Berkeley. The Regents of the University of California, 1978. Bound typescript.
Austin, Mary. Mary Austin Collection. Huntington Library. San Marino, Calif.
Bender, Albert. Papers. F. W. Olin Library, Mills College. Oakland, Calif.
Bentley, Wilder. Papers. San Francisco Public Library.
Flaherty, Robert. The Robert and Frances Flaherty Study Center. School of Theology at Claremont, Claremont, Calif.
Houghton Mifflin Papers. Houghton Library, Harvard University.
Lange, Dorothea. Papers. Oakland Museum.
LeConte, Joseph N. Papers. Bancroft Library, University of California, Berkeley.
Meem, John Gaw. John Gaw Meem Collection. Center for Southwest Research. Zimmerman Library, University of New Mexico, Albuquerque.
Newhall, Beaumont and Nancy. Papers. Special Collections. Getty Research Institute for the History of Art and the Humanities, Los Angeles, Calif.
Norman, Dorothy. Papers. Beinecke Rare Book and Manuscript Library, Yale University, New Haven, Conn.
Olmstead, A. J. Papers. Smithsonian Institution Archives. Washington, D.C.
Sella, Vittorio. Photographs. Frederick H. Morley Memorial Sierra Club Collection. Bancroft Library, University of California, Berkeley.
Sierra Club. Papers. Bancroft Library, University of California, Berkeley.
Sierra Club. Pictorial Collection. Bancroft Library, University of California, Berkeley.
Stieglitz, Alfred. Alfred Stieglitz Collection. Beinecke Rare Book and Manuscript Library, Yale University, New Haven, Conn.
Udall, Stewart. Papers. Special Collections. University of Arizona Library, Tucson.
Waters, George. Papers. Special Collections. Stanford University Library.
Wilson, Adrian. Papers. Bancroft Library, University of California, Berkeley.
Wright, Cedric. Papers. Bancroft Library. University of California, Berkeley.
Yosemite Park and Curry Company. Archives. Yosemite Museum, Yosemite National Park.

2. Books by Ansel Adams

Parmelian Prints of the High Sierras. San Francisco: Jean Chambers Moore, 1927.
Taos Pueblo, with Mary Austin. San Francisco: Grabhorn Press, 1930.
Making a Photograph. London: The Studio; New York: The Studio Publications, 1935.
Sierra Nevada: The John Muir Trail. Berkeley: The Archetype Press, 1938.
Yosemite and the Sierra Nevada. Edited by Charlotte Mauk. Boston: Houghton Mifflin, 1948.
Camera and Lens, Basic Books Series. Hastings-on-Hudson, New York: Morgan and Lester, 1948.
My Camera in Yosemite Valley. Boston: Houghton Mifflin; Yosemite: Virginia Adams, 1949.
The Print. Basic Books Series. Hastings-on-Hudson, New York: Morgan and Lester, 1950.
The Land of Little Rain. Text by Mary Austin, photographs by Ansel Adams. Boston: Houghton Mifflin, 1950.
My Camera in the National Parks. Boston: Houghton Mifflin; Yosemite: Virginia Adams, 1950.

Natural-Light Photography. Basic Books Series. Hastings-on-Hudson, New York: Morgan and Lester, 1952.

The Negative. Basic Books Series. Hastings-on-Hudson, New York: Morgan and Lester, 1958.

Yosemite Valley. San Francisco: Five Associates, 1959.

This Is the American Earth. With Nancy Newhall. San Francisco: Sierra Club, 1959.

Ansel Adams. Edited by Liliane De Cock. Hastings-on-Hudson, New York: Morgan and Morgan, 1972.

Ansel Adams: Images 1923–1974. Boston: Little, Brown, 1974.

Photographs of the Southwest. Boston: Little, Brown, 1976.

The Portfolios of Ansel Adams. Boston: Little, Brown, 1977.

Yosemite and the Range of Light. Boston: Little, Brown, 1979.

The Camera. With Robert Baker. The New Ansel Adams Photography Series. Boston: Little, Brown, 1980.

The Negative. With Robert Baker. The New Ansel Adams Photography Series. Boston: Little, Brown, 1981.

Ansel Adams: An American Place, 1936. Edited by Andrea Gray. Tucson: Center for Creative Photography (supplement to *The Archive*), 1982.

Examples: The Making of 40 Photographs. Boston: Little, Brown, 1983.

Ansel Adams: An Autobiography. With Mary Street Alinder. Boston: Little, Brown, 1985.

Ansel Adams: Classic Images. Boston: Little, Brown, 1985.

Ansel Adams: Letters and Images, 1916–1984. Edited by Mary Street Alinder and Andrea Gray Stillman. Boston: Little, Brown, 1988.

Ansel Adams: The National Park Service Photographs. New York: Abbeville, 1994.

3. Articles by Ansel Adams

"LeConte Memorial Lodge—Season 1921," *Sierra Club Bulletin* 11:3 (1922), 309.

"Lyell Fork of the Merced," *Sierra Club Bulletin* 11:3 (1922), 315–16.

"LeConte Memorial Lodge—Season of 1922," *Sierra Club Bulletin* 11:4 (1923), 435–36.

"LeConte Memorial Lodge—Season of 1923," *Sierra Club Bulletin* (1924), 83.

"Anthology of Alpine Literature," *Sierra Club Bulletin* 13:1 (1928), 98–99.

"On High Hills," *Sierra Club Bulletin* 14:1 (February 1929), 99.

"Tonquin Valley," "Night Wind," and "Crow's Nest," *Troubadour* 1:8 (May 1929), 19.

"Ski-Experience," *Sierra Club Bulletin* 16:1 (February 1931), 44–46.

"Photography." In *Edward Weston Omnibus: A Critical Anthology,* edited by Beaumont Newhall and Amy Conger. Salt Lake City: Peregrine Smith, 1984. First published in *The Fortnightly* 1 (18 December 1931), 21–22.

"Retrospect: Nineteen-Thirty-One," *Sierra Club Bulletin* 17:1 (February 1932), 1–11.

"An Exposition of My Photographic Technique," *Camera Craft* 41 (January 1934), 19–25; (February 1934), 73–74; (April 1934), 173–82.

"Mount Everest from the Air," *Sierra Club Bulletin* 19:3 (June 1934), 107.

"The New Photography." In *Modern Photography 1934–1935.* London: The Studio; New York: Studio Publications, 1935.

"Everest 1933," *Sierra Club Bulletin* 20:1 (February 1935), 114–15.

"Geometrical Approach to Composition." In *The Encyclopedia of Photography,* edited by Willard D. Morgan. New York: Greystone Press, 1943, 9:1632–35. First printed in *The Complete Photographer* 30:5 (10 July 1942), 1918–24.

"Exposure with the Zone System." In *The Encyclopedia of Photography,* edited by Willard D. Morgan. New York: Greystone Press, 1943, 8:1372–81.

"A Personal Credo, 1943." *The American Annual of Photography* 48 (1944), 7–16.

"Francis Holman, 1856–1944." *Sierra Club Bulletin* 29:5 (October 1944), 47–48.

"The Photography of Joseph N. LeConte," *Sierra Club Bulletin* 29:5 (October 1944), 41–46.

"Problems of Interpretation of the Natural Scene." *Sierra Club Bulletin* 30:6 (December 1945), 47–50.

"Vittorio Sella: His Photography." *Sierra Club Bulletin* 31:7 (December 1946), 15–17.

"In the Artist's Print 'We See More Than Our Eyes . . . Could Command'." *The Commonwealth* 300:31 (2 August 1954), 164–66.

"An Essay on Mountain Photography." In *My Camera in Yosemite Valley.* Boston: Houghton Mifflin; Yosemite: Virginia Adams, 1949.

"Yosemite—1958: Compromise in Action." *National Parks Magazine* 32:135 (October–December 1958), 166–75, 190.

"The Artist and the Ideals of Wilderness." In *Wilderness: America's Living Heritage,* edited by David Brower. San Francisco: Sierra Club, 1961.

"Letter from Ansel Adams." *The Photo Reporter* 2:9 (September 1972), 10.

Introduction to *Photographs 1951–1973* by Wynn Bullock. Monterey: Privately published, 1973.

"Change Relates (Presumably) to Progress." *Untitled* 7–8 (1974), 26–27.

"Sixty Years in Photography." *The Photographic Journal* 117:3 (May/June 1977), 128, 131, 133.

Interview by Victoria and David Sheff. *Playboy* 30:5 (May 1983), 67–87, 222–26.

"Interview: Ansel Adams." Interview by Tom Cooper and Paul Hill. *Camera* 55:1 (January 1976), 15, 21, 27, 37–40.

Untitled contribution to "Minor White: A Living Remembrance," *Aperture* 95 (Summer 1984), 30–31.

4. Secondary Sources

Alinder, Mary. *Ansel Adams: A Biography*. New York: Henry Holt, 1996.

Anderson, Douglas R. "Benedetto Croce." In *Companion to Aesthetics,* edited by David E. Cooper, 97. Oxford: Blackwell 1992.

Anderson, Paul L. *Pictorial Photography: Its Principles and Practice*. London and Philadelphia: J. B. Lippincott, 1923.

Armstrong-Buck, Susan. "Whitehead's Metaphysical System as a Foundation for Environmental Ethics." *Environmental Ethics* 8:3 (Fall 1986), 241–59.

Arnheim, Rudolf. "The Splendor and Misery of the Photographer." In *New Essays on the Psychology of Art.* Berkeley: University of California Press, 1986.

Austin, Mary. *The American Rhythm*. 2d ed. Boston and New York: Houghton Mifflin, 1930.

———. "Mexicans and New Mexico." *Survey* 66 (May 1931), 141–44, 187, 189.

Bentley, Wilder. "Photography and the Fine Book." *U.S. Camera* 14 (Spring 1941), 66–67, 72.

Bracher, Katherine. "Charles H. Adams." *Mercury* 24:1 (January–February 1995), 7.

British Library (exhibition notes). *The Roxburghe Club of San Francisco*. London: The British Library Board, 1985.

Brower, David R., ed. *The Sierra Club: A Handbook*. San Francisco: Sierra Club, 1951.

———. *David R. Brower: Environmental Activist, Publicist and Prophet*. Interview by Susan Schrepfer. Berkeley: Regional Oral History Office, The Bancroft Library, University of California, Berkeley, 1980.

———. *For Earth's Sake: The Life and Times of David Brower*. Salt Lake City: Gibbs Smith, 1990.

Brown, Harrison. *The Challenge of Man's Future*. London: Secker and Warburg, 1954.

Bucke, Richard Maurice. *Man's Moral Nature*. London: Trübner, 1879.

———. *Cosmic Consciousness: A Study in the Evolution of the Human Mind*. 1901. Reprint, New York: E. P. Dutton, 1947.

Bunnell, Peter C. *Minor White, The Eye That Shapes*. Princeton: The Art Museum, Princeton University, 1989.

Calmes, Leslie Squyres. *The Letters Between Edward Weston and Willard Van Dyke*. The Archive 30. Tucson: Center for Creative Photography, 1992.

Campbell, Bruce F. *Ancient Wisdom Revived: A History of the Theosophical Movement*. Berkeley, Los Angeles, and London: University of California Press, 1980.

Carpenter, Edward. *Towards Democracy*. 1883. Reprint, London: Swan Sonnenschein, 1905.

———. *Civilization: Its Cause and Cure*. 1889. Reprint, London: George Allen, 1921.

———. *From Adam's Peak to Elephanta*. London: Swan Sonnenschein, 1892.

———. *Angels' Wings*. London: Swan Sonnenschein, 1898.

———. *The Art of Creation*. Rev. and enl. London: George Allen, 1907.

Clark, Ronald W. *Men, Myths and Mountains*. London: Weidenfeld and Nicolson, 1976.

Cohen, Michael. *The Pathless Way: John Muir and American Wilderness*. Madison: University of Wisconsin Press, 1984.

———. *The History of the Sierra Club 1892–1970*. San Francisco: Sierra Club Books, 1988.

Cohn, Sherrye. *Arthur Dove: Nature as Symbol*. Ann Arbor, Michigan: UMI Research Press, 1985.

Collier, John. *John Collier Papers 1922–1968.* Edited by Andrew M. Patterson and Maureen Brodoff. Yale University Library. Sanford, N.C.: Microfilming Corporation of America, 1980.

Collingwood, R. G. *The Principles of Art.* Oxford: Clarendon Press, 1931.

Conger, Amy. *Edward Weston: Photographs from the Collection of the Center for Creative Photography.* Tucson: Center for Creative Photography, University of Arizona, 1992.

Cornish, Vaughn. *Waves of Sand and Snow.* London: T. Fisher Unwin, 1914.

———. *The Poetic Interpretation of Natural Scenery.* London: Sifton Praed, 1931.

Cousins, Margaret E. "Scriabine: A Theosophist Master Musician." *The Theosophist* 46:2 (November 1924), 235–44.

Croce, Benedetto. "Art as Intuition." In *The Problems of Aesthetics,* edited by Eliseo Vivas and Murray Krieger. New York and Toronto: Rinehart, 1953. Originally published in Benedetto Croce, *Aesthetic,* translated by Douglas Ainslie (New York: Macmillan, 1909).

Curran, Thomas. *Fiske the Cloud Chaser.* Oakland: Oakland Museum, 1989.

De Voto, Bernard. "The West Against Itself." *Sierra Club Bulletin* 32:5 (May 1947), 36–42.

———. "The National Parks." *Fortune* 35:6 (June 1947), 120–35.

———. "Conservation Down and on the Way Out." *Harper's* (August 1954), 66–74.

Deevey, Edward S. "This Is the American Earth." *Science* (9 December 1960), 1759.

Dewey, John. *Experience and Nature.* George Allen and Unwin, 1929.

Doyle, Helen MacKnight. *Mary Austin: Woman of Genius.* New York: Gotham House, 1939.

Eddington, Arthur S. *The Nature of the Physical World.* Cambridge: Cambridge University Press, 1928.

———. *Science and the Unseen World.* London: George Allen and Unwin, 1929.

Eiseley, Loren. *Darwin's Century: Evolution and the Men Who Discovered It.* New York: Doubleday, 1958.

Eisenman, Stephen F. and Oskar Bätschmann. *Ferdinand Hodler: Landscapes.* Translated by Danielle Nathanson. Zürich: Verlagshaus Zürich, 1987.

Eisenstein, Sergei. *The Film Sense.* Edited and translated by Jay Leyda. London: Faber and Faber, 1948.

———. *Film Form: Essays in Film Theory.* Edited and translated by Jay Leyda. London: Dennis Dobson, 1951.

Eldredge, Charles C., Julie Schimmel, and William H. Treuttner. *Art in New Mexico, 1900–1945: Paths to Taos and Santa Fe.* Washington, D.C.: National Museum of American Art, Smithsonian Institution; New York: Abbeville, 1986.

Ellis, Havelock. *The New Spirit.* London: Constable, 1926.

Ellwood, Robert S., Jr. "The American Theosophical Synthesis." In *The Occult in America: New Historical Perspectives.* Edited by Howard Kerr and Charles L. Crow. Urbana and Chicago: University of Illinois Press, 1983.

Farquhar, Francis P. "Mountain Studies in the Sierra: Photographs by Ansel Easton Adams," *Touring Topics* (February 1931), n.p.

———. "The Sierra Nevada of California." *Alpine Club Journal,* 46 (May 1934), 88–102.

———. *History of the Sierra Nevada.* Berkeley and Los Angeles: University of California Press in collaboration with the Sierra Club, 1966.

Featherstone, David. "This Is the American Earth: A Collaboration by Ansel Adams and Nancy Newhall." In *Ansel Adams: New Light,* by Robert Dawson and others. San Francisco: The Friends of Photography, 1993.

Fine, Ruth E. *John Marin,* Washington, D.C.: National Gallery of Art; New York: Abbeville, 1990.

Fink, Augusta. *I-Mary: A Biography of Mary Austin.* Tucson: University of Arizona Press, 1983.

Forrest, Suzanne. *The Preservation of the Village: New Mexico's Hispanics and the New Deal.* Albuquerque: University of New Mexico Press, 1989.

Frank, Waldo, Lewis Mumford, Dorothy Norman, Paul Rosenfeld, and Harold Rugg, eds. *America & Alfred Stieglitz: A Collective Portrait.* New York: The Literary Guild, 1934.

French, Patrick. *Younghusband: The Last Great Imperial Adventurer.* London: Harper Collins, 1995.

Fryxell, Fritiof. *François Matthes and the Marks of Time.* San Francisco: Sierra Club, 1962.

Gardner, Arthur. *The Art and Sport of Alpine Photography.* London: H. F. and G. Witherby, 1927.

Gidley, Mick. "Edward S. Curtis's Indian Photographs: A National Enterprise." In *Representing Others: White Views of Indigenous Peoples,* edited by Mick Gidley, 103–19. Exeter: University of Exeter Press, 1992.

Gray, Andrea. *Ansel Adams: An American Place, 1936.* Tucson: Center for Creative Photography, 1982.

Greenberg, Clement. "The Camera's Glass Eye." *The Nation* (9 March 1946), 294–96.

Greenwalt, Emmett A. *The Point Loma Community in California 1897–1942: A Theosophical Experiment.* University of California Publications in History, vol. 48. Berkeley and Los Angeles: University of California Press, 1955.

Hamalian, Linda. *A Life of Kenneth Rexroth.* New York and London: W. W. Norton, 1991.

Hambidge, Jay. *Practical Applications of Dynamic Symmetry.* New York: Yale University Press, 1932.

Hammond, Anne. "Ansel Adams: Natural Scene." *The Archive* 27 (1990), 17–26.

Hammond, Arthur. *Pictorial Composition in Photography.* London: Chapman and Hall, 1932.

Hartley, Marsden. "The Red Man." In *Adventures in the Arts.* 1921. Reprint, New York: Hacker Art Books, 1972.

———. "On the Subject of the Mountains: Letter to Messieurs Segantini and Hodler." 1932. In *Pinnacles & Pyramids: The Art of Marsden Hartley,* by Jeanne Hokin, 135–37. Albuquerque: University of New Mexico Press, 1993.

Heller, Elinor Raas, and David Magee. *Bibliography of the Grabhorn Press, 1915–1940.* San Francisco: Alan Wofsy Fine Arts, 1975.

Helms, Anne Adams. *The Descendants of William James Adams and Cassandra Hills Adams.* Salinas, Calif.: Anne Adams Helms, 1999.

Henderson, Linda Dalrymple. "Mysticism, Romanticism and the Fourth Dimension." In *The Spiritual in Art: Abstract Painting 1890–1985,* edited by Maurice Tuchman, 219–35. Los Angeles: Los Angeles County Museum of Art; New York: Abbeville Press, 1996.

Hendricks, Gordon. *Eadweard Muybridge: The Father of the Motion Picture.* London: Secker and Warburg, 1975.

Hewison, Robert. *John Ruskin: The Argument of the Eye.* London: Thames and Hudson, 1976.

Heyman, Therese Thau, ed. *Seeing Straight: The f.64 Revolution in Photography.* Oakland: Oakland Museum, 1992.

Hickman, Paul A. "The Life and Photographic Works of George Fiske, 1835–1918." Master's thesis, Arizona State University, 1979.

Hickman, Paul, and Terence Pitts. *George Fiske: Yosemite Photographer.* Flagstaff: Northland Press; Tucson: Center for Creative Photography, 1980.

Holme, Bryan. Introduction to *The Studio: A Bibliography, The First Forty Years 1893–1943.* London: Sims and Reed, 1978.

Hulick, Diana Emery. "Continuity and Revelation: The Work of Ansel Adams and Edward Weston." In *Through Their Own Eyes: The Personal Portfolios of Edward Weston and Ansel Adams.* Exhibition catalogue. Seattle: Henry Art Gallery, University of Washington, 1991.

Hutchings, J. M. *In the Heart of the Sierras.* Yosemite Valley: The Old Cabin; Oakland: Pacific Press Publishing House, 1886.

Ingersoll, Robert G. *Gods.* Manchester: Abel Heywood; London: Watts, 1885.

James, William. *The Varieties of Religious Experience.* London, New York and Bombay: Longmans, Green, 1902.

———. *Pragmatism.* London, New York, Bombay, and Calcutta: Longmans, Green, 1907.

———. *William James: Collected Essays and Reviews,* London: Longmans, Green, 1920.

———. *Pragmatism: A New Name for Some Old Ways of Thinking.* New York and London: Longmans, Green, 1922.

Jeffers, Robinson. *Poems.* San Francisco: The Book Club of California, 1928.

———. *Themes in My Poems.* San Francisco: The Book Club of California, 1956.

Jeffrey, Ian. "The New Photography." *Neue Sachlichkeit Photography: New Realism in German Photography of the 20s.* Exhibition brochure. London: Arts Council of Great Britain, [c. 1978].

John Marin. Tributes by William Carlos Williams et al. Berkeley and Los Angeles: University of California Press, 1956.

Jung, C. G. *Memories, Dreams, Reflections.* 1963. Reprint, London: Collins, 1974.

Kamerling, Bruce. "Theosophy and Symbolist Art: The Point Loma Art School." *Journal of San Diego History* 26:4 (Fall 1980), 230–55.

Kandinsky, Wassily. "Extracts from 'The Spiritual in Art'." *Camera Work* 39 (July 1912), 34.

————. *Concerning the Spiritual in Art*. Translated and with an introduction by M. T. H. Sadler. New York: Dover, 1977. First published as W. Kandinsky, *The Art of Spiritual Harmony*. London: Constable, 1914.

Keyserling, Count Hermann. *Creative Understanding*. New York and London: Harper and Brothers, 1929.

King, Clarence. *Mountaineering in the Sierra Nevada*. London: Sampson Low, Marston, Low, and Searle, 1872.

————. *Mountaineering in the Sierra Nevada*. With photographs by Ansel Adams. New York: Norton and Norton, 1935.

King, Thomas Starr. "A Vacation Among the Sierras." *Boston Evening Transcript* (26 January 1861), 1.

Kriebel, Richard T. "Stereoscopic Photography." In *Encyclopedia of Photography*. Edited by Willard D. Morgan. New York: Greystone Press, 1944, 19:3530–31.

Latour, Ira H. "Ansel Adams, the Zone System, and the California School of Fine Arts." *History of Photography* 22:2 (Summer 1998), 147–54.

Lawrence, D. H. "Taos." *The Dial* 74:3 (March 1923), 251–54.

————. *Phoenix: The Posthumous Papers of D. H. Lawrence*. Edited by Edward D. McDonald. London: Heinemann, 1936.

————. *Letters of D. H. Lawrence*. 7 vols. Edited by J. T. Boulton et al. Cambridge: Cambridge University Press, 1979–93.

LeConte, Helen M. "The Heart of Nature." *Sierra Club Bulletin,* 11:4 (1923), 458.

————. *Reminiscences of LeConte Family Outings, Sierra Club, and Ansel Adams*. Interview by Ruth Teiser. Sierra Club Oral History Series. Bancroft Library, University of California, Berkeley. San Francisco: Sierra Club, c. 1977. Typescript.

LeConte, Joseph. "On Some of the Ancient Glaciers of the Sierras." *American Journal of Science and Arts*, 3d series, 5 (May 1873), 325–42.

———— *Journal of Ramblings through the High Sierras of California*. San Francisco: Francis and Valentine, 1875.

————. *Sight: An Exposition of the Principles of Monocular and Binocular Vision*. London: C. Kegan Paul, 1881.

————. *Evolution and Its Relation to Religious Thought*. London: Chapman and Hall, 1888.

————. *Elements of Geology*. New York: D. Appleton, 1889.

————. "My Trip to Kings River Canyon." *Sunset* 5:6 (October 1900), 275–85.

LeConte, Joseph N. *A Summer of Travel in the High Sierra*. Written 1890; published posthumously. Ashland, Ore.: Lewis Osborne, 1972.

————. "Parmelian Prints of the High Sierra." *Sierra Club Bulletin* 13:1 (1928), 96.

Leopold, Aldo. "The Wilderness and Its Place in Forest Recreational Policy." *Journal of Forestry* 19 (1921), 718–21.

————. "A Biotic View of the Land." *Journal of Forestry* 37:9 (September 1939), 727–30.

————. "Wilderness Values." *Living Wilderness* 7:7 (March 1941), 24–25.

————. *A Sand County Almanac and Sketches Here and There*. 1949. Reprint, New York and Oxford: Oxford University Press, 1987.

Lewis, Oscar. *To Remember Albert Bender: Notes for a Biography,* San Francisco: Oscar Lewis, 1973 [privately printed by Robert Grabhorn and Andrew Hoyem].

Lowe, Sue Davidson. *Stieglitz: A Memoir/Biography*. London: Quartet, 1983.

Lucas, George R., Jr. *The Genesis of Modern Process Thought: A Historical Outline with Bibliography*. Metuchen, N.J.: The American Theological Library Association; London: The Scarecrow Press, 1983.

Luhan, Mabel Dodge. *Winter in Taos*. New York: Harcourt Brace, [1935].

Lukan, Karl, ed. *The Alps and Alpinism*. London: Thames and Hudson, 1968.

Manchester, Ellen. "'Ansel Adams': About His Work, Not His Editor." Review of *Ansel Adams*, edited by Liliane De Cock. *Afterimage,* May 1973, 5.

Mather, Stephen T. "Ideals and Policy of the National Park Service." In *Handbook of Yosemite National Park,* by Ansel F. Hall. New York: G. P. Putnam's Sons; London: Knickerbocker Press, 1921.

Matthes, François E. *Sketch of Yosemite National Park and An Account of the Origin of the Yosemite and Hetch Hetchy Valleys*. Washington, D.C.: U.S. Government Printing Office, 1928.

———. *Geologic History of the Yosemite Valley.* Professional Paper 160. Washington, D.C.: U.S. Government Printing Office (U.S. Department of the Interior/Geological Survey), 1930.

———. *Sequoia National Park: A Geological Album.* Edited by Fritiof Fryxell. Berkeley and Los Angeles: University of California Press, 1950.

———. *The Incomparable Valley: A Geologic Interpretation of the Yosemite.* Edited by F. Fryxell. 1950. Reprint, Berkeley and Los Angeles: University of California Press, 1956.

Mees, C. E. Kenneth. *Photography.* London: G. Bell and Sons, 1936.

Michaels, Barbara L. *Gertrude Käsebier: The Photographer and Her Photographs.* New York: Harry N. Abrams, 1992.

Mills, G. H. Saxon. "Modern Photography: Its development, scope and possibilities." *Modern Photography* (*The Studio* Special Number). London: The Studio; New York: William Edwin Rudge, 1931, 2–14.

Mitchell, Richard G., Jr. *Mountain Experience: The Psychology and Sociology of Adventure.* Chicago and London: University of Chicago Press, 1983.

Morgan, Ann Lee. *Arthur Dove: Life and Work, with a Catalogue Raisonné.* Newark: University of Delaware Press; London and Toronto: Associated University Presses, 1984.

Mortensen, William. "Venus and Vulcan: An Essay on Creative Pictorialism. Fallacies of Pure Photography." *Camera Craft* 41 (June 1934), 257–65.

———. "Venus and Vulcan: An Essay on Creative Pictorialism. 5. A Manifesto and a Prophesy." *Camera Craft* 41 (July 1934), 309–17.

Moss, M. E. *Benedetto Croce Reconsidered.* Hanover and London: University Press of New England, 1987.

Muir, John. "Studies in the Sierra, No. 2." In *South of Yosemite: Selected Writings of John Muir,* edited by Fred Gunsky. Garden City, N.Y.: The Natural History Press, 1968. First published in *Overland Monthly* (June 1874).

———. *The Mountains of California.* London: T. Fisher Unwin, 1894.

———. *My First Summer in the Sierra.* London: Constable; Boston: Houghton Mifflin, 1911.

———. *John of the Mountains: The Unpublished Journals of John Muir.* Edited by Linnie Marsh Wolfe. Boston: Houghton Mifflin, 1938.

Naef, Weston. *Era of Exploration: The Rise of Landscape Photography in the American West, 1860–1885.* Buffalo: Albright-Knox Art Gallery; New York: Metropolitan Museum of Art, 1975.

Nash, Roderick. *Wilderness and the American Mind.* New Haven and London: Yale University Press, 1982.

———. *The Rights of Nature: A History of Environmental Ethics.* Madison: University of Wisconsin Press, 1989.

Newhall, Beaumont. *In Focus: Memoirs of a Life in Photography.* Boston: Little, Brown, 1993.

Newhall, Nancy. "The Enduring Moment." Ansel Adams Archive, Center for Creative Photography, University of Arizona, Tucson. Typescript (intended as vol. 2 of a biography of Adams).

———. "The Photographer and Reality: Ansel Adams." c. 1950. Sierra Club Papers, Ansel Adams Papers. Bancroft Library, University of California, Berkeley. Also Beaumont and Nancy Newhall Papers, Special Collections, Getty Research Institute for the History of Art and the Humanities, Los Angeles. Typescript (131-page draft of a biography).

———. *Ansel Adams: The Eloquent Light.* 1963. Reprint, Millerton, N.Y.: Aperture, 1980.

———. *From Adams to Stieglitz: Pioneers of Modern Photography.* New York: Aperture, 1989.

Nickel, Douglas R. "An Art of Perception." In *Carleton Watkins: The Art of Perception.* San Francisco: San Francisco Museum of Modern Art, 1999.

Norman, Dorothy. "Art is an Equivalent." In *Dualities,* by Dorothy Norman. New York: privately printed for An American Place, 1933.

———. "Alfred Stieglitz—Seer," *Aperture* 3:4 (1955), 3–24.

———. *Alfred Stieglitz: An American Seer.* New York: Duell, Sloan, and Pearce, 1960; Millerton, N.Y.: Aperture, 1973.

———. "Alfred Stieglitz: Introduction to an American Seer." *Aperture* 8:1 (1960), 3–65.

Northrop, F. S. C. "The Functions and Future of Poetry." In *Logic of the Sciences and Humanities.* Westport, Conn.: Greenwood Press, 1947. First printed in *Furioso* 1:4 (1941).

———. *The Meeting of East and West.* New York: Macmillan, 1946.

Obata, Chiura. *From the Sierra to the Sea*. Berkeley: Archetype Press, 1937.

O'Day, Edward F. *John Henry Nash: The Aldus of San Francisco*. San Francisco: San Francisco Bay Cities Club of Printing House Craftsmen, 1928.

Orage, A. R. *Nietzsche in Outline and Aphorism*. London and Edinburgh: T. N. Foulis, 1907.

———. *Selected Essays and Critical Writings*. Edited by Herbert Read and Denis Saurat. London: Stanley Nott, 1935.

Ouspensky, P. D. *Tertium Organum: The Third Canon of Thought. A Key to the Enigmas of the World*. London: Kegan Paul, Trench Trübner, 1923.

Ozenfant, Amédée, and Charles-Edouard Jeanneret. "Le Purisme." In *Ozenfant and Purism: The Evolution of a Style,* by Susan L. Ball. Ann Arbor: UMI Research Press, 1981. Translated by the author. Originally published in Amédée Ozenfant and Charles-Edouard Jeanneret, *Après le Cubisme* (Paris, 1918).

Ozenfant, Amédée. *Foundations of Modern Art*. London: John Rodker, 1931.

Persons, Stow, ed. *Evolutionary Thought in America*. 1950. New York: George Braziller, 1956.

Peterson, Christian A. *After the Photo-Secession: American Pictorial Photography, 1910–1955*. New York and London: The Minneapolis Institute of Arts in association with W. W. Norton, 1997.

Pictorialism in California: Photographs 1900–1940. With essays by Michael G. Wilson and Dennis Reed. Malibu, Calif.: J. Paul Getty Museum; San Marino: Henry E. Huntington Library and Art Gallery, 1994.

Poore, Henry Rankin. *Art Principles in Practice*. New York and London: G. P. Putnam's Sons and The Knickerbocker Press, 1930.

Powys, John Cowper. *The Complex Vision*. New York: Dodd, Mead, 1920.

———. *In Defence of Sensuality*. London: Victor Gollancz, 1930.

———. *Autobiography*. London: The Bodley Head, 1934.

———. *John Cowper Powys: A Selection from His Poems*. Edited by Kenneth Hopkins. London: Macdonald, 1964.

Read, Herbert. "Science and the Modern World." *New Criterion* 4:3 (June 1926), 581–86.

Rexroth, Kenneth. "The Objectivism of Edward Weston: An Attempt at a Functional Definition of the Art of the Camera." 1931. *History of Photography* 22:2 (Summer 1998), 179–82.

———. "Prolegomena to a Theodicy," "Fundamental Disagreement with Two Contemporaries," and "The Place for Ivor Winters." In *An "Objectivists" Anthology,* by Louis Zukofsky, 53–78, 189–92; 79–86; 165–68. Le Beausset, Var, France: TO, 1932.

Rookmaaker, H. R. *Gauguin and Nineteenth Century Art Theory,* Amsterdam: Swets and Zeitlinger, 1972 (originally published as *Synthetist Art Theories,* 1959).

Rowbotham, Sheila, and Jeffrey Weeks. *Socialism and the New Life*. London: Pluto Press, 1977.

Royce, Josiah, Joseph LeConte, G. H. Howison, and Sidney Edward Mezes. *The Conception of God: A Philosophical Discussion Concerning the Nature of the Divine Idea as a Demonstrable Reality*. New York and London: Macmillan, 1897.

Rudhyar, Dane. *The Magic of Tone and the Art of Music*. Boulder, Colo.: Shambhala, 1982.

Runte, Alfred. *Yosemite: The Embattled Wilderness*. Lincoln, Nebraska, and London: University of Nebraska Press, 1979.

Ruskin, John. *The Complete Works of John Ruskin*. 38 vols. Edited by E .T. Cook and Alexander Wedderburn. London: George Allen; New York: Longmans, Green, 1903–1912.

Sandeen, Eric J. *Picturing an Exhibition: "The Family of Man" and 1950s America*. Albuquerque: University of New Mexico Press, 1995.

Santayana, George. *Interpretations of Poetry and Religion*. New York: Charles Scribner's Sons, 1916.

———. *Platonism and the Spiritual Life*. London: Constable, 1927.

———. *The Genteel Tradition: Nine Essays by George Santayana*. Edited by Douglas L. Wilson. Cambridge: Harvard University Press, 1967.

Schama, Simon. *Landscape and Memory*. London: Fontana Press, 1996.

Schilpp, Paul Arthur, ed. *The Philosophy of Alfred North Whitehead*. 2d ed. New York: Tudor, 1951.

Schloezer, Boris de. *Scriabin: Artist and Mystic*. Oxford: Oxford University Press, 1987.

Scully, Vincent. *Pueblo: Mountain, Village, Dance*. New York: Viking Press, 1972.

Seelig, Hugo. *Wheel of Fire*. Oceano: Round Table Book Company, 1936.

Seligmann, Herbert J. *Alfred Stieglitz Talking*. New Haven: Yale University Library, 1966.

[Sella, Vittorio]. *Summit: Vittorio Sella, Mountaineer and Photographer, The Years 1879–1909.* With David Brower, Greg Child, Paul Kallmes, and Wendy M. Watson. Millerton, N.Y.: Aperture, 1999.

Sellars, Roy Wood. *Evolutionary Naturalism.* Chicago and London: Open Court, 1922.

Shaw, Christopher E. "Identified with the One: Edward Carpenter, Henry Salt and the Ethical Socialist Philosophy of Science." In *Edward Carpenter and Late Victorian Radicalism,* edited by Tony Brown, 33–57. London: Frank Cass, 1990.

Simmel, Georg. "Die Alpen." In *Philosophische Kultur.* 1923. Reprint, Berlin: Verlag Klaus Wangenbach, 1986, 125–30.

Smythe, Frank S. *Climbs and Ski Runs.* Edinburgh and London: W. Blackwood and Sons, 1929.

———. *The Mountain Scene.* London: Adam and Charles Black, 1937.

Snyder, Robert L. *Pare Lorentz and the Documentary Film.* Norman: University of Oklahoma Press, 1968.

Spaulding, Jonathan. *Ansel Adams and the American Landscape.* Berkeley, Los Angeles, and London: University of California Press, 1995.

Starr, Kevin. *Americans and the California Dream.* New York: Oxford University Press, 1973.

Starr, Walter A., Jr. *Guide to the John Muir Trail and the High Sierra Region.* San Francisco: Sierra Club, 1934.

Starr-Jordan, David. *California and Californians, and The Alps of the King-Kern Divide.* San Francisco: Whitaker-Ray, 1903.

Stein, Roger B. *John Ruskin and Aesthetic Thought in America 1840–1900.* Cambridge: Harvard University Press, 1967.

Stephen, Leslie. "Mountaineering in the Sierra Nevada." *Alpine Journal* 5 (1872), 389–96.

———. *The Playground of Europe.* Oxford: Basil Blackwell, 1936.

Stephens, Lester D. *Joseph LeConte: Gentle Prophet of Evolution.* Baton Rouge and London: Louisiana State University Press, 1982.

Stieglitz Memorial Portfolio 1864–1946: Tributes—In Memoriam. Edited by Dorothy Norman. New York: Twice a Year, 1947.

Strand, Paul, and Nancy Newhall. *Time in New England.* 1950. Rev. ed. Millerton, N.Y.: Aperture, 1980.

Strumia, M. M. "Moods of Mountains and Climbers." *American Alpine Journal* 1:1 (1929), 31–39.

Szarkowski, John. "Kaweah Gap and Its Variants." In *Ansel Adams: 1902–1984,* edited by James Alinder. Carmel, Calif.: The Friends of Photography, 1984, 13–15.

———. Introduction to *Ansel Adams: Classic Images.* Boston: Little, Brown, 1986.

———. "Ansel Adams and the Sierra Nevada." In *Ansel Adams: Yosemite and the High Sierra.* Boston: Little, Brown, 1994.

———. *Alfred Stieglitz at Lake George.* New York: Museum of Modern Art, 1995.

Thoreau, Henry David. *Walden: Or Life in the Woods.* Boston: The Limited Editions Club, 1936.

Tilney, F. C. *Principles of Photographic Pictorialism.* London: Chapman and Hall, 1930.

Tyndall, John. *The Glaciers of the Alps and Mountaineering in 1861.* London: J. M. Dent; New York: E. P. Dutton, [1906].

Udall, Sharyn Rolfsen. *Modernist Painting in New Mexico 1913–1935.* Albuquerque: University of New Mexico Press, 1984.

Van Dyke, Willard. "Group f/64." *Scribner's Magazine* 103:3 (March 1938), 54–55.

Varian, Dorothy. *Russell and Sigurd Varian: The Inventor and the Pilot.* Palo Alto, Calif.: Pacific Books, 1983.

Varian, John O. "Body of God." *Troubadour* 1:8 (May 1929), 6–7.

———. *Doorways Inward and Other Poems.* Halcyon, Calif.: Halcyon Temple Press, 1934.

Waters, George. *Ansel Adams 1902–1984: A Tribute by His Roxburghe Friends* [San Francisco: privately printed, 1984].

Weaver, Mike. *William Carlos Williams: The American Background.* Cambridge: Cambridge University Press, 1971.

———. *Alvin Langdon Coburn: Symbolist Photographer.* New York: Aperture, 1986.

Weston, Edward. "Imogen Cunningham, Photographer." In *Imogen Cunningham: Selected Texts and Bibliography,* edited by Richard Lorenz. Oxford, U.K.: Clio Press, 1992. First published in *The Carmelite* (17 April 1930), 7.

———. [Statement, in conjunction with Delphic Studios exhibition, 1930], *The San Franciscan* 5:2 (December 1930), 23.

————. "Photography." In *Enjoy Your Museum,* edited by Carl Thurston. Pasadena: Esto Publishing Company, 1934.

————. *The Daybooks of Edward Weston.* 2 vols. Edited by Nancy Newhall. Millerton, N.Y.: Aperture, 1973.

————. *Edward Weston on Photography.* Edited by Peter C. Bunnell. Salt Lake City: Peregrine Smith, 1983.

————. *Edward Weston Omnibus: A Critical Anthology.* Edited by Beaumont Newhall and Amy Conger. Salt Lake City: Peregrine Smith, 1984.

White, Minor. "Photography is an Art." *Design* 49 (December 1947), 6–8, 20.

————. "The Camera Mind and Eye." *Magazine of Art* 45 (January 1952), 16–19.

———— "Fundamentals of Style in Photography and the Elements of Reading Photographs." c. 1953–54. Minor White Archive, The Art Museum, Princeton University. Typescript.

————. "A Unique Experience in Teaching Photography." *Aperture* 4:4 (1956), 150–56.

————. "Happenstance and How It Involves the Photographer." *Photography* 11 (October 1956), 40–45, 73.

————. "On the Strength of a Mirage." *Art in America* 46 (Spring 1958), 52–55.

————. Foreword to "The Way Through Camera Work." *Aperture* 7:2 (1959).

————. *Mirrors, Messages, and Manifestations.* New York: Aperture, 1969.

White, Minor, and Walter Chappell. "Some Methods for Reading Photographs." *Aperture* 5:4 (1957), 156–71.

Whitehead, Alfred North. *Science and the Modern World.* Lowell Lectures, 1925. Cambridge: Cambridge University Press, 1926.

————. *Process and Reality: An Essay in Cosmology.* London: Cambridge University Press, 1929.

————. *Nature and Life.* Cambridge: Cambridge University Press, 1934.

————. *Modes of Thought.* Cambridge: Cambridge University Press, 1938.

———— *Dialogues of Alfred North Whitehead.* Recorded by Lucien Price. Westport, Conn.: Greenwood Press, 1954.

Wilenski, R. H. *The Modern Movement in Art.* London: Faber and Gwyer, 1927.

————. *The Meaning of Modern Sculpture.* London: Faber and Faber, 1932.

Wilkins, Thurman. *Thomas Moran: Artist of the Mountains.* Norman, Oklahoma: University of Oklahoma Press, 1998.

Williams, William Carlos. "Charles Sheeler—Paintings—Drawings—Photographs." 1939. In *Selected Essays of William Carlos Williams.* New York: Random House, 1954.

Wilson, Charis, and Wendy Madar. *Through Another Lens: My Years with Edward Weston.* New York: Farrar, Straus, and Giroux, 1998.

Wilson, Joyce Lancaster, ed. *The Work and Play of Adrian Wilson.* Austin: W. Thomas Taylor, 1983.

Wright, Cedric. "Trail Song: Giant Forest and Vicinity: 1927." *Sierra Club Bulletin,* 13:1 (February 1928), 20–23.

————. *Words of the Earth.* San Francisco: Sierra Club, 1960.

Wright, Peter, and John Armor. *The Mural Project.* Santa Barbara: The Reverie Press, 1989.

Young, Ella. *Flowering Dusk.* New York and Toronto: Longmans, Green, 1945.

Younghusband, Sir Francis. *The Heart of Nature; or The Quest for Natural Beauty.* London: John Murray, 1921.

Zukofsky, Louis. "An Objective." In *Prepositions: The Collected Critical Essays of Louis Zukofsky.* London: Rapp and Carroll, 1967. First published in *Poetry* (1931):20–26.